EARTH
WATCH

A Survey of the World from Space

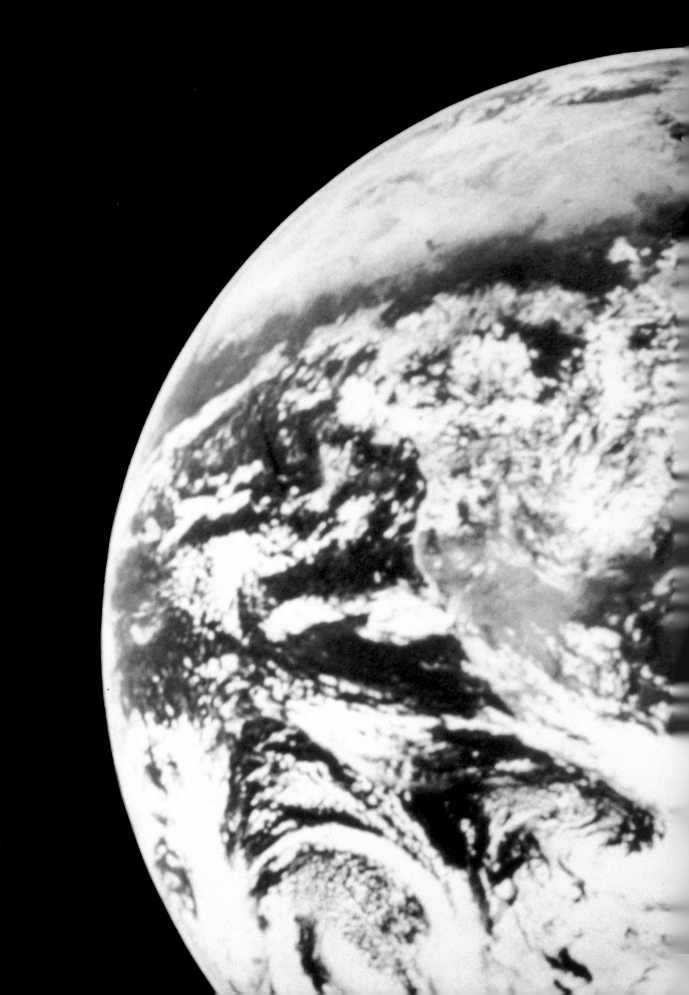

EARTH WATCH

CHARLES SHEFFIELD

MACMILLAN
PUBLISHING CO., INC.
NEW YORK

To Bob and Lee Porter, for non-obvious reasons

Acknowledgements Many sources and individuals have contributed to the content of this book. I would like to thank particularly Linda Zall for her help in all phases of image selection, evaluation, and description; Max Miller, Ron Hodge, Byron Loubert, Betty Hall, Brian Hollen, Carl Selsky, and Larry Norris for photographic consultation and image production; Martha Williams and Tom Jones for map layout and review; Ray Kreig, Orville Russell, Jon Dykstra, Steve Prucha, and Chuck Dorigan for discussions of particular scenes; Wolf Drewes and the Resource Planning Unit of the World Bank; and Jane Heller, who initiated the project and led production from original idea to final product. Finally, I would like to recognize my debt to earlier U.S. government works on the Landsat system and images, notably texts by staff of the U.S. Geological Survey and of N.A.S.A.'s Goddard Space Flight Centre.

Page 1: Star dunes in the Grand Erg Oriental
Pages 2-3: photograph taken by Apollo 17 in 1972, reproduced courtesy of National Aeronautics and Space Administrations

Design by Paul Watkins

Macmillan Publishing Co., Inc.
866 Third Avenue, New York, N.Y. 10022

Library of Congress catalog card Number: 81-3676

ISBN 0-02-610090-8

First American Edition 1981

Printed in Italy by New Interlitho S.p.A. Milan

Contents

Introduction

The total surface area of the earth, land and sea combined, is about 200 million square miles. An observer standing on the top of a high mountain, armed with a good telescope might, under ideal conditions, be able to view an area of 5,000 square miles — one forty-thousandth of the whole. Until two centuries ago, piecemeal observation of this type was all that mankind could achieve. It was easier to draw a good map of the moon than one of the earth.

In the last 200 years there has been a gradual broadening of our perspective, beginning with observations from hot-air and hydrogen balloons in the late eighteenth and the nineteenth centuries, and then aircraft reconnaissance and photography in the first half of the twentieth. In the past twenty years we have advanced to space observation and measurement, and a truly global view.

This widening of physical vistas has been matched by a change in perception. For almost all of history we have been obsessed with minor and local concerns, extending at most to the national level. Only recently, coinciding with the first images of the earth as a whole provided in 1968 by the hand-held cameras of the Apollo astronauts, have we come to recognize that earth must be regarded as one entity, a cohesive and finite life-support system for the creatures that inhabit it.

Weather satellites, with a ground resolution (smallest visible area) of only a square mile or so, have been mapping our atmosphere continuously since the launch of TIROS-1 in April 1960. Images provided by manned space missions were usually single shots of different parts of the earth taken as an incidental part of the mission. They were obtained under variable conditions with an assortment of cameras at various angles and at different times of day. The results indicated a great apparent diversity in the surface of the earth. The need to map the resources of the world became increasingly obvious as pressures grew on both renewable resources (food, fibres, and forests) and non-renewable ones (minerals and fossil fuels), and in 1965 the Earth Resources Survey Program was established by N.A.S.A. This had as its objective the development of a series of earth resources satellites which would observe the surface of the earth repeatedly, from the same viewing angle (directly above), with good resolution, using uniform equipment and observation conditions.

The first of these satellites, known originally as ERTS-1 (Earth Resources Technology Satellite One), and later as Landsat-1, was launched on 23 July 1972 and continued to function until 1979. Landsat-2 and Landsat-3 were launched in January 1975 and March 1978 respectively. When the first images were returned from Landsat-1 the results were a revelation. They showed that the diversity that appeared on the Apollo photographs was not the result of variation in equipment or conditions. It was real. The blue-grey-brown globe that can be seen from the moon displays an incredible richness of colour and texture when looked at with good resolution from a distance of 500 miles.

That multiplicity of texture and appearance is the subject of this book. The earth is on display here. Ranging from the lush richness of great forests to the stark wilderness of the hot deserts, from immense rivers to snow-covered mountain ranges, from sprawling conurbations to the vast oceans, earth's surface shows bewildering variety and beauty.

Each Landsat satellite carries an imaging system that views the earth in two visible and two infra-red wavelengths. Since the human eye

cannot see infra-red light, the satellite data are usually recreated as 'false-colour' images: the longer of the two infra-red wavelengths as red, true red as yellow, and true yellow as blue. (Healthy vegetation, however, appears red, because it strongly reflects infra-red light.) As the human eye sees only three primary colours, the shorter infra-red band is usually omitted. The information content of a single Landsat scene is huge. The spacecraft returns more than a million separate items of information to the earth *each second*. It does this every day of the year, whenever it is on the daylight side of the globe; 30 billion bits (binary elements of information) a day, 365 days a year. A single scene from Landsat shows a ground area of 13,000 square miles and calls for the processing of more than 30 million numbers before any of the returned data can be used in the form of an image. In fact, additional special computer enhancement is often required before a comprehensible display can be made in picture form.

The special processing methods that are applied to maximize the usefulness of Landsat data are covered in this book, but its primary focus is the uses themselves. Communications satellites are usually pointed to as the clearest case where the space programme has shown commercial returns on investment, but close behind communications, rivalling it and perhaps in the 1980s surpassing it, comes earth resources. Landsat images offer a cornucopia of information to geographers, geologists, agronomists, prospectors, foresters, hydrologists, soils scientists, cartographers, land use planners, oceanographers, coastal zone analysts, and environmentalists. The uses of these space-derived data now form a standard part of natural resources investigations. The beauty of the images is striking − they have been the subject of space art exhibitions, and are stocked by specialist art galleries. However, their usefulness was the criterion used to select the pictures presented here.

A number of reasons make Landsat images valuable to so many different people. *Uniform repeated coverage* allows comparison of the condition of the earth today with that of a month ago, or a year ago, or five years ago. *Broad area coverage* in a single picture enables continuous ground features to be traced for many miles, as is seldom possible with aerial photographs. Geologists have been able to trace major fractures of the earth's surface from Landsat images, noting where the fault line 'disappears' under sediment and then re-emerges five, ten or twenty miles further on. *Good resolution* reveals features that are as small as an acre in size. We can inventory crops, measure the area of forest logging programmes, watch the growth and shrinkage of water bodies and snow cover, and follow the movement of sand dunes into areas that are becoming tomorrow's deserts.

Finally, *infra-red observation* permits analyses that cannot be made from visible light images. We can observe the health of growing crops and see how they are affected by drought and disease. We can use special processing methods to look at surface rock types and apply that information to geological prospecting and exploration. With other special processing, we can estimate biomass − the amount of growing vegetation − on any single acre of the earth's surface. This information is vital to food supply, land use planning, environmental monitoring, and the management of grazing lands and wildlife preserves.

The examples that follow illustrate how each general property of the Landsat images translates to special uses in different disciplines. We can observe the changing seasons and monitor crop germination and growth. We are given a bird's-eye view of the glaciers, enabling us to map them as they could never be mapped before spaceborne sensors were developed. We can also trace their footprints during the relentless march south in the last Ice Age. We can observe the most remote and inaccessible

parts of Asia, South America, Australia, and Africa, and locate mineral deposits without leaving our office. The same methods of analysis permit us to judge where wells should be drilled for scarce ground water in the most inhospitable deserts of the world.

Annual flooding of the great rivers decides the life and death of hundreds of millions of people, providing necessary enrichment of the soil as well as devastation. Landsat images show how these floods result from the melting of snow in the ranges of the Andes and the Himalayas, on down through the flood plains to the big estuaries, where we can see how millions of tons of sediment are carried out into the oceans. Erosion, soil loss, and desert movement can be seen in South Africa, where the process occurs naturally, and in North America, where it is the result of earlier abuses of the land. Modern agricultural practices aimed at minimizing soil loss appear clearly on the Landsat pictures, as do some national boundaries, through the visible differences in agricultural methods used in neighbouring countries.

Man's impact is clear on many scenes that appear in this book. Swirls of pollution can be seen in the great bays near big cities, and the effects of over-grazing by herds of nomadic tribes are visible in West Africa, threatening the region with new deserts if less destructive practices are not introduced there. On many images we can see strong evidence of the fragility of natural ecologies. The differences between the pictures of undeveloped areas and those affected by human activity are striking.

Of all the forces at work on the earth that can affect the future of mankind, by far the most dangerous and most active is revealed as man himself. The resources of the earth are huge, diverse, and widespread; but they are not inexhaustible, nor are they indestructible. Landsat offers one of our best hopes for minimizing the risk of self-destructive change.

The Landsat Spacecraft
image processing and image selection

Landsat is a relatively simple satellite. About one ton in weight, it travels round the earth in an almost circular orbit, with a revolution time of 103 minutes. The orbit has been chosen to be sun-synchronous, so that the satellite always sweeps across the earth at the same local time of day, about nine-thirty in the morning.

Each Landsat spacecraft flies at a height of about 570 miles, in an orbit that passes close to the poles. As the earth turns beneath the orbiting spacecraft, the instruments on board take pictures of the successive swaths of ground directly below. Like flat tape being wound onto a ball, these swaths of coverage gradually envelop the earth with a full layer of tape being added to the ball every eighteen days (see **Figure 1**). Thus every day each Landsat takes another picture of the same ground area that it scanned eighteen days before. Until 1980, Landsat-2 was synchronized to Landsat-3, and between them they produced images of the same area every nine days. Technical malfunctions now prevent this.

Not quite the whole earth is covered by these swaths. The spacecraft never traverse the north and south poles, and images are restricted to regions that lie at latitudes below 81 degrees. This is a minor practical limitation since it excludes only a part of Antarctica, the northern tip of Greenland, and parts of the north Canadian Queen Elizabeth Islands and Franz Joseph Land in the Arctic Ocean. The future value of these areas may be high (think of the North Slope of Alaska, with its giant oil fields), but at present they hold few people and little known resources.

Each spacecraft carries two different kinds of instruments for obtaining pictures: the Multi-Spectral Scanner and the Return Beam Vidicon. Most of the images obtained by Landsat (and all the colour pictures in this book) have been taken using the first instrument. It does not take photographs like a camera, but, as its name implies, continuously scans the area that lies directly below the spacecraft as it moves along in its orbit and senses the brightness of sunlight reflected from the earth. It thus sees the earth, when cloud cover permits, as a series of strips of surface, about 115 miles wide, each running roughly north-to-south. These strips overlap by sixteen miles at the equator and more at higher latitudes where the coverage converges. For convenience of processing, each strip is divided into 115 × 115-mile sections after the information has been received on the ground. Each section is known as a single Landsat 'frame', or scene.

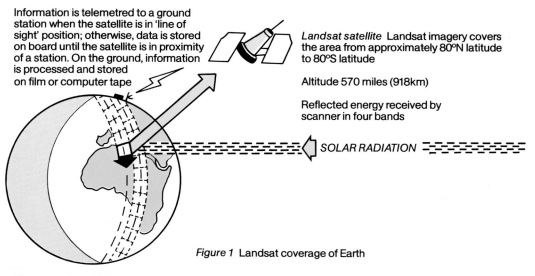

Information is telemetred to a ground station when the satellite is in 'line of sight' position; otherwise, data is stored on board until the satellite is in proximity of a station. On the ground, information is processed and stored on film or computer tape

Landsat satellite Landsat imagery covers the area from approximately 80°N latitude to 80°S latitude

Altitude 570 miles (918km)

Reflected energy received by scanner in four bands

SOLAR RADIATION

Figure 1 Landsat coverage of Earth

The scanner senses the reflected sunlight in four different 'colours', or wavelengths. Two of these wavelengths are too long for the human eye to perceive, and the other two are the yellow and red wavelengths of visible light. The four separate images are converted to voltages and returned to earth as electronic pulses, digital signals that must be received at a ground station in line-of-sight radio contact with the spacecraft. There are twelve such stations now in use: three in the U.S.A., two in Canada, two in South America (Brazil and Argentina), two in Europe (Italy and Sweden), two in Asia (Japan and India), and one in Australia. Several more are proposed or under construction. The 'footprint' of each station — the area within which Landsat data can be acquired — is a circle with a radius of about 2,000 miles, centred at the station. The coverage that is provided by existing stations is shown in **Figure 2**.

Images of those areas of the earth that are not in line-of-sight range of the spacecraft are recorded on two on-board tape recorders, for later transmission to receiving stations. The next generation of Landsat spacecraft will improve on this system by using a satellite in much higher orbit to relay the data to the ground. Information will be sensed by Landsat and transmitted upwards to the relay satellite, which in turn will send it down to a ground station. The height of the relay satellite (22,000 miles) will give it line-of-sight transmission capability of almost a full hemisphere. When two relay satellites are launched, future Landsat spacecraft will no longer need to carry tape recorders.

The smallest ground area seen by the scanner is about 210 feet square, and the final images that we see are therefore constructed from a large number of these small picture elements. Before that image appears a good deal of work must be done, both computational and photographic.

The reflected brightness in each picture element is converted to digital signals (i.e. numbers) and each number is returned as a radio pulse to the receiving stations on the ground. This data stream is first corrected for distortion caused by the motion of the spacecraft relative to the rotating, curved earth. Then the data from each wavelength sensed by the scanner (usually termed a *spectral band*) is used to create a black and white image by placing every recorded brightness as a tone of grey in its correct position on a piece of film (see **Figures 3** and **4**).

The black and white image now has to be converted to colour. We have four wavelengths (spectral bands), but there are only three primary colours — the scanner on Landsat not only sees wavelengths that are longer than we can perceive, it also sees *more colours* than we can recognize. The four 'primary colours' of Landsat have somehow to be translated into the three primary colours that we can see. There are

Figure 2 Coverage pattern for Landsat ground receiving stations

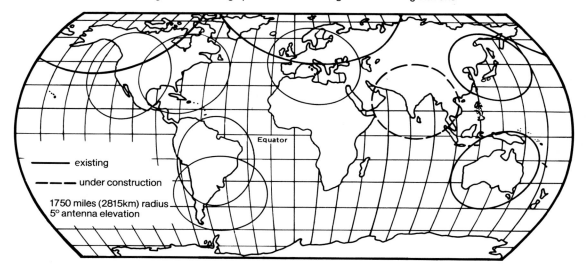

existing
under construction
1750 miles (2815km) radius
5° antenna elevation

Equator

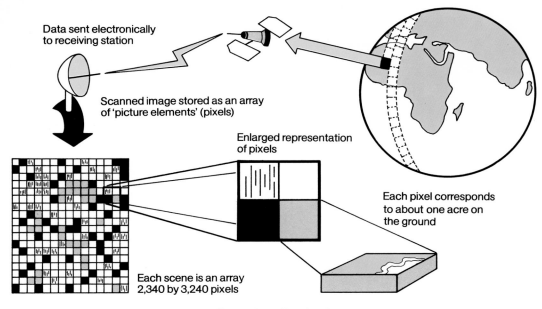

Data sent electronically
to receiving station

Scanned image stored as an array
of 'picture elements' (pixels)

Enlarged representation
of pixels

Each pixel corresponds
to about one acre on
the ground

Each scene is an array
2,340 by 3,240 pixels

Figure 3 Processing of Landsat images

several solutions to this problem, none of them completely satisfactory
because no single picture can completely represent the information
collected by the scanner. One way — the most common one — is to leave
out completely one of the two infra-red spectral bands (both of which,
incidentally, are much shorter in wavelength than *thermal* infra-red,
which is heat radiation). The yellow band (0.5 to 0.6 micrometres
wavelength), the red band (0.6 to 0.7) and the longer infra-red (0.8 to 1.1)
are used, and the shorter infra-red (0.7 to 0.8) is omitted. Most of the
examples in this book were created in this way. It results in healthy
growing vegetation appearing as a bright *red* on the image.

Another method, which has a striking impact on both the appearance
and the use of Landsat images, involves the creation of a *digital ratio*
image, which is especially useful for displaying subtle changes of contrast
in bright or dark areas of an image, and in mapping certain types of
geology. The four separate brightnesses for each picture element are
stored as numbers, which permits twelve brightness ratios. (If the

Figure 4 Image production

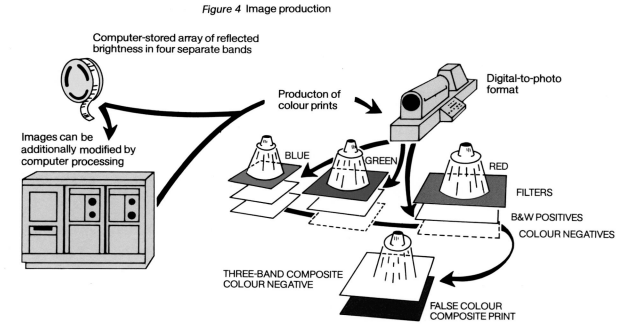

Computer-stored array of reflected
brightness in four separate bands

Production of
colour prints

Digital-to-photo
format

Images can be
additionally modified by
computer processing

BLUE

GREEN

RED

FILTERS

B&W POSITIVES

COLOUR NEGATIVES

THREE-BAND COMPOSITE
COLOUR NEGATIVE

FALSE COLOUR
COMPOSITE PRINT

brightness values for a picture element are A, B, C, and D, then the possible ratios are A/B, B/A, A/C, C/A, A/D, D/A, B/C, C/B, B/D, D/B, C/D, and D/C.) Any one of these can be used to create a new 'ratio band', in which ratios of brightness replace the brightness for each point of the image. Three ratio images may then be assigned to the three primary colours of the photographic process, and a colour 'ratio image' then produced. This might at first appear to compound the problem, as twelve bands have been created from which to choose, rather than the original four. But this is not really the case because the information content of the scene itself can be used as a guide to determine which ratios should be used. The calculations needed to create a ratio image are not trivial — they involve at least 22 million divisions per scene unless short-cuts in the computation can be found.

Numerous other combinations of the original four spectral bands are possible and can produce great variety in the appearance of an image. Pages 14−15 demonstrate how the choice of representation of a scene can make a great difference to its apparent information content and utility, even though the data provided from Landsat was the same for each case. Page 14 shows a typical false-colour image of the Battle Mountain, Nevada, area of the United States. It was constructed using the yellow, red, and second infra-red bands. The degree of visible detail is high in most places, but very bright areas of the image have saturated and they show as white regions with no internal structure. Page 15 top left shows a digital ratio of the same area, and the picture top right is a variation known as a pseudo-ratio. Both these images show more detail in areas where the false-colour image was saturated. This detail is often obtained at a price: residual scan lines are usually more visible in such products. The two pictures at the bottom of page 15 are 'eigenimages', or 'principal component images', which are especially effective for mapping surface rock types and for delineating geological alteration zones. These exotic presentations give maximum expression to the contrasts in the scene, using the three colours, but effective use of this method depends strongly on the content of the scene itself.

As the examples suggest, the number of possible band combinations of a single scene is very large. Deciding which one should be used necessitates knowing the purpose for which the picture is required, whether it is for geology, hydrology, snow mapping, agronomy, or simply for a striking wall display. Each of these uses has its own preferred band combinations and selected processing.

If the numerous ways that Landsat data can be processed and presented seems confusing, the next generation of earth resources spacecraft will provide even more of a challenge. These will carry *seven* spectral bands, rather than four!

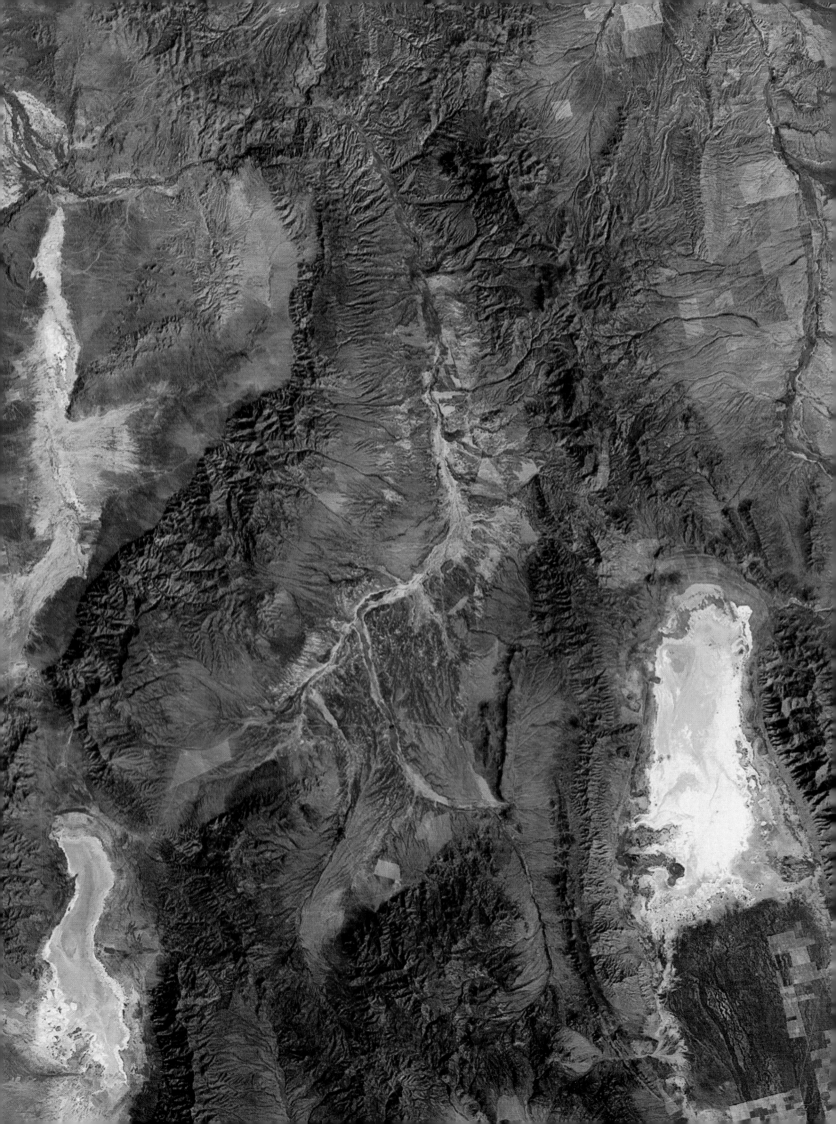

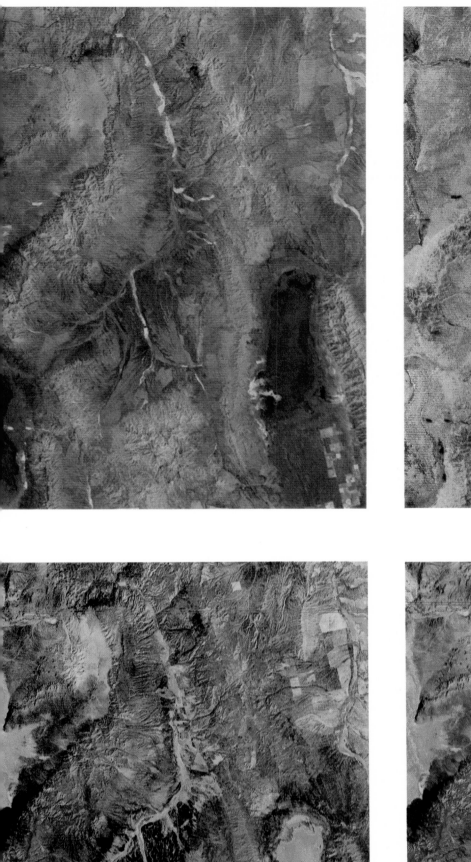
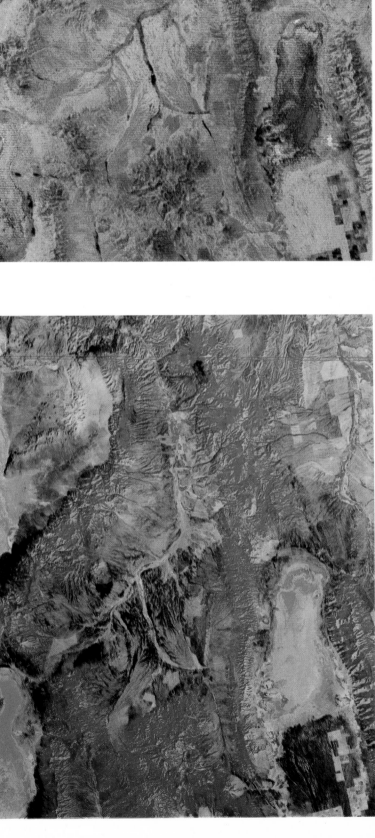

Rivers and Valleys

Few 'great' rivers of history are noted for either their length or the volume of water they carry. The Tiber, Thames, and Jordan Rivers, for example, have a combined length of only 660 miles — less than a quarter that of the Amur (China), Parana (South America), or Mackenzie (north-west Canada) individually, rivers that most people might have trouble placing on the world map. Landsat images, unaffected by historical emphases, give the world a true geographical perspective, and redefine the great rivers of the world. They do not, however, show much detail within the rivers themselves. The best wavelength of light for penetrating clear water is at 0.48 micrometres, just a little shorter than Landsat can record. The 'yellow' band of Landsat extends from 0.50 to 0.60 micrometres and penetrates water quite well, down to a depth of maybe fifteen metres (fifty feet). But this is also the Landsat spectral band that is most degraded by atmospheric haze and moisture. The other bands are almost useless for penetrating water. Red light is stopped in a few feet, and infra-red light finds water almost completely opaque.

A Landsat image of water thus derives useful information mainly from the yellow band, which leads to its characteristic appearance on false-colour images. Deep, clear water always appears as perfect black. Shallow or muddy water, and water that is carrying dissolved or suspended materials, shows as various shades of blue. The resulting images are useful for two complementary purposes. Water bodies can be mapped with ease and accuracy, and this constitutes a new and inexpensive mapping tool of particular value in remote parts of the world. Changes in shoreline and river course are easily detected. The same images show how much sediment is being carried by a river at any season, and soil erosion, coastal flow patterns, and seasonal flooding effects can be monitored. Changes as small as a few acres in eroded or silted areas can be detected.

In many cases the presence of small streams can be inferred from Landsat images even though their size is too small to be seen directly by the satellite. Most river valleys are marked by greater fertility over surrounding areas, and the resulting swath of bright vegetation gives unmistakeable evidence of the presence of water. This is especially noticeable in otherwise desert areas — the image of the Nile on page 21 is a striking example. At the same time, such inferences must be handled with care. A line of vegetation may not indicate a surface stream. In the Namib Desert shown on pages 66–7 the source of water for the vegetation is below ground, in channels of gravel.

Bangladesh and the Ganges

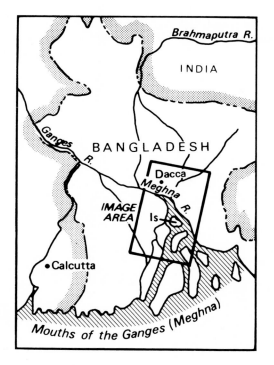

Mouths of the Ganges (Meghna)

The whole of Bangladesh lies within the great river delta of the Ganges and the Brahmaputra. With no mineral resources, coal, oil or gas with which to trade for food, the country relies on the annual monsoons and the flooding of the delta to provide a domestic food supply.

The Landsat image overleaf was recorded in early February, at the end of the dry season that runs roughly from November to March. The true monsoon lasts from June to August, but the pre-monsoon months of March and April are much wetter in the Ganges delta than in most of the rest of India. The crop calendar is completely controlled by these seasonal changes. *Aus* rice grows in pre-monsoon and early monsoon months, *aman* rice is planted before the monsoon and harvested in October and November, and *boro* rice is grown in the dry season. *Boro* rice shares field space with *rabi* — a mixture of legumes, wheat, onions, and other vegetable and fibre crops. The large population and small land area (75 million people on 60,000 square miles) oblige very intensive agriculture, with two or more crops per year often grown on the same plot of land.

The continuous red areas on the image, such as that south of Dacca, are dry-season crops, almost mature and ready to harvest. Further south, the pale blue areas dotted with red are regions that have been planted with *rabi* and are now being prepared for the planting of *aus* rice. Each tiny red dot is likely to be an individual farm, only a couple of acres of land. To the south-west, the greenish areas are an extensive region of infertile swamp land.

Even though this is a dry-season image, note the definite blue tone at the river mouth. It indicates that huge volumes of sediment are being carried out into the Bay of Bengal. The delta is still building, with hundreds of millions of tons of silt being carried every year from the Himalayan foothills and across the inland plains. Later in the year, monsoon floods are likely to completely change the course of the delta rivers. For example, the large island (**Is.** on the map) was absent from maps made in 1971. The face of the delta is constantly changing as streams move to new beds. The World Bank, looking for ways to update land use and land area maps at low cost, has turned to Landsat images of Bangladesh as an economical and practical way to keep track of the moving pattern of rivers and land. Analyses using Landsat typically run less than 1 per cent of the cost of aerial photographic surveys.

Image scale and date: 1 inch = 6 miles, February 1977 N

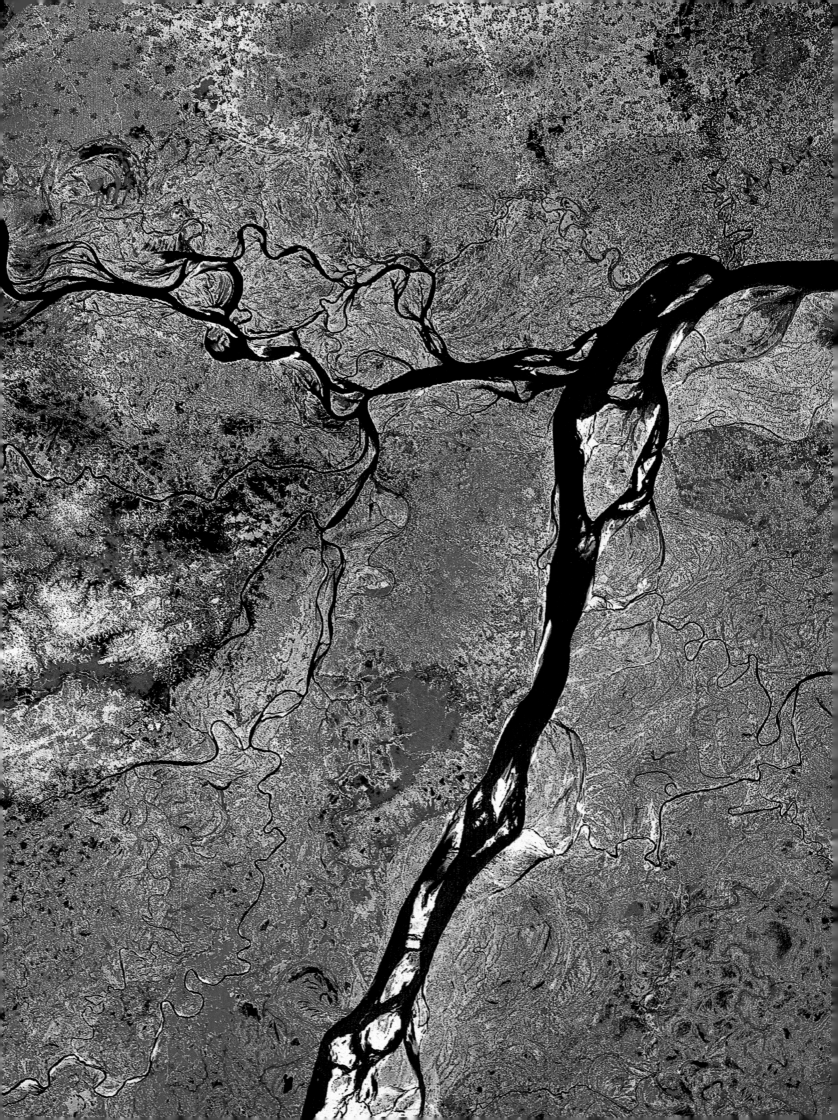

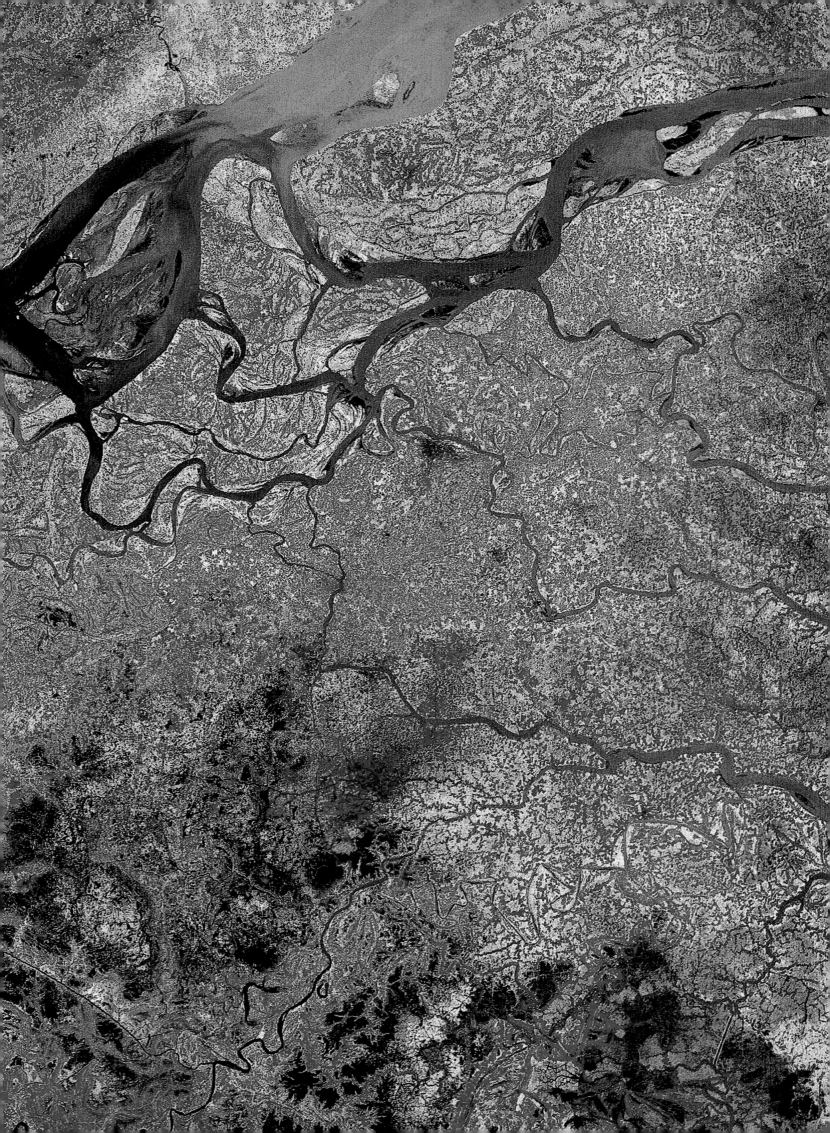

The Nile

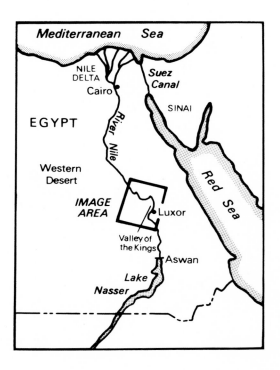

Shakespeare had Cleopatra in mind rather than the river itself when he spoke of 'my serpent of Old Nile'. But this image certainly shows a snake, twisting its way towards Cairo and the Nile delta. The river at this point has flowed almost 4,000 miles, all the way from its source in the headwaters of the Luvironza.

The river winds its way as a black thread through the irrigated valley of red-displayed vegetation, just as it has done for the past 6,000 years. Attempts to predict the time of its spring flooding were a major stimulus for the development of astronomy and mathematics. The flooding ceased with the building of the Aswan Dam and the creation of Lake Nasser, which holds 5,000 million gallons of water, about 100 miles south of the area of this image.

The loop in the river at the centre of the image contains the Valley of the Kings, on the west bank across from Luxor (see map). Thebes (El Karnak), the ancient capital of Egypt, was located at Luxor. Its sixty-acre complex of temples, obelisks and stone statues of the Pharaohs is visible as a dark-grey blob among the red vegetation, just east of the river and north of Luxor. No other evidence of the works of ancient Egypt can be seen. Drifting sand has covered much of the City of the Dead and the Valley of the Kings.

The rainfall in this area is only 1 inch per year or less, with what little there is falling between November and March. The numerous white drainage patterns visible north and west of the river are dry wadis (stream gullies). Note that even though this is a January scene and therefore taken during the rainy season, the wadis show no sign of vegetation along their banks. The irrigation of the alluvial strip (at most about twelve miles wide) is provided totally from the waters of the Nile.

The south-west part of the scene shows a characteristic blurring of detail and an overall north-west to south-east streaking that marks the presence of drifting sands. This is the beginning of Egypt's Western Desert.

N

Image scale and date: 1 inch = 8 miles, January 1976

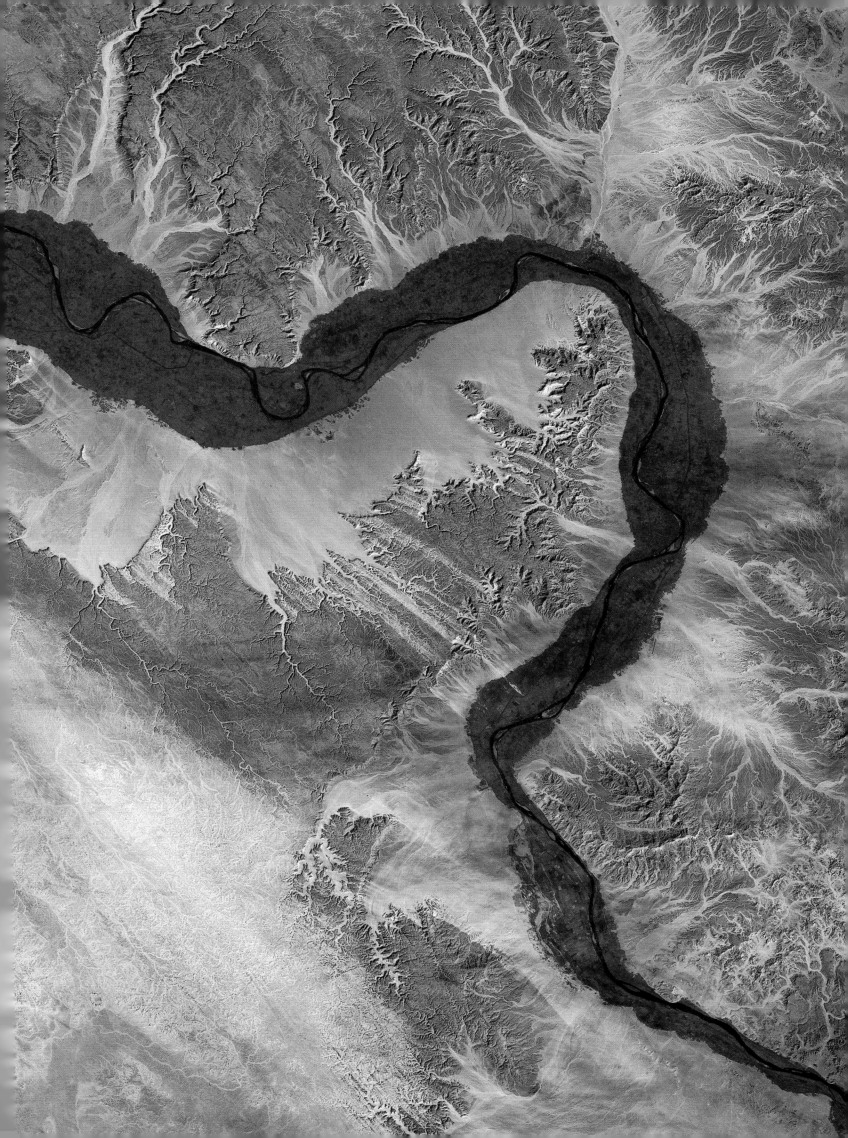

London and the Thames Valley

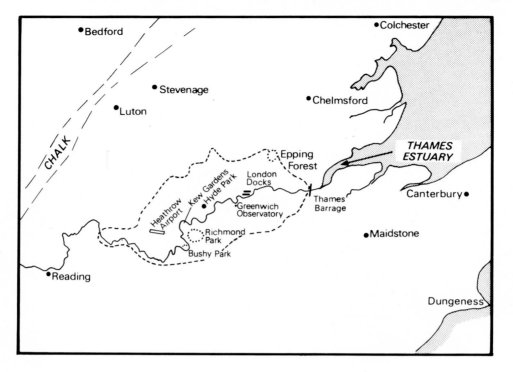

This cloud-free view of southern England was taken on 29 July 1975. The area shown is bordered by Northampton in the north, Reading in the west, Canterbury and Dungeness in the east, and Maidstone in the south. Each town shows as a clearly-defined area of greyish-blue amongst the red vegetation. Other towns easily seen on the image include Bedford, Bletchley, Luton, and Stevenage in the north-west, and Chelmsford and Colchester to the north-east of London. The extended mass of Greater London itself runs as an almost uninterrupted urban development for forty miles across the image.

The black thread of the Thames is visible as it twists its way from Reading, past the Water Authority reservoirs that show as black splotches between Staines and Thames Ditton, and on through central London. Heathrow airport is a blue-white oblong north of the reservoirs. In the middle of London the river becomes laden with sediment, and its colour on the image changes from black to light blue as it continues on to the Thames Estuary and the North Sea. The shallows of Foulness Sands and Maplin Sands show light blue on the estuary's northern shore.

The bluer tone that runs from north of Reading up to Cambridge and Bury St Edmunds is a line of surface chalk, which has comparatively low soil moisture and thus less vegetation cover and agricultural production.

Most Landsat images of London are obscured by haze. This scene is unusually clear. The red tones of Epping Forest, Richmond Park, Bushy Park, and Kew Gardens are visible. So are the great London docks, with the Victoria, Royal Albert, King George V, and West India Docks all showing as black horizontal lines on the image. Other dark areas to the north of this are the Higham Hill reservoirs near Epping Forest. The excavation around the Thames barrage can be clearly seen as white, and just visible also are the Serpentine in Hyde Park and the Greenwich Observatory, through which the prime meridian passes.

Image scale and date: 1 inch = 8 miles, July 1975

N

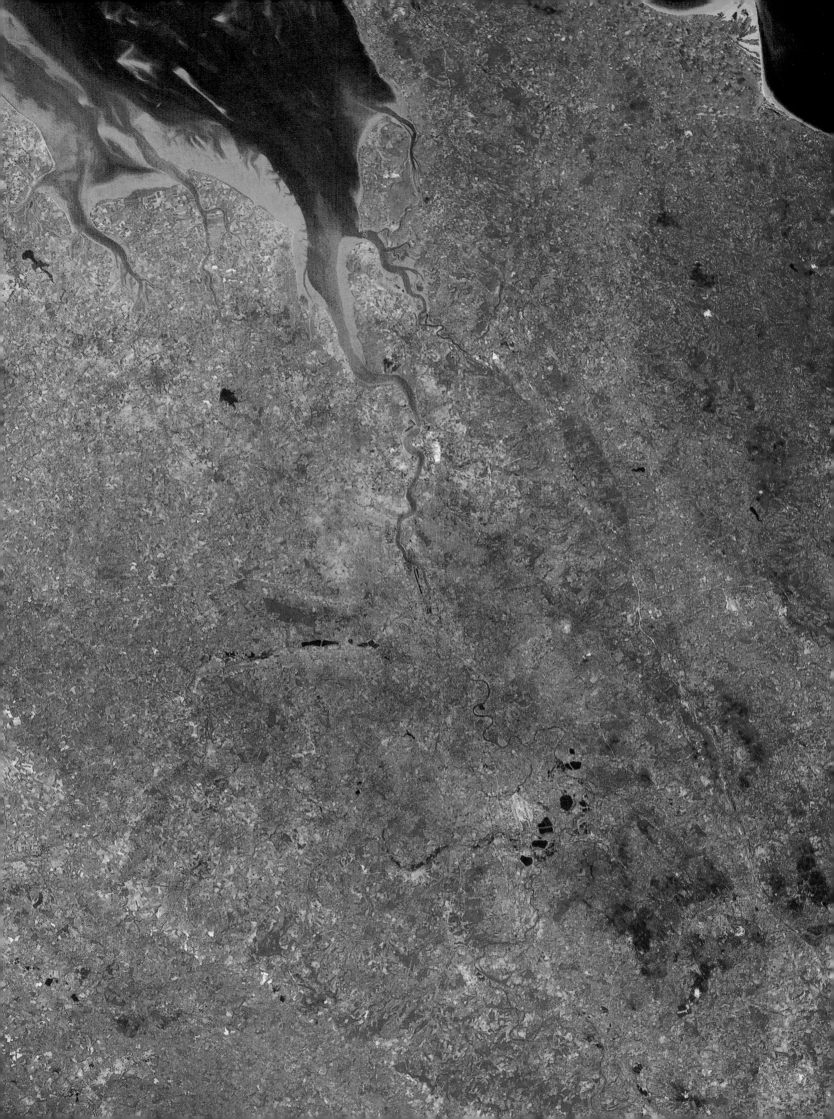

The Rio Grande and New Mexico

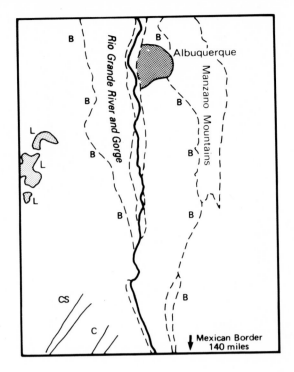

The Rio Grande River, a dark line at the centre of red vegetation in the gorge, dominates this image. The river is the fifth longest in North America, stretching 1,885 miles from its source in north-west Colorado to its outlet in the Gulf of Mexico. About 140 miles south of the image area the river meets the Mexican border at El Paso, then becomes the boundary between the United States and Mexico (where it is known as the Rio Bravo del Norte).

The city of Albuquerque is the clearly defined blue and red patch on the northern part of the scene. Forty years ago this part of the United States was so desolate and barren that it was chosen for the site of the Manhattan Project, where the first atomic bomb was designed, built, and tested at Los Alamos, sixty miles to the north. However, in the past twenty years Albuquerque has become one of the principal cities of the 'Sun Belt', to which people have been moving in increasing numbers. The city's population has jumped from 40,000 in 1940 to more than 300,000 in 1980.

The area is very dry. Vegetation grows in the cooler and damper mountains, as in the Manzano range east of Albuquerque, where the terrain rises sharply from 5,500 feet in the city to more than 10,000 feet just a few miles east. Otherwise there is irrigated agriculture, which can be seen, with very large fields, on the right of the picture and in the valley of the Rio Grande.

This scene offers an excellent example of the way in which large-scale geological features can be mapped from satellite images more simply than with conventional mapping techniques. The black lava beds (**L** on the map) to the left of the image are quite unmistakeable, as are the north-south lithological boundaries (**B**) on each side of the Rio Grande. However, expert geological advice is still advisable to ensure accurate interpretation of Landsat images. For example, at the very bottom of the picture are two dark lines (**CS**) which might be taken for ground features. But there is a matching pair of white lines (**C**) just south-east of them. These are, in fact, a pair of contrails from jet aircraft, together with their shadows on the ground. The angle of the sun at almost 9.30 on the December morning when this was taken was 26 degrees above the horizon. Knowing this, and measuring the distance between each contrail and its shadow, it is possible to work out the altitude of the aircraft. They were flying at 26,000 feet.

Image scale and date: 1 inch = 8 miles, December 1975

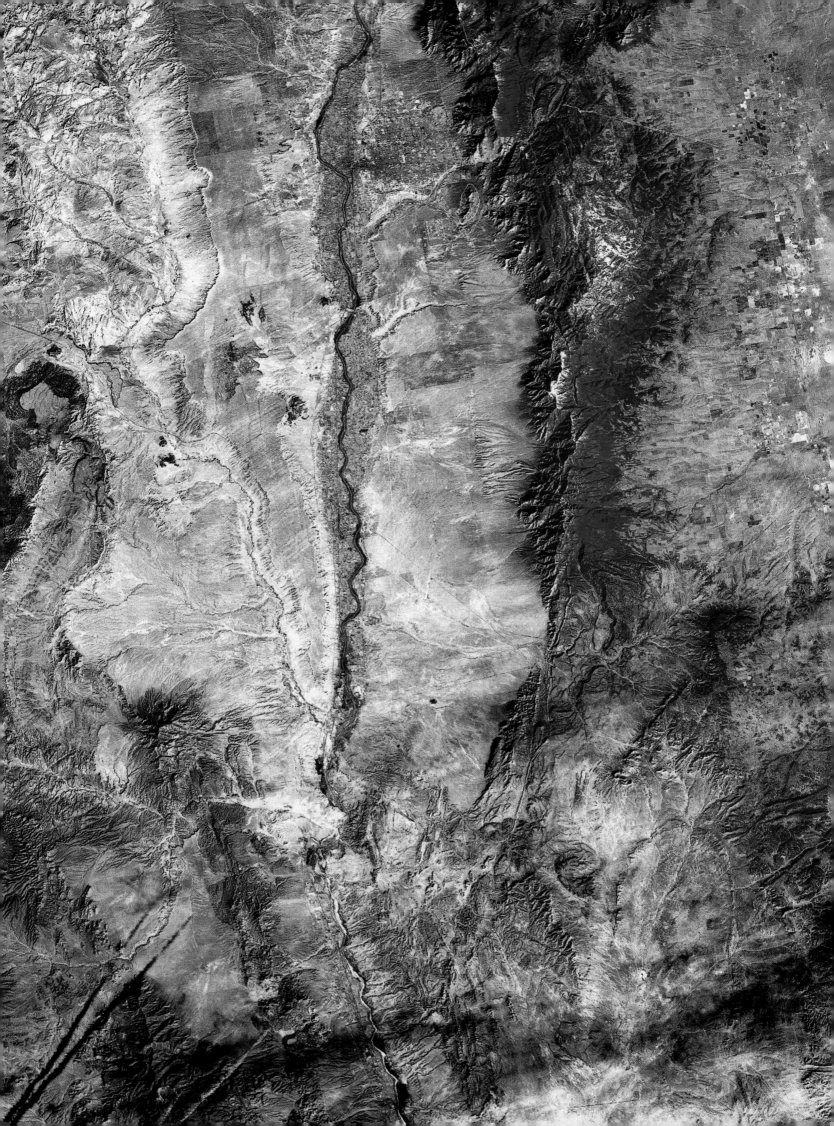

The Pampas, Patagonia, and the Rio Negro

The Rio Negro divides the 2,000 mile length of Argentina roughly in two, north from south. North of the river are the great grassland plains, the *pampas*, that stretch across Argentina from the Atlantic Ocean to the Andes. South of the river lies Patagonia, the sparsely populated desert region of the country. This image shows the great differences between the areas north and south of the river.

In the south-east, where the Rio Limay curls down to the dark body of water at the bottom of the picture, there is a pinkish-grey area that marks the beginning of the North Patagonian Massif. Further west, across the river, evidence of recent volcanic activity is visible as a set of miniature cones and craters (**V** on the map). This area, between the Rio Limay and the Rio Neuquén, is one of Argentina's most promising oil exploration regions, with production already under way at Centenario and at Campo Grande. An oil refinery has been built at the town of Plaza Huincul. The south-west to north-east streaks visible on the image between the oil fields and the Rio Neuquén are the result of prevailing south-west winds blowing sedimentary material from the western plain.

Although oil creates most of the current interest in this region, the picture here shows considerable areas of irrigated agriculture along the valleys of the Negro, Limay, and Neuquén. Water from the Andes is controlled through the use of reservoirs, seen on the image as dark areas. The biggest are the Cerros Colorades Reservoir south of the town of Anelo on the Rio Neuquén, and the Eziquiel Ramos Mexia Reservoir at the lower edge of the image. The towns that are supported by and control this agriculture are Neuquén, Cipolletti, Anelo, and General Roca. The first two towns are visible on the image as blue-grey round patches within the bright red strip of growing crops.

The straight white lines that show with such clarity on the dark volcanic rocks in the northern part of the picture are roads. They connect the Rio Negro valley through the province of La Pampa to the city of Buenos Aires, 600 miles away to the north-east.

The horizontal red line near the bottom of the image is a missing scan line, not something on the ground. Somewhere between the satellite scan of the scene and the read-out of the processed image to film, part of one line of data has been lost.

Image scale and date: 1 inch = 9 miles, April 1977

N

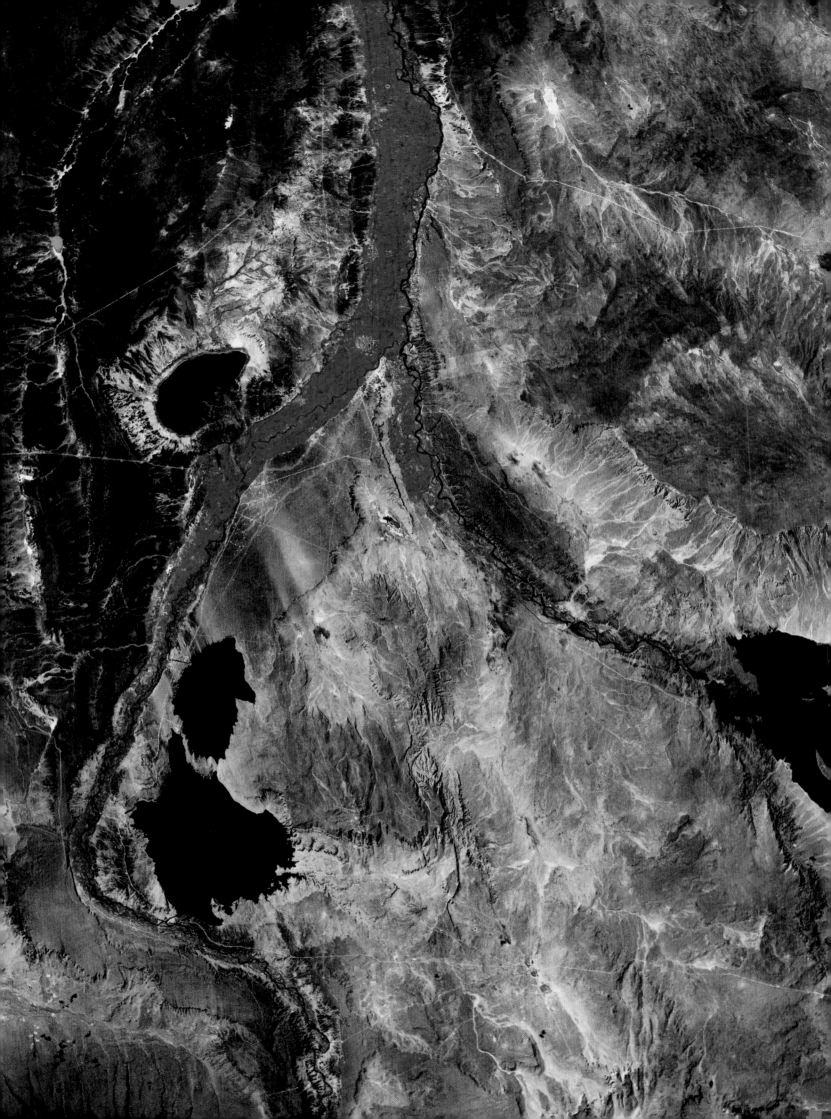

The Grand Canyon

The Colorado River rises in the mountains of Colorado and Wyoming and flows 1,500 miles to meet the Pacific Ocean in the Gulf of California. For much of its course through Arizona the river passes through a huge gorge of its own creation, the Grand Canyon, a phenomenon that early explorers were unanimous in declaring 'a spectacle unrivalled on this earth'. Two hundred and eighty miles long, up to eighteen miles wide, and more than a mile deep, the Canyon runs from Marble Canyon at the northern boundary of Arizona to Grand Wash Cliffs near the Nevada state line. This image gives an overview of its western portion.

As shown on the map, the river flows west through the Havasupai Indian Reservation, the Coconino and Shivwits Plateaus, and the Hualpai Indian Reservation. Finally it reaches the Grand Wash Cliffs and Lake Mead, which is on the extreme left of the image. Over the years more than 10 million million tons of rock have been carried downstream as the river dug its way gradually through the surface layers of the earth to form the Grand Canyon. The gorge narrows as it deepens, and the satellite image of it gives a unique view of the region's geological history, unaffected by the variations in sun and viewing angle that distort ground and aerial photographs.

The oldest rocks in the scene are Precambrian (marked as **1** on the map), ancient strata of volcanic and sedimentary origin, seen as slightly darker shades of blue in the pale blue area bottom left. The tan-coloured rocks (**2**) are from the Pennsylvanian Age, perhaps 280 million years old. Brownish-red tones indicate Kaibab limestone (**3**), maybe 240 million years old and formed in the Permian Age. Above this are more recent lavas (**4**), some less than 1,000 years old, recognizable from their very dark colours, flow marks and wrinkles. Finally, there are the blues and whites of sands and gravels (**5**), mobile layers that are like moving seas around the islands of older rocks. The wispy white patches on the right of the scene (**C** on the map) and the darker areas just north of them (**S**) have no geological significance, however. They are clouds and their shadows.

Image scale and date: 1 inch = 8 miles, September 1972 N

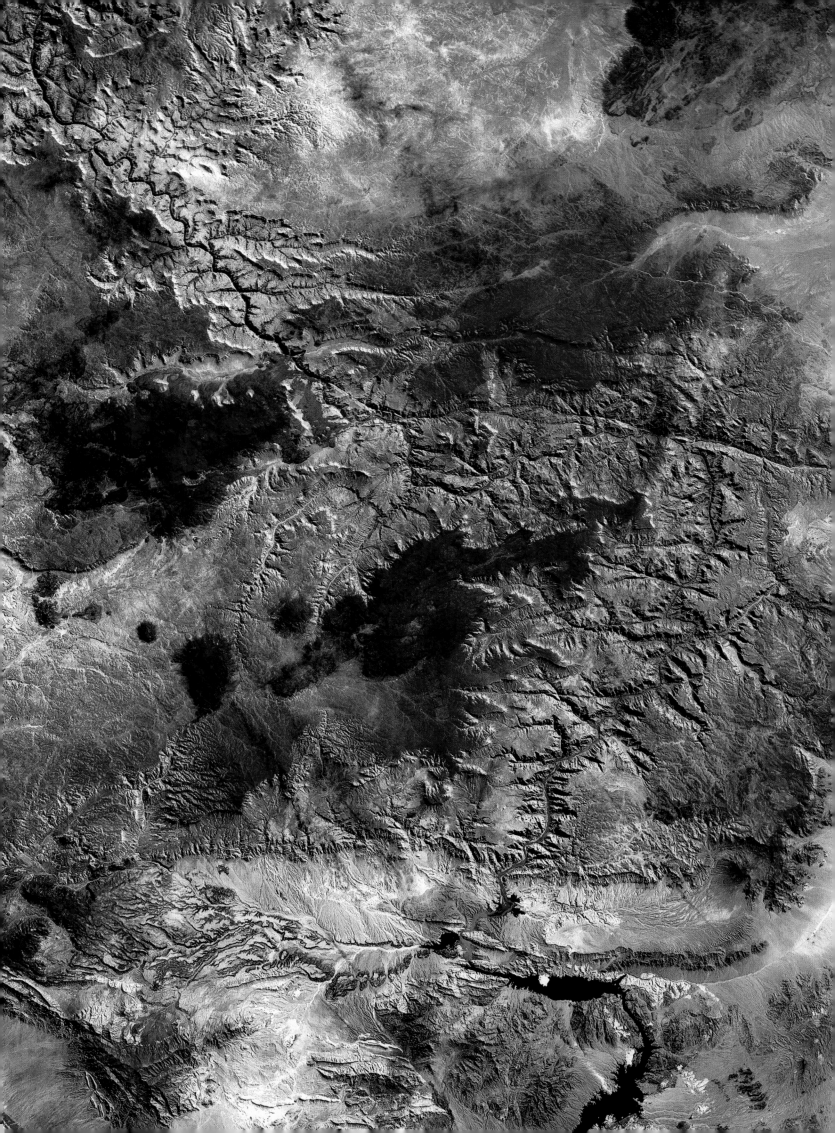

The Great African Rift Valley

A rift valley is a region of tension in the earth's crust, where sections are being pulled apart and lava from the earth's interior is closing the gap. One great rift of this type runs from the eastern end of the Mediterranean, down the line of the Dead Sea, through the Red Sea, and on into East Africa where it passes through Ethiopia, Somalia, Sudan, Kenya, and Tanzania. It comes to an end in Botswana, more than 5,000 miles from its starting point.

This image shows a central portion of the Great African Rift Valley's eastern segment in Kenya. The image centre is almost exactly on the equator, 200 miles east of Lake Victoria, 100 north of Nairobi, and about 300 from the nearest point of the Indian Ocean.

The Rift at this location is thirty to fifty miles across, and the land within it has sunk 2–3,000 feet below the surrounding plateau. The whole area is highly volcanic. The image displays the Rift's numerous north-south linear features in a series of dark lines and streaks all through the centre of the scene. Small lakes, most of them without connecting rivers, spot the middle of the picture. Many of them,

such as Lake Elmenteita, Lake Hannington, and Lake Nakuru are rich in minerals, the salts and carbonates produced by active volcanoes in the area. Lake Baringo in the north-west corner is particularly striking, with its bright blue colour and central island.

Further south the image shows heavy vegetation, notably the eastern side of the Mau Escarpment, with the extinct volcano of Mount Eburru at its eastern edge, and the Aberdare Mountains and National Park on the lower right of the picture. Within the Aberdare Mountains the dark 12,916-foot peak of Mount Kinangop and that of Mount Lesatima (13,120 feet) are visible. To the right of Mount Lesatima rise the western slopes of Mount Kenya, at 17,088 feet second only to Kilimanjaro on the African continent.

To the north, around Rumuruti, is the blue-white plain of Laikipia, with the Laikipia Escarpment easily visible. It lies east of Lake Baringo, a line that shows dull pink vegetation on the right and blue on the left. The area was an early home for white settlers, and is still a thriving agricultural region.

Image scale and date: 1 inch = 8.5 miles, January 1973

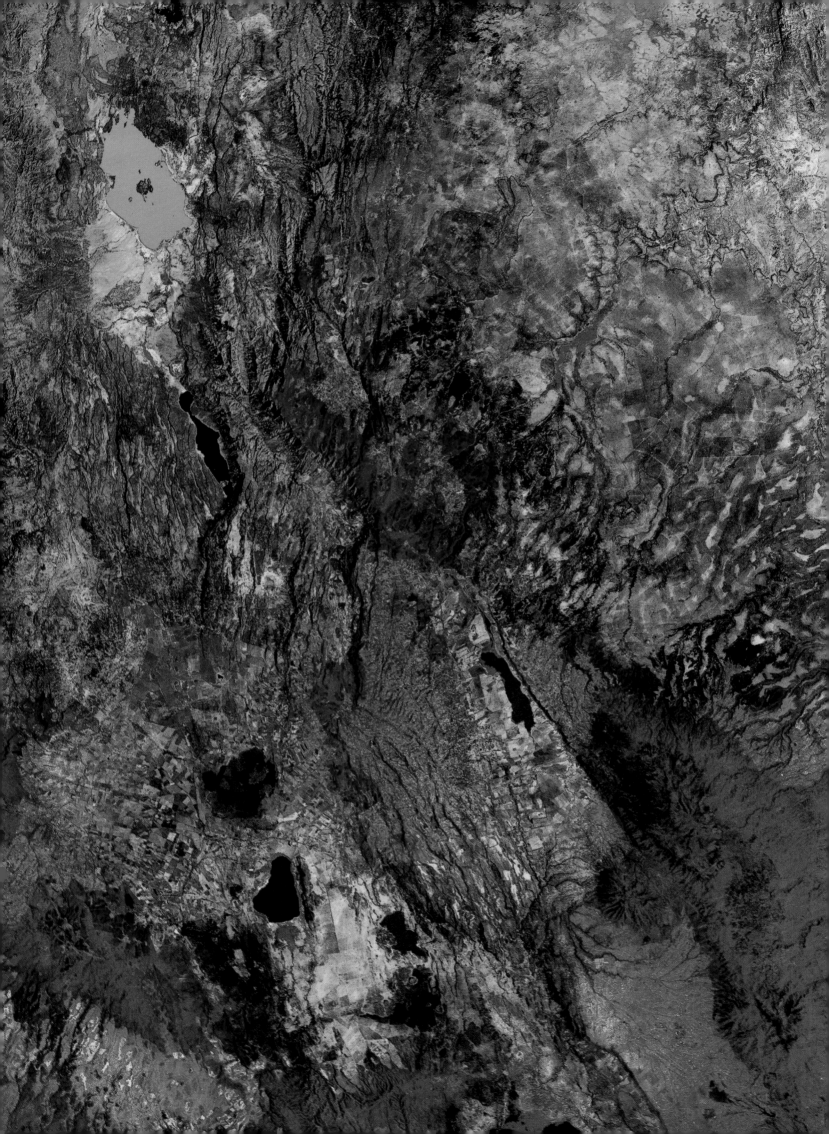

The Roof of the World

Seventy per cent of the world's surface is covered by water. Of the remainder, only about 9 per cent is used for crop cultivation, and another 17 per cent is forest and grassland of potential use for agriculture. The remaining land area is presently judged too arid (20 per cent), too cold (20 per cent), too mountainous (20 per cent), or infertile because of poor soil (14 per cent). Irrigation and improved crop species may one day turn the 30 million square miles of the earth's deserts to productive agricultural use; but the conversion of the 30 million square miles of great mountain ranges seems a much more difficult task. Precipitous terrain, thin air, high winds, and bare rock surfaces combine to frustrate the hardiest of plants and farmers.

The most famous mountain ranges around the world can be grouped into two great orogenic or mountain-building zones. The Alpine-Himalayan ranges begin in West Africa and Europe, with the Atlas Mountains of Morocco and the Spanish Pyrenees. They run on eastward, through the Alps to the Pindhos Mountains of Greece and the Taurus Range in Turkey, then on to the Elburz and Zagros Mountains of Iran. The chain reaches its greatest heights in the Hindu Kush of Afghanistan, the Karakoram Range of Pakistan, and the Himalayas of North India and Tibet. The nine highest mountains in the world lie in these last three ranges. From here the orogenic zone dips south through Burma and Malaya and peters out in the Barisan Mountains of Sumatra and the ranges of Java, the Lesser Sunda Islands, and the Celebes.

The second great chain circles the Pacific. It runs south from the Alaska Range and the Rocky Mountains of North America to the Cordillera of the Andes, then swings back north through New Zealand, New Guinea, the Philippines, Japan, and Kamchatka. Like the eastern end of the Alpine-Himalayan chain, the western part of this great circle ends in partially drowned areas. Island peaks emerge from deep water, with the Philippines lying just west of the Marianas Trench.

These two great mountain chains intersect in Indonesia, the most highly volcanic region on earth, with more than 100 active or recently active peaks. They do not include the Urals, the Appalachians, the African ranges along the Great Rift Valley, and others of great geological importance. However, they feature every mountain in the world higher than 20,000 feet (Mount Kilimanjaro in Tanzania is just under at 19,340 feet), and exhibit a striking continuity.

Mountains and high plateaus may be useless for agriculture and settlement, but they contain great mineral resources. Unfortunately, thin air and rough terrain hinder ground exploration for minerals also, which makes surveys from high altitudes an attractive alternative. Landsat images show as much detail on high peaks as they do on lowland plains, with no greater cost in obtaining them. The absence of fog and haze from industry or from transpiring vegetation results in clearer images, and the direct mapping of rock types from satellite pictures is easier where there is no topsoil. Image analysis supplemented by selected ground sampling offers an efficient tool for exploration of large and inaccessible areas.

In the next fifty years the preservation of available agricultural lands, grazing country, forests, and coastal zones will be more and more important. Those parts of the great mountain ranges where there is no topsoil to be destroyed by mining, no existing agriculture or forests to be displaced, and no delicate balance of plants and animals to disturb will become an increasing source of minerals.

The Himalayas

TIBET
NEPAL

W. RONGBUK

RONGBUK

KANGSHUNG

Mount
Everest

P

NGOJUMBA

KHUMBU

LHOTSE

BARUN

Q

To Jubing,
25 Miles

Nepal and Mount Everest

The mountain kingdom of Nepal lies between the north of India and Tibet. It is a long, narrow country, stretching more than 500 miles from east to west but often less than 100 miles across. The image on page 34 shows the middle of Nepal, from its capital city Kathmandu left of centre, to Mount Everest and the Tibetan border in the top right.

Kathmandu is distinguishable as an area of brighter red, indicating increased agriculture around the city. The main food crop is wheat in winter and rice in summer. At the centre of the cultivated area is a blue-grey patch that typifies urban development as seen on Landsat images. Kathmandu has a population of about 200,000 and is situated in Chobhar Gorge, with low mountains north and west of the city.

From the Kathmandu Valley, at 4,400 feet, the land rises steadily to the north-east. Would-be conquerors of Mount Everest often start from Kathmandu and proceed east along the Sun Kosi River, seen here as a wispy blue line running from east of the city towards the right of the image. From there, climbers must travel north along the Dudh Kosi River over increasingly difficult terrain. Each small crest on this image represents half a day's hike.

Interest in scaling the world's highest mountain has created an unusually thorough mapping of the area around Mount Everest. Every glacier and possible ascent route has been carefully noted, and the information that appears on maps of the area in current world atlases is the result of years of painstaking labour. A few minutes of work with the top picture on page 35, an enlarged detail showing Mount Everest, delineating the characteristic blue-white strips that indicate glaciers, will produce a map that gives as much information. If there are differences, the old maps will usually be in error.

North India and the Hill Country

The mountain chain of the Himalayas continues along the full length of Nepal and becomes the boundary between Tibet and north-west India. The bottom picture on page 35 shows part of the cool hill country of Himachal Pradesh. Simla, the summer capital of India, is in the lower left of the scene. The blue-black lake, about thirty miles south-east of the town, was created when the Bhakra Dam was built across the Sutlej River.

Simla is about sixty miles from the Tibetan border, and 240 miles east of Pakistan. The rust-red vegetated hills to the north-east are covered mainly with rhododendrons and deodar, right up to the snow line in the extreme upper right.

Image scales and dates:
Page 34 − 1 inch = 8.5 miles, March 1977
Page 35 top − 1 inch = 3.3 miles
Page 35 bottom − 1 inch = 13.1 miles, December 1978

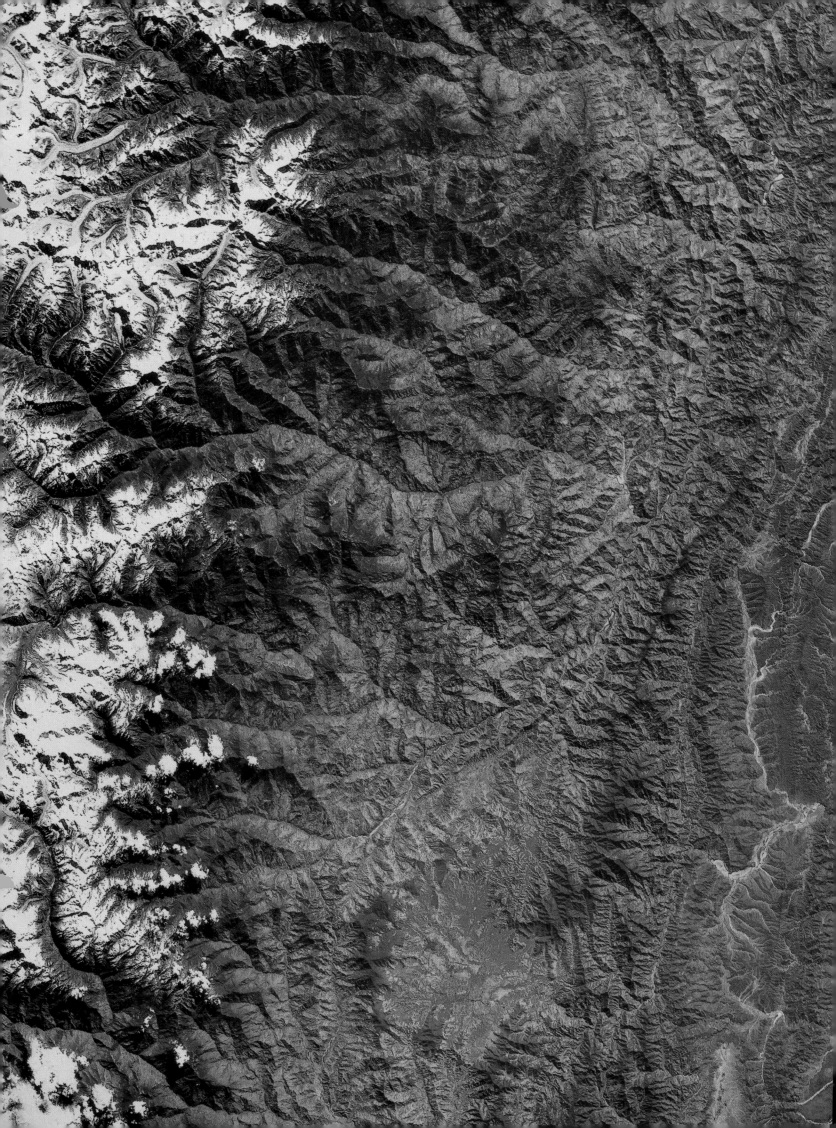

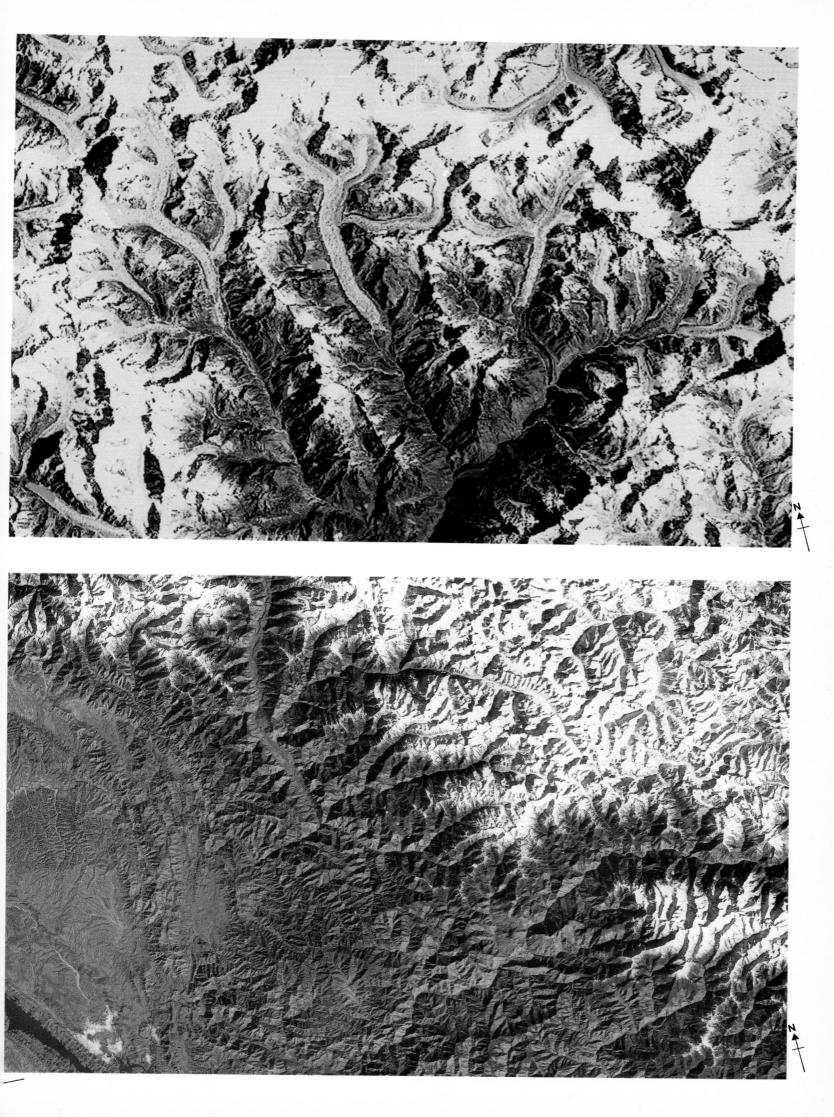

Peru and the Andes Mountains

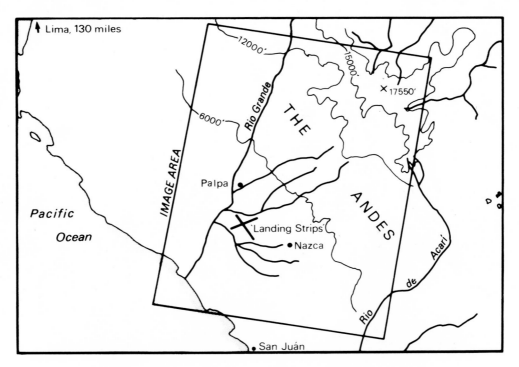

The area shown here is in central Peru, with Lima about 200 miles away along the coast to the north-west. The scene illustrates how the whole Andes chain hugs the west coast of the South American continent. The Rio Grande and its tributaries, each less than 100 miles long, run down steeply from up to 17,000 feet in the Peruvian Andes to the Pacific Ocean. By comparison, the rivers that enter the north-east part of the image flow eastwards until they eventually meet the Ucayali River, then the Amazon, and finally reach the Atlantic Ocean 4,000 miles later.

The precipitous slope of the western face of the mountain range is clear from the spectacular drainage patterns visible on this scene east of Nazca (see map). Rainfall in the dry desert of the coastal plain is only 1−2 inches per year, so all the red vegetation patterns displayed on the lower part of the picture are close to the river valleys. Despite its equatorial location, this western plain remains cool throughout the year. Water is deep off-shore, and the north-running Humboldt Current constantly carries chill Antarctic waters close in to the land.

The mountains in this scene are higher than one might think. The image was recorded in mid-February when all the snow had left the high peaks (we are at 15 degrees south, so this is a mid-summer view). Much of the north-east part of the picture is above 12,000 feet, and isolated peaks run to over 17,500 feet.

There are no major towns within the image area; even the largest, Nazca, is not visible on the picture. The only evidence of human activity on this scene seems to be the curious white lines forming a cross west of Nazca. Nestled between two tributaries of the Rio Grande, the lines run perfectly straight on the ground for over five miles. They are old, and certainly pre-date the conquest of Peru in 1527 by Francisco Pizarro. It is not known what they are, but at least one writer has advanced the theory that they are ancient landing strips by which alien astronauts flew to and from the earth.

Image scale and date: 1 inch = 8 miles, February 1974

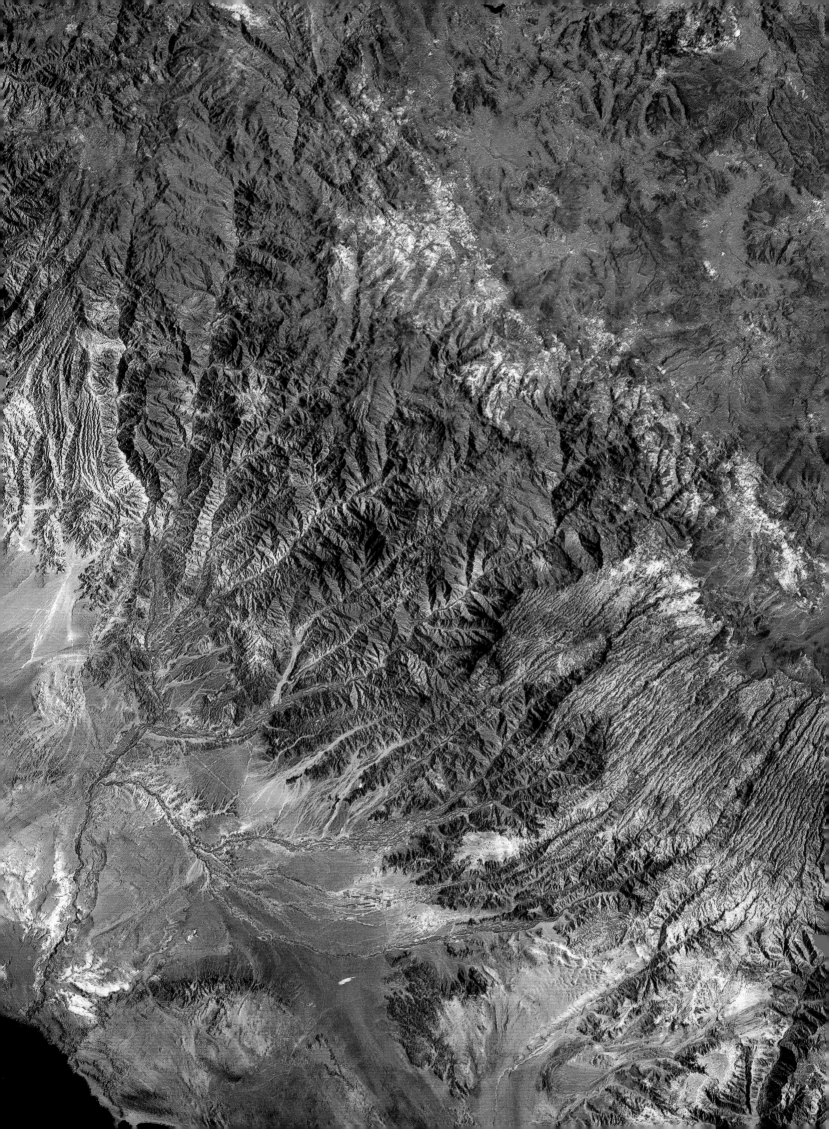

The Western Andes

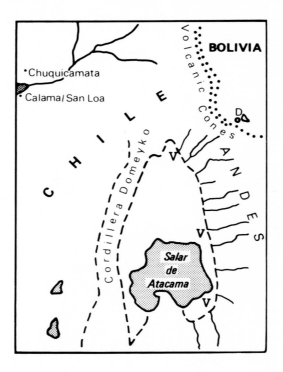

This image shows Chile at its widest, where the 2,600-mile long country swells from an average of less than 100 miles across to a modest maximum of 200 miles from the Pacific Ocean to the Bolivian border. Antofagasta, one of Chile's principal ports, lies due west of here.

The border with Bolivia is marked by an almost continuous line of snow-capped and cratered volcanic peaks, ranging in height here from 15,000 to 19,500 feet. They lie to the east, and the centre of this scene can be thought of as a kind of depression, a pocket on the western slope of the Andes, even though it is still at a height of 9,000 feet. The central area of flat, grey tone is the Salar de Atacama, a salt flat on which nothing can grow. To its west is the Cordillera Domeyko, a range that rises to 14,000 feet near the northern end of the Salar de Atacama. This range is actually still a part of the Andes, which divides around the depression.

The scene area is mainly uninhabited, with the town of Calama being the only one of significance. It, and its smaller neighbour San Loa, are at the extreme left edge of the image near the top, and an aqueduct runs from Calama all the way to Antofagasta on the coast. Despite its sparse population, this region is actually one of great commercial importance. At the very western edge of the image lies Chuquicamata, which has the world's largest known deposit of copper (1,000,000,000 tons of 2 per cent ore). Chuquicamata also holds the world's largest single copper-producing plant, at over half a million tons of finished metal a year. Silver has been mined from this area since pre-Columbian times, though now most of it extracted from the same ores that yield the copper.

The vivid colours and excellent ground detail on this scene enable many types of surface to be mapped. In the brown area to the north, the numerous diagonal lines indicate fractures in sedimentary rocks. The small blobs of royal blue across the Bolivian border are drying lakes (**D** on the map). To the east of the grey salt flat lie slate-blue sedimentary rocks with distinct drainage patterns on their surface. Water passing over these areas from the western slopes of the Andes permits the meagre growth of vegetation (**V**) visible east of the salt flat. To the north, prominent dark areas on the border between Chile and Bolivia are volcanic extrusive rocks, a reminder of recent geological activity in this region.

Image scale and date: 1 inch = 9 miles, March 1976

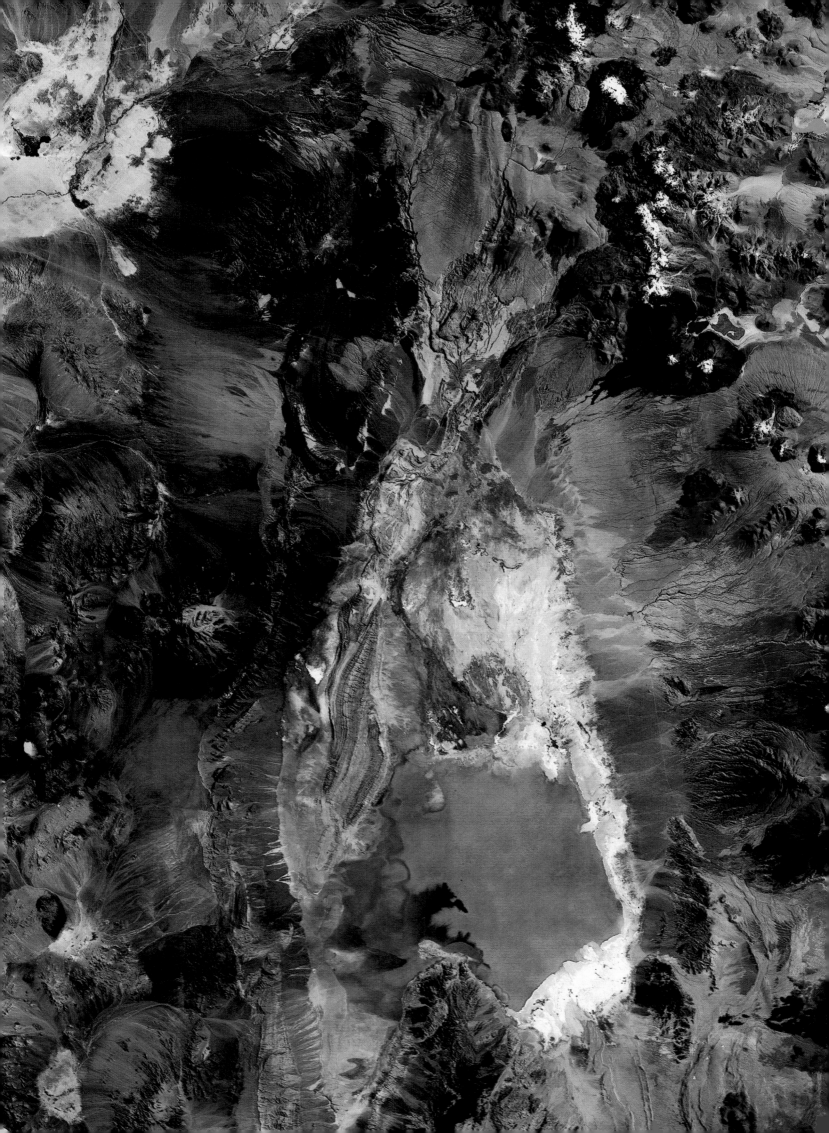

The Canadian Rockies

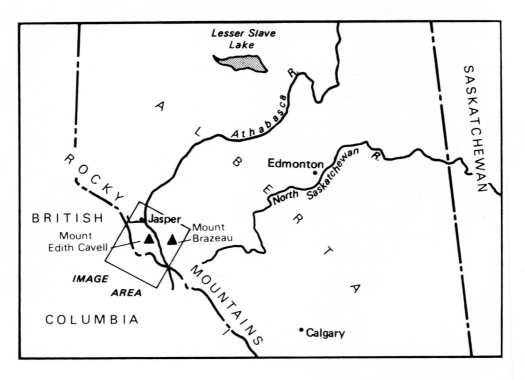

Viewed from space, some parts of the earth appear as alien and unfamiliar to our eyes as the surface of Jupiter's satellites. This image displays a portion of the Canadian Rocky Mountains in and around Jasper National Park. The town of Jasper is close to the border of Alberta and British Columbia, with Edmonton and Calgary some 200 miles east.

The Jasper National Park lies squarely across the main ridge of the Canadian Rockies, at an average height of about 8,000 feet. The Yellowhead Pass east of Jasper is the low point at 3,700 feet, and north and south are individual peaks that reach almost 13,000 feet. The town of Jasper lies in the north-west part of the image, where the blue-green streak of the Athabasca River runs south and forks into two branches. The main river follows the western fork, where the river valley is obscured by a broad streak of dirty white fog. It is bordered a few miles south of Jasper by the highest peaks on the scene, Mount Brazeau at 11,390 feet on the east, and Mount Edith Cavell at 11,030 feet on the west. Further down the picture, the valley of the Canoe River forms a dark strip of greenish black, trending from south-east to north-west.

The strangeness of this image derives from three main factors. First, the area is composed of complexly folded and tilted sedimentary rocks, which accounts for the twisted appearance of the landscape. There is a partial cover of snow on the peaks, seen as bright white areas. Second, thick fogs, seen here as streaks of dirty white, cloak the valley bottoms. Rust-red vegetation covers their slopes. Third, this image lies quite far north (latitude 62 degrees) and it was taken late in the year, in November. Since Landsat images are all recorded at the same local-time, about 9.30 a.m., the sun has risen only a few degrees above the horizon and stands in the south-west quadrant. This slanting illumination creates the shadowed areas of greenish-black that are visible on most of the north-west slopes of the whole image area.

Image scale and date: 1 inch = 4.25 miles, November 1974

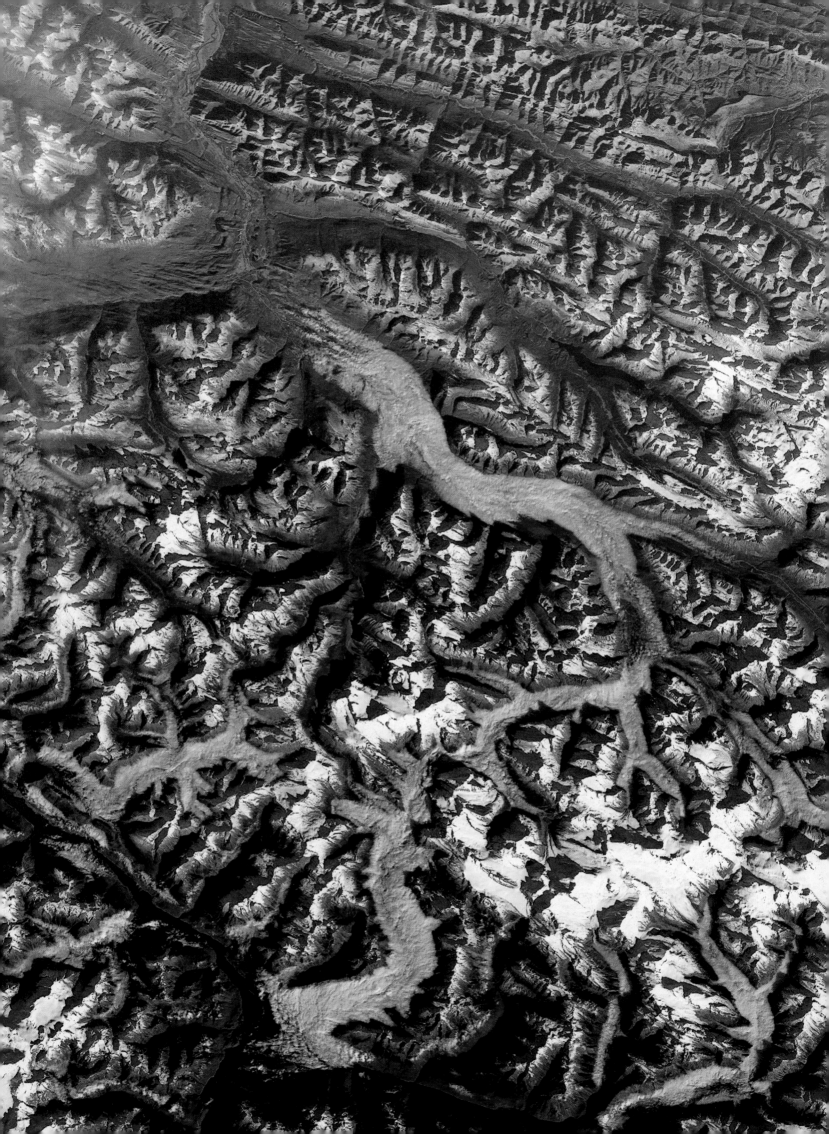

Mount St Helens and Northern Oregon

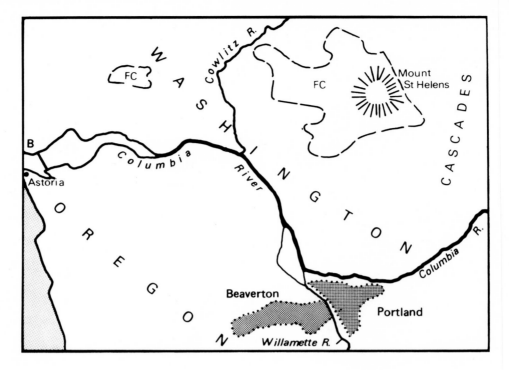

The Cascade Mountains run as an almost unbroken chain from northern California up to southern British Columbia. They range as high as 14,400 feet (Mount Rainier), and the gorge cut by the Columbia River provides one of the few easy routes for an east-west crossing. Through this pass came the first trans-continental exploration expedition, led by Meriwether Lewis and William Clark. This famous journey west ended on 15 November 1805, when the travellers reached the Pacific Ocean.

This scene shows the region between the Cascade Mountains and the Pacific coast. The city of Portland is prominent at the fork of the Columbia and Willamette Rivers as a compact and continuous area of light blue tone. The less densely urban area of Beaverton is west of the Willamette, and other towns can be discerned as blue dots all the way along the Columbia River out to its mouth at Astoria. The bridge (**B** on the map) across the river mouth can be seen as a straight lighter blue line on the image. It is about four miles long.

North of Portland, in Washington State, we see the unmistakeable snow-capped peak of Mount St Helens

(9,677 feet). Until the summer of 1980 the mountain enjoyed a modest fame as a known volcano, somewhat overshadowed in reputation by its taller neighbours such as Mount Rainier and Mount Hood. Its spectacular 1980 eruption blew 1,500 feet off the top of the mountain, razed hundreds of thousands of acres of valuable timber land on the north and west slopes, and covered the whole area from Portland up to Seattle with a layer of grey volcanic ash. The image shown here was recorded in June 1978.

The areas marked **FC** on the map to the west of Mount St Helens and north of the mouth of the Columbia might be thought to be more urban development, though their tone is slightly greener than that of Portland. These blue-green blobs are actually regions of forest cutting, where Douglas fir (the most important lumber tree in the area) has been harvested. The resolution of a Landsat image is good enough, and the change from uncut to cut area sufficiently clear on the picture, for the State of Washington to use scenes of the area to estimate the year-to-year changes in timbered regions. Estimates to within 1 per cent of actual tree counts are possible.

Image scale and date: 1 inch = 8.9 miles, June 1978

N

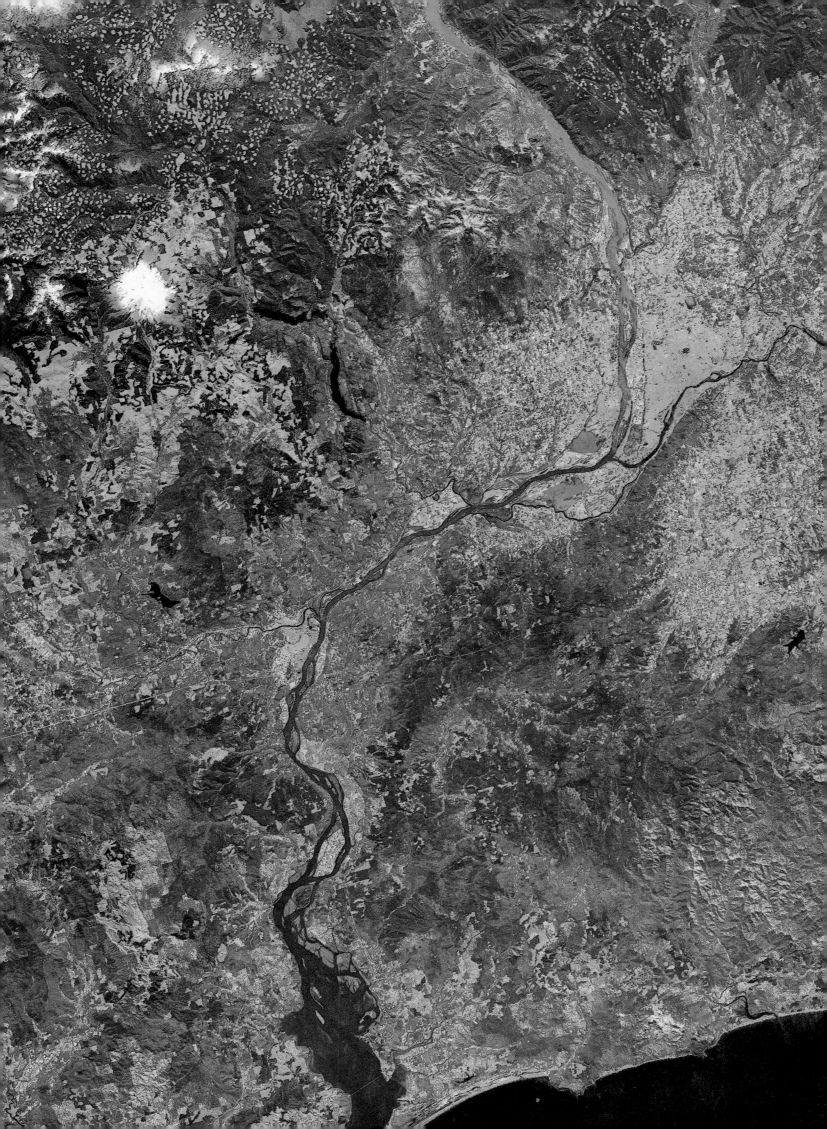

Cities

Landsat was not intended for urban analysis. When it was first designed, its resolution and wavelengths were chosen mainly to fulfil the needs of agriculture and, as a second priority, geology. With a field of view that sees nothing smaller than a couple of hundred feet, something the size of a football field might be visible, but roads, gardens, buildings, bridges, and all the other trappings of a city should be too small to see.

This is generally the case. Where a bridge or a road is sufficiently different in colour from its background, it is occasionally possible to pick it out even though it is much narrower than 200 feet. In fact, very bright objects, even when they are small, can sufficiently change the overall amount of light that Landsat receives from their vicinity for us to be able to see them. A two-foot mirror reflecting sunlight will show on a Landsat image — though its whereabouts within the 200-foot picture element obviously cannot be located.

Landsat does permit some useful study of urban areas, however. It is sometimes possible to map city streets that are very wide and well separated; and even when this is not possible, and there are no distinguishable features within an urban area, a city's growth and change from year to year can still be observed. This is possible because asphalt, concrete and brick look very different from woods and fields. The blue-grey tones that denote the presence of a city on a Landsat false-colour image are clearly visible. Something else becomes evident also: the cities of the world are mostly built in the wrong place.

Prime agricultural land, level and well watered, is at a premium in the world. It should not be diverted to other uses. Unfortunately, this is exactly where people have usually chosen to build their cities. Convenient rivers mean easy transportation, and good surrounding land provides food for the city dwellers. Both these factors should be less relevant in the future. Logically, we should place our cities on sites that are good for nothing else, or at the very least we should use urban development methods that allow the city to blend into the landscape. At the moment, with inner cities obscured by a haze of burnt hydrocarbons from automobile exhausts, rivers turbid and sediment-laden, and with plumes of pollution spreading for miles off-shore, cities are revealed on Landsat images as — quite literally — blots on the landscape.

At present there are thirteen cities in the world that each have more than 5 million inhabitants — Buenos Aires, São Paulo, Peking (Beijing), Shanghai, Paris, Bombay, Calcutta, Tokyo, London, Seoul, Mexico City, Moscow and New York — with half a dozen more hovering on the threshold. Landsat images taken years apart illustrate how rapidly cities are growing, and it is no surprise to learn that by the year 2000 this list is expected to increase by twenty. By then, perhaps, we will have become wiser about where future cities should be allowed to grow.

An interesting characteristic of cities that future satellite systems will be able to monitor is the urban heat island each one creates. These heat islands can bring forward the date of spring thaws and put back the earliest autumn frosts. A sensor to record heat in a thermal infra-red wavelength was actually on Landsat-3, but unfortunately it malfunctioned and no images were produced.

Santiago, Chile

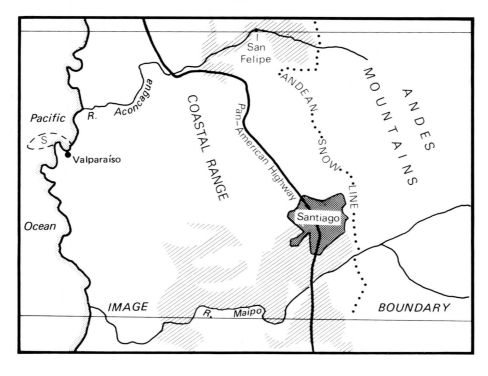

Chile is a long, narrow country, stretching over 2,500 miles from Peru to Tierra del Fuego. For most of its length it is less than 100 miles wide. Santiago (see map) is its largest city, with a population of more than 3 million. Valparaíso, north-west of Santiago, is the country's major port. Both cities are about 33 degrees south, in the most fertile and climatically pleasant part of the country. West of Santiago lies a coastal range, and to the east the Cordillera of the Andes. About twenty miles north of the area shown on this image, Mount Aconcagua, at 22,800 feet the tallest mountain in South America, rises less than 100 miles from the coast.

Page 46 shows autumn coverage, which in this part of the world, south of the equator, means late March. There is plenty of healthy vegetation, particularly in the north near San Felipe, which is just outside the image area (see map), and in the area to the south of Santiago where the region is watered by the Maipo River and its tributaries. Santiago itself shows the characteristic blue-grey of urban development.

The image on page 47 was taken in winter, on 27 June. It is easy to trace the snow line in the east, and deduce that this is the backbone of the Andes in this region. However, note that parts of the Maipo Valley are also snow-covered, whereas the San Felipe area to the north remains free of snow. The San Felipe area enjoys a more sheltered and equable climate than the southern river valley, which is clear from the June scene but not from the March one. On the other hand, in June the agricultural area in the north and the urban area of Santiago have similar colour. Both might be labelled urban. But a quick look at the March scene removes any possibility of such confusion. Notice also the plume of off-shore sediment (**S** on the map) that is visible at Valparaíso on the June but not on the March image. This is caused by the seasonal change in the prevailing current. Use of multiple coverage of this type — difficult to acquire using aerial photography or other methods — is one reason why Landsat data prove so valuable. The other great strength of space-derived data is the wide area coverage. A glance at this scene makes the virtues of Valparaíso Bay as clear to us as they were to Sir Francis Drake when he attacked the town in 1578. Its situation gives the harbour excellent shelter from southerly and westerly storms.

Image scales and dates:
Page 46 — 1 inch = 8 miles, March 1975
Page 47 — 1 inch = 8 miles, June 1977

N

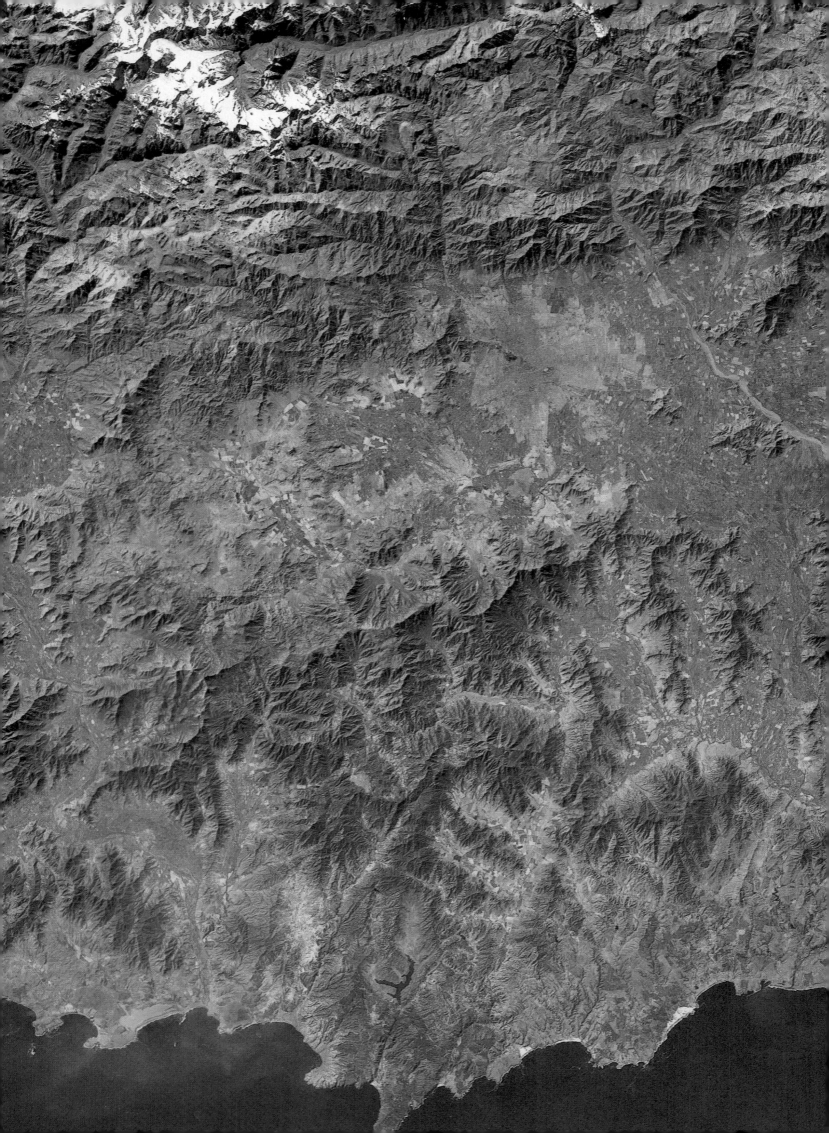

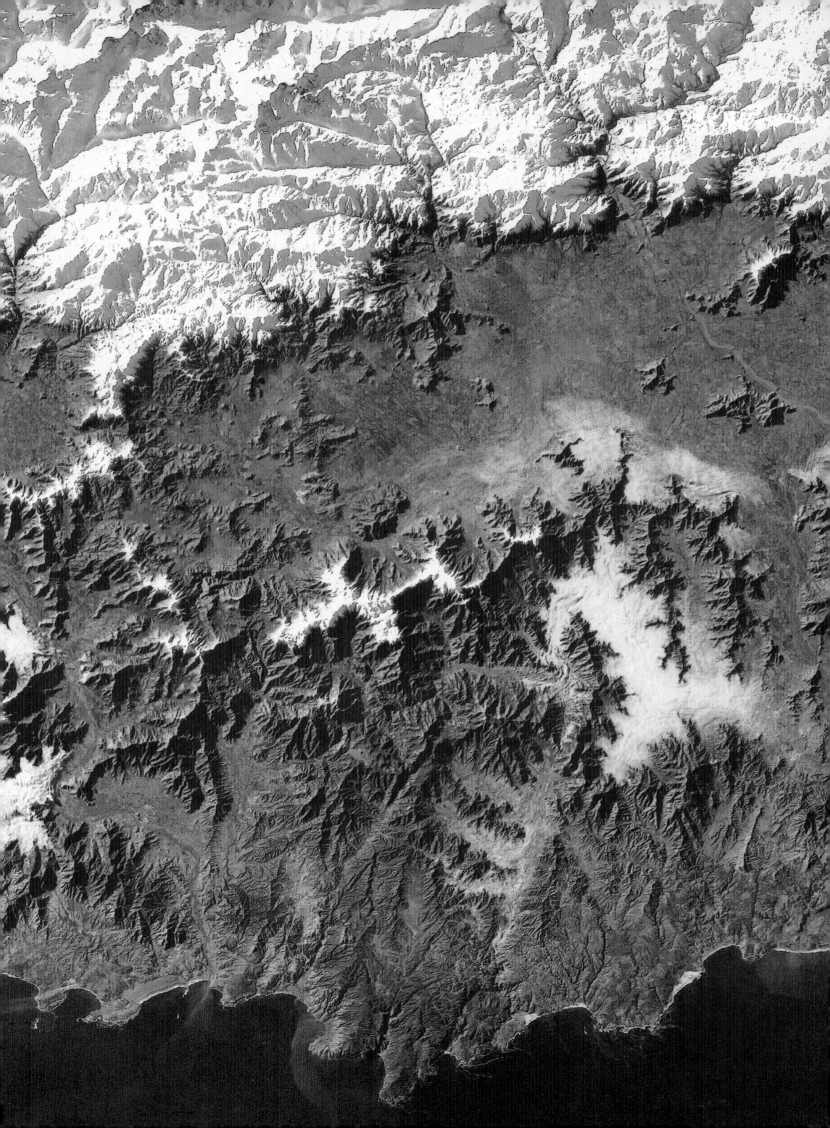

Tehran and the Elburz Mountains

The city of Tehran lies in the lower centre of this Landsat image, recorded by the spacecraft in April 1975. The Elburz Mountains lie to the north, in part permanently snow-capped, and the dormant volcano of Mount Damavand is north-east of the city. At 16,600 feet, it is the highest mountain in Iran.

The mountain range, as this scene makes clear, forms a climatic dividing line. To the north the foothills are red with vegetation, to the south they are almost bare. On the Mazandaran Plain, between the Elburz Mountains and the shallow waters of the Caspian Sea, the rainfall is heavy (up to 60 inches per year) and the climate at Now Shahr is Mediterranean to sub-tropical. The country's best forests and vegetation grow here. The south, by contrast, is arid, with a rainfall of 10 inches or less per year. In the south-east of the scene is the beginning of the real desert, the north-west tip of the barren Dasht-e-Kavir.

This image displays a characteristic pattern of Iranian agriculture. The broad strip of red vegetation that runs south of Tehran and Karaj is irrigated by a system of horizontal wells (**G** on the map) that run underground along the aquifers originating in the Elburz Mountains. These wells, known as *qanats*, carry water to supply the needs of both agriculture and the 4 million people of Tehran.

The street patterns within the city show up with surprising clarity (see image detail), even though the Tehran air is usually heavily polluted with car exhausts. Enough detail is visible to permit a reasonable update of old city maps, showing both roads and major buildings. For example, the main railway station is very evident, a dark rectangle in the south of the city at the tip of a wedge of major avenues. The sharpness of the street patterns is due partly to the fact that the main streets are wide and well separated. Along each major thoroughfare run narrow water-filled ditches called joobs (*juiha*). They are too narrow to show on the image, but they water the regular lines of plane trees that grow along each main street, and these do help to make the city pattern more visible.

Iran was an early and enthusiastic user of earth resources satellite data, and in 1978 construction began for a station to receive Landsat images directly. It was close to completion at the time of the Shah's departure from the country in 1979; then all work stopped. The shell of the building still stands west of Tehran, but it seems unlikely that the station will ever be operated.

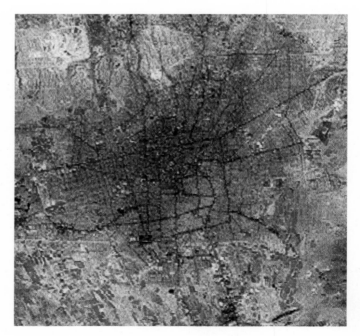

N

Image scales and date: 1 inch = 8.5 miles
(detail: 1 inch = 3.1 miles), April 1975

48

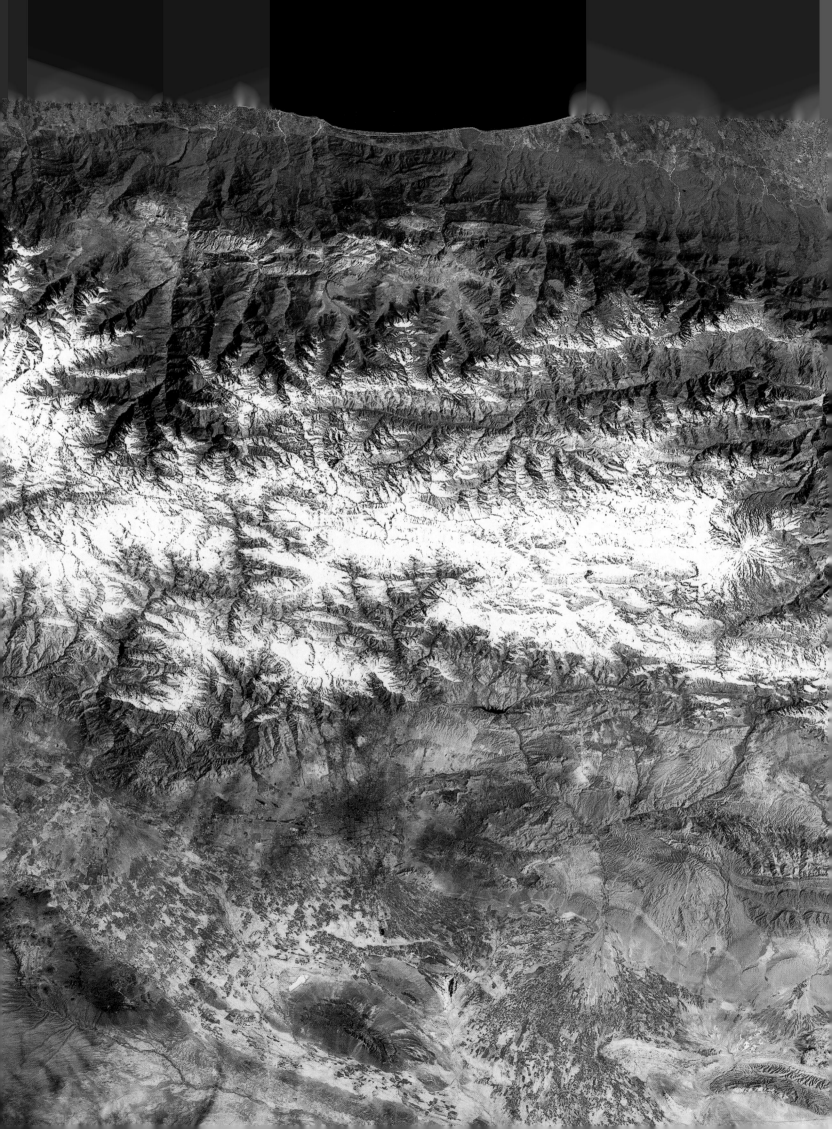

Los Angeles

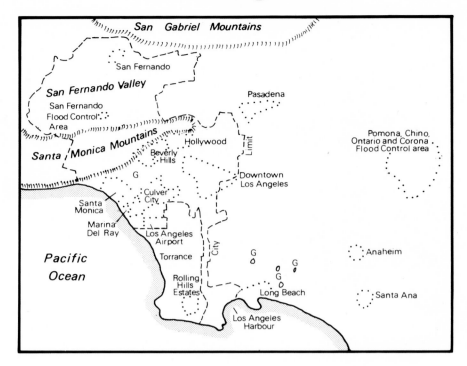

In the official census of United States cities, Los Angeles ranks third after New York and Chicago; but as this Landsat picture makes clear, in at least one respect Los Angeles comes an easy first. It is the biggest city in area, sprawling over more than 460 square miles. Officially, 2.7 million people live here, but there are millions more in the nearby suburbs, plus an estimated half million illegal immigrants.

With a thirteen-storey building limit imposed because of the fear of earthquakes, the city was forced to spread horizontally until 1970, when the lifting of the restriction permitted upward growth. There are now buildings as high as sixty-two storeys in the downtown area. Meanwhile, the pattern of growth at the outward edges of the urban area continues, producing a true megalopolis that is thirty-five miles across and still spreading. Numerous well-known districts as well as some of the major highways are easily seen on this image, recorded in October 1975 when the city was almost completely free of its infamous smog.

Downtown Los Angeles shows as a large patch of grainy turquoise in the middle of the image. Hollywood and Beverley Hills continue this patch to the north and west, leading to the red vegetated slopes of the Santa Monica mountains. Beyond the

mountains lies the developed area of the San Fernando valley, with the bright red patch of the San Fernando Flood Control Area in its south and the city of San Fernando in the north. Parallel to this, and north-east of downtown Los Angeles, lie Pasadena and the San Gabriel mountains. Brush and forest fires are a frequent problem in this region. The large dark grey-green patch in the western part of these mountains is a burnt area, the result of an unplanned fire.

Santa Monica lies on the coast, south of the Santa Monica mountains. Below it are Culver City, the Marina del Rey and the Los Angeles airport. Further south is Torrance, with the Rolling Hills Estates on the cape distinguishable by their lack of urban development. Along the coast to the east lies Los Angeles harbour and Long Beach. The bright red spots that scatter this area (**G** on the map) are usually golf courses.

The eastern part of the scene, outside the city of Los Angeles, shows Santa Ana and Anaheim as blue-grey urban patches. On the extreme right of the picture the fan-shaped agricultural developments of Pomona, Chino, and Ontario can be seen, with the bright red of the Corona flood control area beneath and to the left of it.

Image scale and date: 1 inch = 5.4 miles, October 1975 N

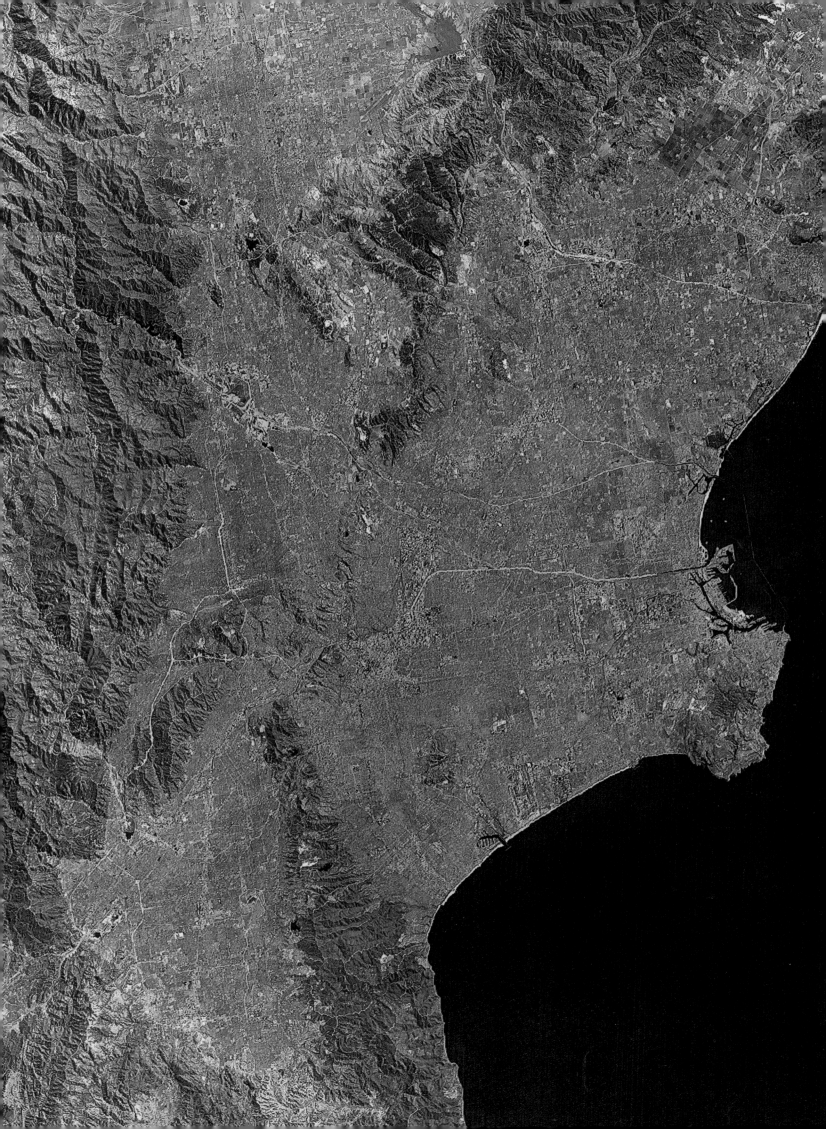

Venice and the Lombardy Plain

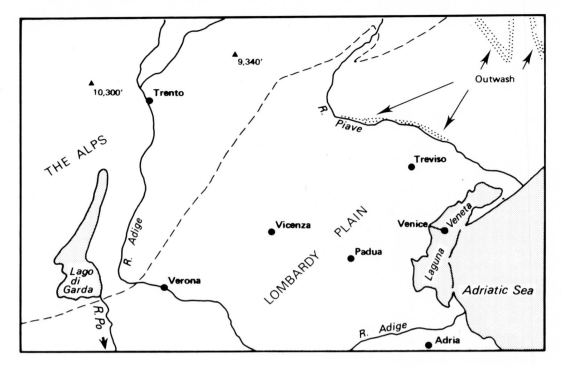

Venice is situated at the northern end of the Adriatic Sea, with the Lombardy Plain on the west and the Austrian Alps to the north. Milan is 150 miles to the west, Bologna eighty miles south-east.

The Lombardy Plain is growing steadily, extending itself slowly further into the Adriatic. This Landsat image shows exactly how the process occurs. In the north part of the picture, sedimentary outwashes from the Alps appear as bright blue-white streaks on the plain. Over the years, the Piave, Po, Adige, and other rivers have carried sediment down from the mountains to build a rich alluvial plain, and the whole coastline has extended eastward. Old ports such as Ravenna and Adria now lie well inland. At the same time, an Adriatic current flowing east deposits sediment further along the shore. The banks of silt grow, and in time form a new shoreline, such as can be seen in the lower right of the image enclosing the Laguna Veneto.

Apart from Venice, a number of other well known Italian cities are visible on this image. Verona, Vicenza, and Padua can all be seen as distinct greenish blobs across the lower part of the scene. As one might expect, Venice itself looks substantially different. It is in the Laguna Veneta, and the two-and-a-half-mile causeway that connects the islands of the city with the mainland shows here as a straight blue line. The Grand Canal that passes through the centre of the main city can be seen as a reversed letter S. The other islands within the lagoon show the red of vegetation. Although land is rising to seaward, Venice itself is sinking steadily below sea level. The easiest solution may be to complete the line of silt banks on the seaward side, and maintain Venice with a lowered sea level around it.

Image scale and date: 1 inch = 8.5 miles, October 1975

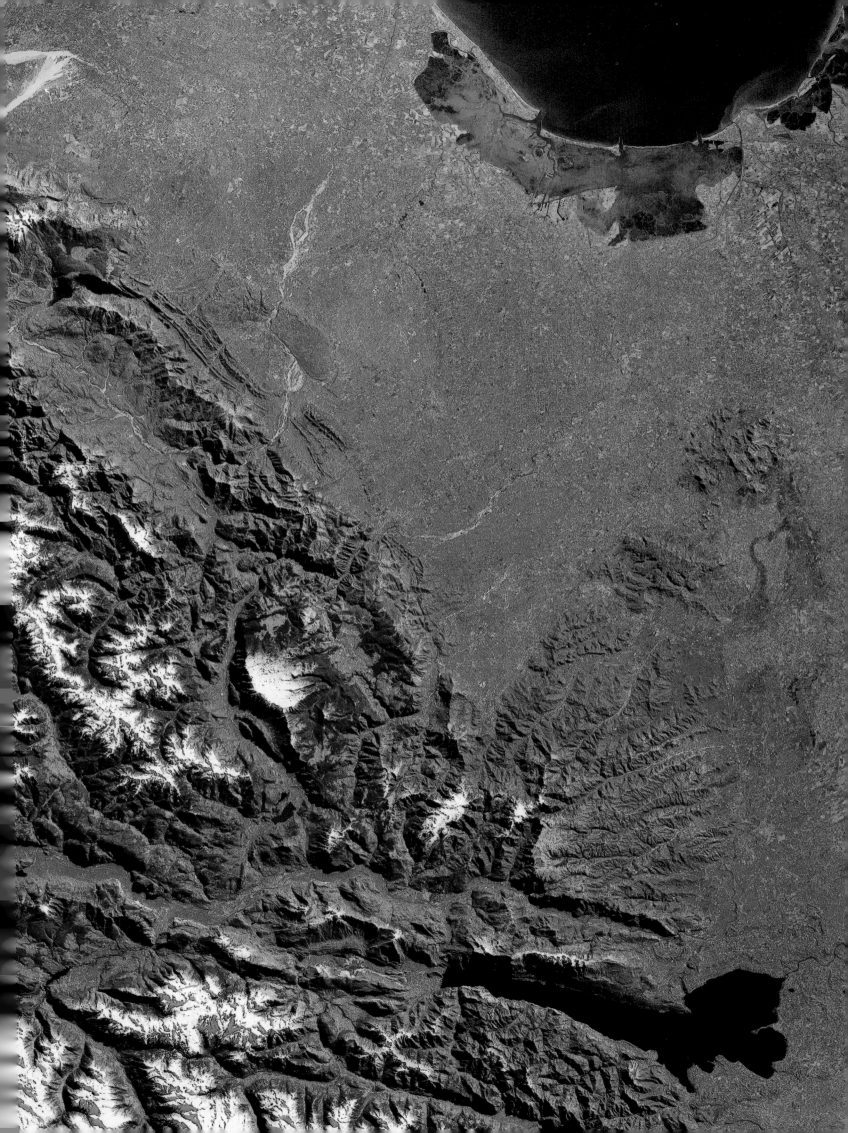

Tokyo

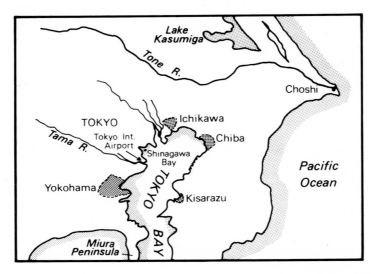

Although Tokyo, formerly known as Edo, has a history that goes back at least to 1456, almost all its buildings belong to this century. In 1923 a great earthquake and fire killed 74,000 people and caused widespread destruction of property. Then bombing during the Second World War again flattened the centre of the city.

Tokyo appears on this November image as a large diffuse patch of blue-grey. The city has a population of 8.7 million, the third largest in the world. There are more than 30 million living within a thirty-five-mile radius of the centre.

South of the main city, jutting out into Shinagawa Bay, the wedge of Tokyo International Airport at Haneda can be seen, and further south the port of Yokohama, its wharves and jetties visible like blue-grey teeth projecting into the bay. This port was developed because the northern part of Tokyo Bay was too shallow for large ocean-going vessels. In the 1930s, dredging deepened the access, and industrial development accelerated in Chiba, Ichikawa, and the other towns north of the bay.

Despite its heavily urban centre, Tokyo has a large number of parks. They are visible as bright red spots within the overall blue of the city. Pollution in the bay appears as a faint grey-green haze in the water. This should be distinguished from the greenish tinge off the coast on the east side of the image, which denotes beaches and shallow water rather than pollution. Differentiating turbidity from shallow water on Landsat images is never easy, and usually additional data is needed for verification.

North of the city and Tokyo Bay, the Tone River runs east to the Pacific Ocean, meeting it at the town of Choshi. The main body of water visible north of the Tone River is Lake Kasumiga, one of many lakes and swampy areas in the region, where drainage is poor.

The peninsula seen to the south of Tokyo Bay is Miura. It was the home of William Adams, an English pilot who arrived aboard the Dutch ship *Liefde* in 1600, and stayed until his death in 1620. His Japanese name was *Miura-Anjin* (Miura the Pilot), and it was his life that provided the central character for James Clavell's massive novel *Shogun*.

Image scale and date: 1 inch = 8 miles, November 1972

N

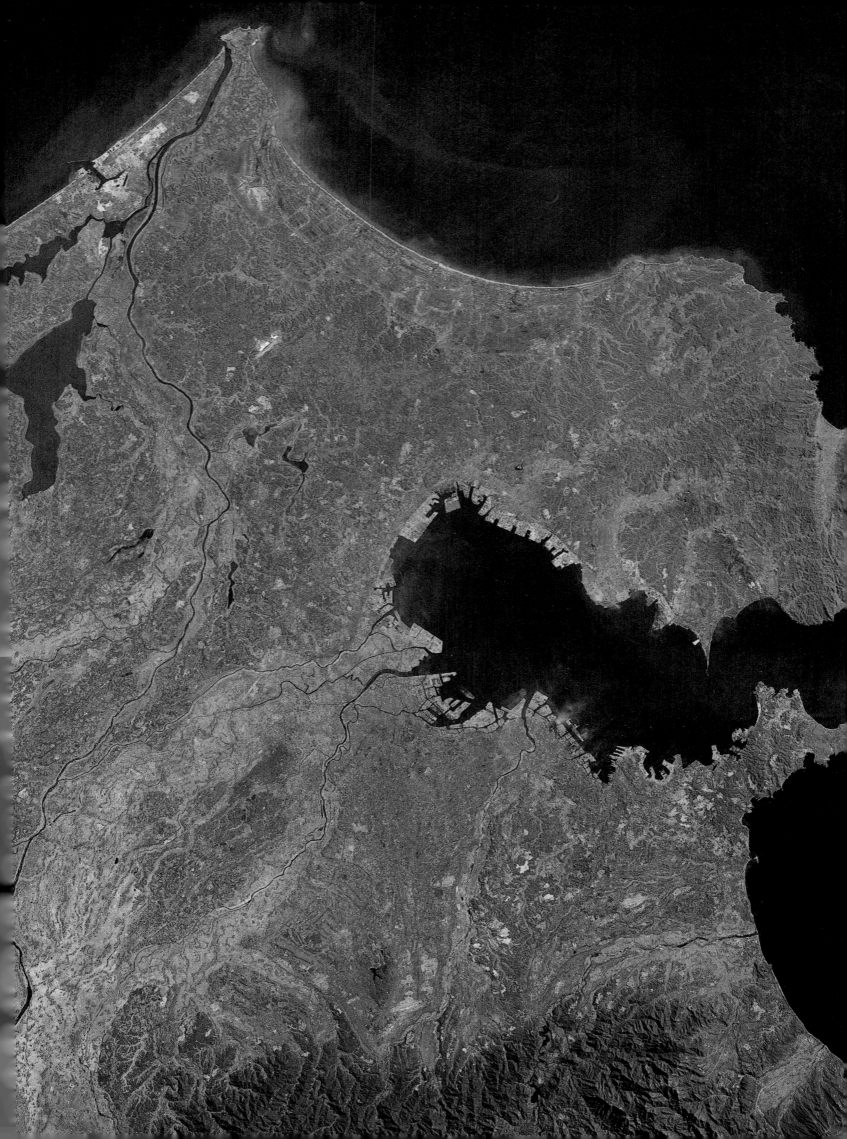

The Cities of Northern England

This image includes most of northern England, from the Scottish border down to Leeds. Since the whole area is thoroughly mapped and surveyed, it serves as a good control area for Landsat, showing what can reasonably be mapped and what is beyond the resolution of the satellite's sensors.

Built-up areas are usually blue-grey on Landsat false-colour images. This May 1977 scene shows how building has proceeded to the point where individual towns have merged and their boundaries are no longer clear. There is the Newcastle/South Shields conurbation around the mouth of the Tyne; Middlesbrough/Stockton south of this, along the River Tees; Leeds/Bradford/Huddersfield/Wakefield, which are beginning to merge, in the south-east. Further west, across the border into Lancashire, Blackburn, Accrington, and Burnley can be seen. Other individual cities visible on the image include Preston, west of Blackburn, Blackpool on the coast, Harrogate and York to the east, Durham and Sunderland on the River Wear, and Darlington just north of the River Tees. The blues that appear on the shoreline in the west should not be confused with cities. They are the shoals and sands of Morecambe Bay, north of the mouth of the Lune River.

Higher elevations show well on this image, since at this time of year there is little vegetation on them. They show as browns and dirty greens. The North York Moors in the east, and the whole Pennine chain in the image centre can be mapped. The river valleys of the Tees and Ure particularly show as well-defined bright red spears of vegetation penetrating the Pennine uplands. Cross Fell, at 2,930 feet the highest point of the Pennines, is a green patch (**C** on the map) a few miles to the west of the dark water of Cow Green Reservoir (**R**).

The continuous line of red vegetation that runs right across the image clearly shows a break in the Pennines west of the Tyne. Hadrian's Wall, built in the second century, runs along the north side of this natural valley, from Wallsend near Newcastle across the country to Carlisle and the Solway Firth at the mouth of the River Eden.

The small white and black dot pairs visible in parts of the image are not ground features. They are clouds and their shadows.

Image scale and date: 1 inch = 8.7 miles, May 1977

Montevideo and Southern Uruguay

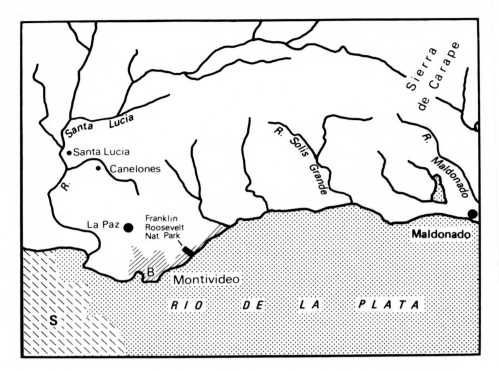

Montevideo is by far Uruguay's largest city, with a population of well over 1 million out of the country's total of less than 4 million people. It is also Uruguay's capital, chief port, and commercial, cultural, political, and industrial centre.

The city lies on the north bank of the broad estuary of the Rio de la Plata, and is very nearly the southernmost point of Uruguay. It has developed around a fine bay and natural harbour, which has been improved by breakwaters and jetties. They are visible on this image on the east side of the bay (**B** on the map). Past them, the city has extended eastwards, and now runs along the coast past the Franklin Roosevelt National Park, seen here as a red-brown rectangle jutting inland from the line of the coast. A number of lagoons and lakes lie along the southern shore, as far as the easternmost point of the image, at Maldonado. The Rio Maldonado runs north-west on the right of the picture.

The southern part of Uruguay consists of broad areas of prairie grasses, through which run forested rivers and streams. This whole scene is covered with a filigree of fine red lines among the bluer grasslands and agricultural areas. Along these river valleys grow poplars, alders, willows, acacias, imported eucalyptus and, in the east, palm trees. The scene was recorded in the southern summer, on 24 December. The more heavily vegetated land of the Sierra de Carape top right can easily be mapped from its redder tones.

Apart from Montevideo and its immediate suburbs, such as La Paz, Canelones, and Santa Lucia, the south provinces are also heavily agricultural. Large individual fields can be seen in the lower part of the image, where wheat, sunflowers, flax, rice, and maize are grown. Since the country has no oil, coal, or iron, it is heavily dependent on its agriculture and livestock. Fortunately, the land is flat and fertile, with no part of the south of Uruguay more than 2,000 feet above sea level.

The Rio de la Plata's estuary suddenly widens near Montevideo from fifty miles to more than 100. The river sediments give a cloudy green tone (**S**) to the water west of Montevideo. Where they are diluted by the waters of the North Atlantic the green tone changes abruptly to the black of clear, deep water.

The German pocket battleship *Graf Spee* was scuttled just outside Montevideo harbour in 1939. The ship lies off the south-west entrance to the harbour. Enhanced single-band images from Landsat show a faint light spot here, but there is no certainty that this is evidence of the ship rather than some other feature of underwater topography or sediments.

Image scale and date: 1 inch = 8 miles, December 1975

N

Peking

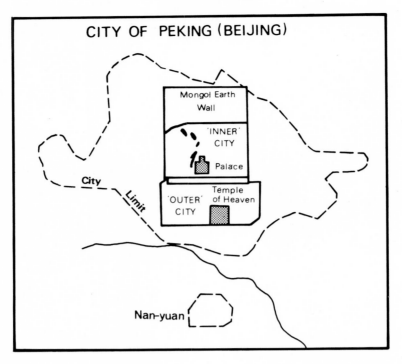

CITY OF PEKING (BEIJING)

Mongol Earth Wall

'INNER' CITY

Palace

City

Limit

'OUTER' CITY

Temple of Heaven

Nan-yuan

In its long history Peking ('the northern capital') has been called Nanching ('the southern capital'), Chung-tu ('the middle capital'), Ta-tu ('the great capital'), Yu-chow, Yenching, Peiping, and Khanbaliq. Its official name now, according to the Pinyin system of transcription, is Beijing. The city is situated 100 miles inland from the Gulf of Chihli (Bo Hai), and seventy miles from Tientsin (Tianjin). It is unmistakeable in the lower left of this image as a blue framed rectangle above an oblong bounded by a faint dark line: the Inner and Outer Cities. The Inner City is the upper blue rectangle, whose main walls were completed in the thirteenth century. The walled area is roughly four miles by three. Within it the dark outline of the old Palace, now a museum, can be seen, with the black ponds of the old Imperial City visible to its west. The Outer City was added to the southern wall of the Inner City in the middle of the sixteenth century. It covers an area of about ten square miles and contains within it the Temple of Heaven, a reddish patch on the southern side.

Peking has a population of about 7.6 million, making it the fourth largest in the world (but only the second largest in China — Shang-hai, with over 10 million people, is the largest in the world). It has now extended far beyond the old city walls, and the blue-grey of urban development stretches south-east halfway to T'ung-hsien (Tongxian). Further east lies the dark line of the Chi River, its leveed banks showing as white lines, running south-east to Tientsin.

The city lies at the northern apex of the alluvial plain of north China. The area is agricultural, with the main crops in the fields north and south of the city being wheat, maize, cotton, and sweet potatoes. In the north-east of the image is the reservoir east of Chi-hsien (Jixian). Other reservoirs lie just north of the city, although Peking's main supply of water comes from further away, a reservoir forty miles to the north-west of the city.

The Great Wall of China, completed in the third century B.C. to keep out the northern barbarians, runs a few miles north-east of the image area. Other Landsat pictures reveal that it is just about at the limit of Landsat's resolution, visible only here and there as it wends its way across northern China.

Image scale and date: 1 inch = 6 miles, March 1975

N

Marseille and the Gulf of Lyons

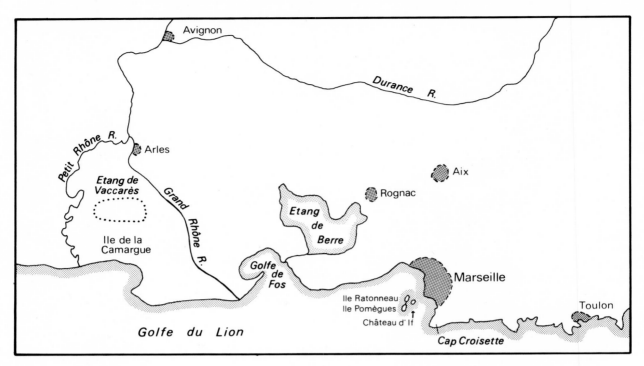

Marseille, the premier port of France and of the Mediterranean Sea, is close to the centre of this October image. Located on a fine natural bay and facing west across the Gulf of Lyons, the city is about 530 miles south of Paris and has a population of 600,000 people. The jetties of the port are clearly visible projecting into the harbour behind the long breakwater, with the islands of Ratonneau and Pomègues lying offshore between Marseille and Cap Croisette. The bridge that connects the two islands shows as a short white line. Inshore between Ratonneau and Marseille stands the small island of Château d'If, familiar to readers of Alexandre Dumas and *The Count of Monte-Cristo*. It appears as a small white point on the image.

West of Marseille is the Etang de Berre and the Golfe de Fos, and beyond them the mouth of the Rhône. Both the Grand Rhône and Petit Rhône appear on this scene, with the Ile de la Camargue as a delta between them. Most of it, particularly close to the sea, is a salt marsh and swamp, with poor vegetative cover. The bright blue oval in the middle of the delta is the Etang de Vaccarès. More salt ponds near the coast give the pattern of turquoise at the mouth of the Grand Rhône.

At the head of the delta is Arles. The Rhône River and a major tributary, the Durance River, meet just below Avignon further north, and the latter can be seen on the image merging in as a blue line from the east.

Following the Durance upstream, the landscape changes to a complex pattern of red-brown hills. This is the foot of the Basses Alpes, a low range that becomes the true Alps fifty miles further north and west. Aix-en-Provence lies north of Marseille. Running through the hills to the east is the main road to Cannes, showing as a white line that begins at Marseille, passes through Aix, and then runs almost due east.

The eastern boundary of the image is at the city of Toulon, a naval station, dockyard, and old fortress. The docks on the north side of the harbour are just visible. The Iles d'Hyères, famous recreation sites for tired north-Europeans, lie a few miles further east.

To the west, between the Rhône and the Etang de Berre, is a low-lying, swampy area, the vegetation showing bright red and cleared areas grey. Beyond it, across the Rhône, is the plain of Languedoc that leads to Nîmes and Montpellier. At the extreme north-west of the image, areas of brownish-red indicate more hills, the southern boundary of the Massif Central that covers much of southern France.

Image scale and date: 1 inch = 8 miles, October 1972

N

Deserts

Desert exploration is a difficult, uncomfortable and sometimes dangerous business. Only the lure of precious metals, and more recently of oil and minerals, has drawn prospectors to the hot sands of Arabia's Rub al Khali (the Empty Quarter), the frozen permafrost of northern Alaska, and the bleak deserted plateaus of Chile and western China. Even then, travel and analysis has usually been limited to a few routes where food, water, and negotiable paths were available. Space imagery provides a superb new tool for desert exploration. There is seldom a problem with cloud cover; the haze produced by transpiring vegetation is absent; and dry sand and rock offer excellent media to allow fracture patterns and other structure to become visible. As we will see, desert images are amongst the most striking that the earth can provide.

One of the surprises about the world's deserts is their diversity. There are the extreme, hyper-arid regions where rain falls only once every few years, those where rain is adequate but wasted, and areas that are deserts only because man has made them so. Despite many efforts at land reclamation, the deserts are still growing. Each year, another 30,000 square miles of arable land is lost to them. This may seem negligible when compared with the 15,000,000 square miles that are already desert. It becomes more significant when it is remembered that the total arable land of Great Britain is no more than 30,000 square miles.

Of all the unfarmed land area in the world, deserts hold the most potential. They are more easily accessible than mountains or the frozen poles. They are often on level ground and in sunny climates. Many would be good collection areas for solar energy, or prime candidates for mineral mining. And most important of all, many deserts need only good water management, soil conservation, and careful selection of crops to become fertile and productive, as has been achieved in China, western U.S.A., and the Negev Desert in Israel.

The formation of new deserts can be forestalled; but although preventive measures that can be taken are straightforward and rational, the trend is still in the wrong direction. The need for food forces people to raise two and three crops a year on the same plot of land, without giving the earth time to rest and recuperate. It drives them to practise slash and burn methods of agriculture whereby perennial vegetation is cut down, the area burnt, and crops planted, which leads to rapid loss of topsoil. The need for energy results in the destruction of forests for charcoal production, and the scarring of the land in open-pit mining. All these are roads that quickly lead to loss of fertility, erosion, and new deserts. The dust bowls continue to grow around the world.

As long as the earth's population goes on increasing, neither Landsat nor any other tool of technology can reduce the pressures that lie behind the growth of the deserts. All that satellites can do is tell us what we are losing by measuring changes in productive lands, and perhaps give early warning of new problem areas.

Swakopmund and the Namib Desert

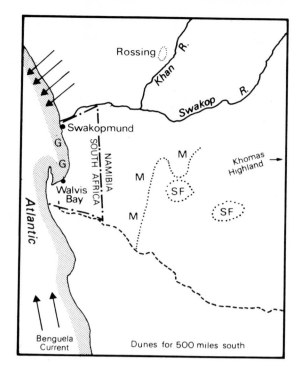

Namibia lies on the west coast of Africa, with Botswana to the east and Angola to the north. It is a big country, over 300,000 square miles, most of it in the Namib and Kalahari Deserts. The plates on the following two pages show the west central portion, between the capital Windhoek and the Atlantic Ocean.

Two different presentations of the same image area are given. The one on page 66 is the usual three-band composite that has been used for all the areas covered so far; page 67 shows a three-band eigenimage, constructed from combinations of the original four spectral bands of Landsat. Eigenimages are employed to make certain types of features more readily visible.

Both pictures illustrate the unusual nature of this part of the earth. The southern region is covered with giant longitudinal sand dunes which continue all the way down to the border with South Africa, 500 hundred miles away. These are the biggest dunes on earth, up to 1,000 feet high and two miles wide. Their northern boundary is quite sharp and well-defined.

The marbled area at the top of the image is rich in minerals. At the southern end of the elliptical area above the Khan River lies Rossing, the world's biggest uranium deposit. Copper, lead, zinc, and diamonds are also found here.

The Khan River, like the Swakop River that it joins, is usually dry. What can be seen on the image is vegetation growing along the gravel-filled riverbed, through which water runs below ground level. Notice how easily the rivers can be traced on the eigenimage compared with the standard image. Riverbed vegetation is just about all that there is in the western part of the image. There are pinker tinges in

the uplands to the east, but the whole area is arid. The cold waters of the Benguela current sweeping up from the Antarctic inhibit rain.

In the left-centre of the image is the town of Walvis Bay, lying in a small 374-square-mile enclave, which is part of South Africa. The roads that run from Walvis Bay and Swakopmund towards the Khomas Highlands and Windhoek appear on the image like white threads. Further north, off-shore prevailing winds have streaked the land along the curve of the coastline.

The technique used to produce an eigenimage can be varied to give alternative colour mixtures; the general rules that red is vegetation and blue-grey is urban or cleared ground do not apply. The one used overleaf has three advantages over the other, more usual, type of picture. The vegetation can be mapped more readily; it shows greater detail in the off-shore area, where sediments are carried by the current near Walvis Bay; and many of the inland geological features, such as the marble beds (**M** on the map) and sand flats (**SF**), are easier to plot. However, not all features are more visible on the eigenimage. The tiny specks (**G**), which are islands between Walvis Bay and Swakopmund stand out better against the black water of the standard image. These 'islands', which at first glance might be mistaken for a defect in the photographic film, are rather unusual. They are in fact man-made guano collection platforms set up to gather the natural fertilizer produced by millions of sea birds that live along the coast and find the islands convenient resting-places between forays for fish.

N

Image scale and date: 1 inch = 8.5 miles, August 1973

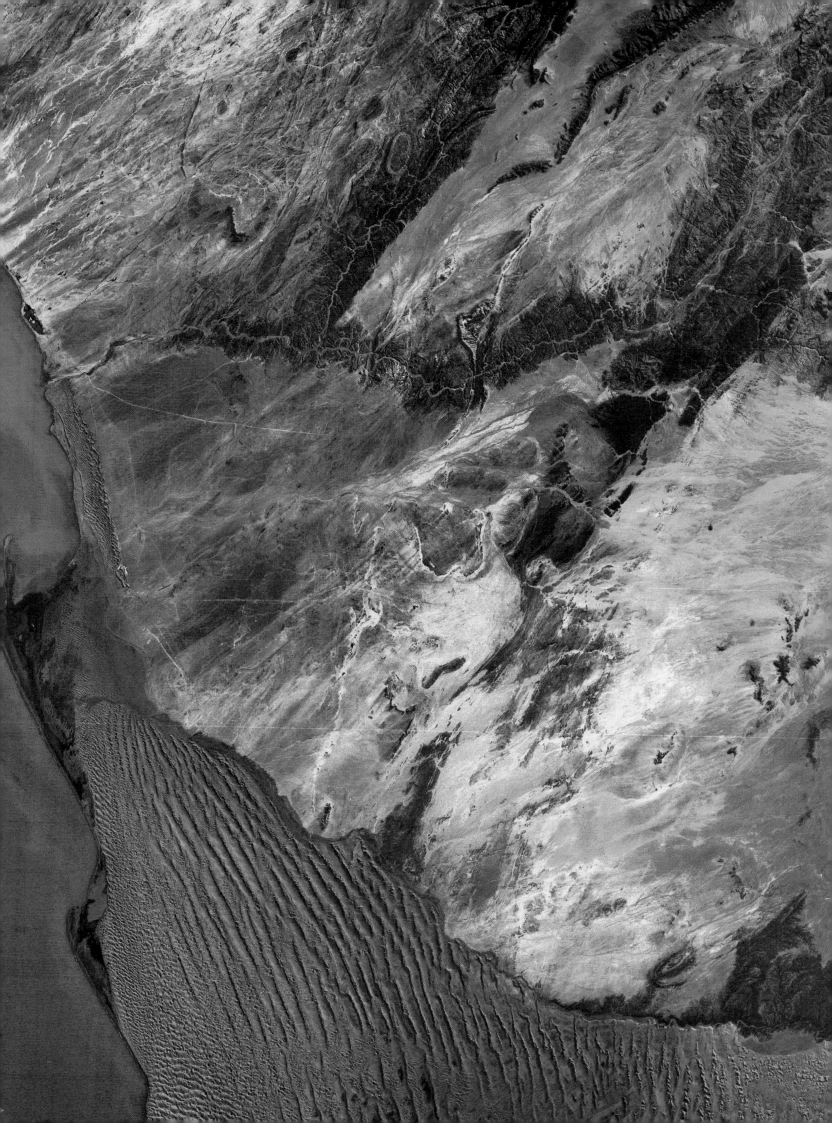

Rub al Khali

Between Oman and southern Saudi Arabia, covering almost a quarter of a million square miles of land, lies the Rub al Khali – the 'Empty Quarter'. It measures about 800 miles by 300, stretching across the whole of southern Saudi Arabia, from the Yemen Arab Republic in the west, along the northern boundary of South Yemen and the northern mountains of Oman, all the way to the United Arab Emirates. It is one of the world's most extreme deserts, a place where few plants and animals can be found and no permanent human settlements.

The image on pages 70–1 shows one of the most unapproachable parts of the great sea of sand, south of the huge salt flat of Al Uruq al Mutaridah. There are no towns or rivers, and no vegetation, only sand dunes. In the centre of the picture are *seif* dunes, long ridges with arrow-head breaks and connectors. Further east they change to a star dune pattern, more compact and isolated. Both types seen here are up to 500 feet high and the sand is soft, making travel across them very difficult.

In this picture the brown dunes seem to float above a sky full of summer clouds. The physical reality is far less romantic. The Rub al Khali is a closed geological basin, with a self-contained drainage system. As a result, the upper soil stratum is a dingy mixture of clay, brinish silt, and muddy sand. When the surface is wet it looks blue on a false-colour image (longer wavelength light is absorbed), and where it is drier it reflects light strongly to appear completely white. The striking patterns seen here are created by the windblown drier surface sand.

Image scale and date: 1 inch = 4.7 miles, November 1972

The Turfan Depression

The region covered by the image on pages 72−3 was a thriving centre of civilization and commerce 2,000 years ago. It lay on the Silk Road, the route followed by merchants carrying luxury goods between China and the West, and it was the last hospitable area before the blind wastes of the Takla Makan Desert.

The Turfan Depression lies on the north side of the desert (see map on page 74), and at its lowest point is over 500 feet below sea level. The source of water for the irrigated vegetation that can be seen there is the Tien Shan, the Celestial Mountains to the north of the depression. White drainage patterns running south are clearly visible, but most of the surface water evaporates before it can be used for irrigation. The farmers of Turfan tap the aquifers with horizontal wells. The technique was introduced to this part of the world by travellers from Persia, and the oldest such wells (termed *karez*, rather than the Persian *qanats*) date back to the Han dynasty, about the time of the birth of Christ.

At the eastern edge of the depression there is a great grey sea of sand, a total desert without vegetation or people. To the north, the railway between Ha-mi and Urumchi can be seen as a faint line crossing the drainage patterns above the Turfan Depression. Further north is the divide of the Tien Shan, beyond which lies more fertile land, with wooded slopes on the north side of the hills and beyond them evidence of agriculture. The reprieve is only temporary. Still further north is the colder desert of western Mongolia stretching away for hundreds of miles.

Image scale and date: 1 inch = 5.6 miles, October 1972

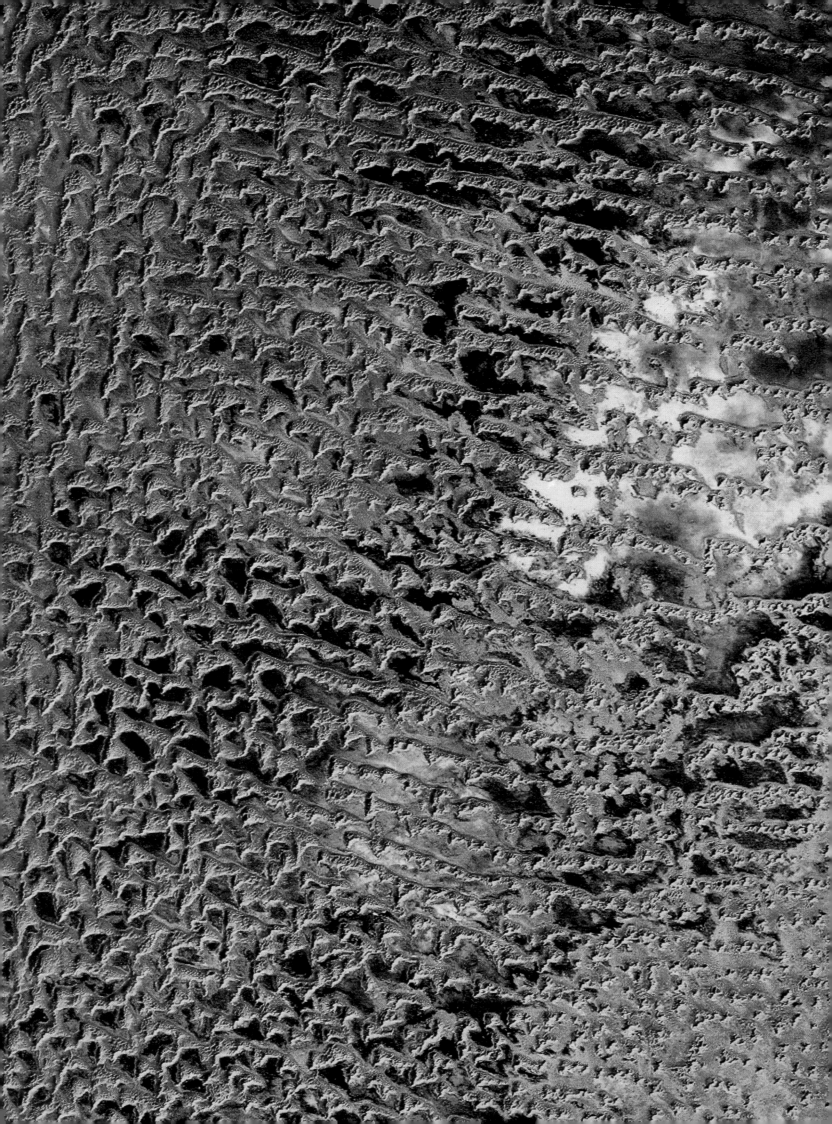

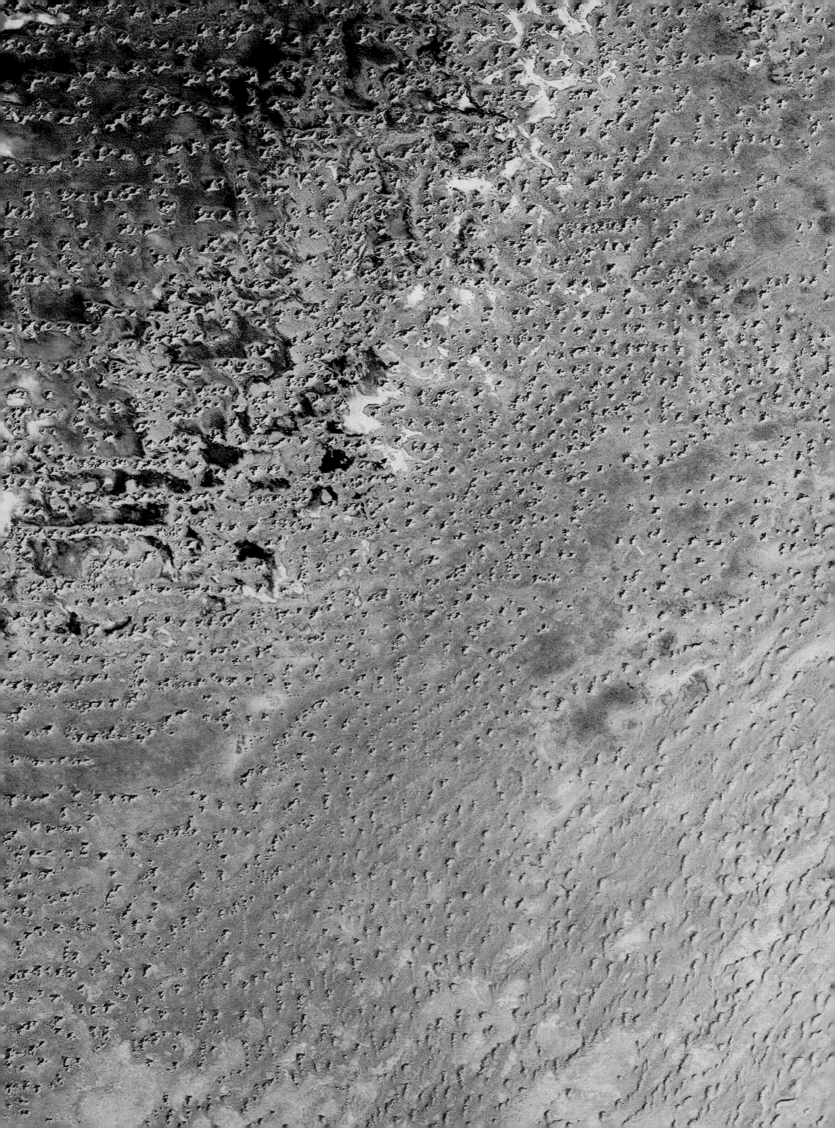

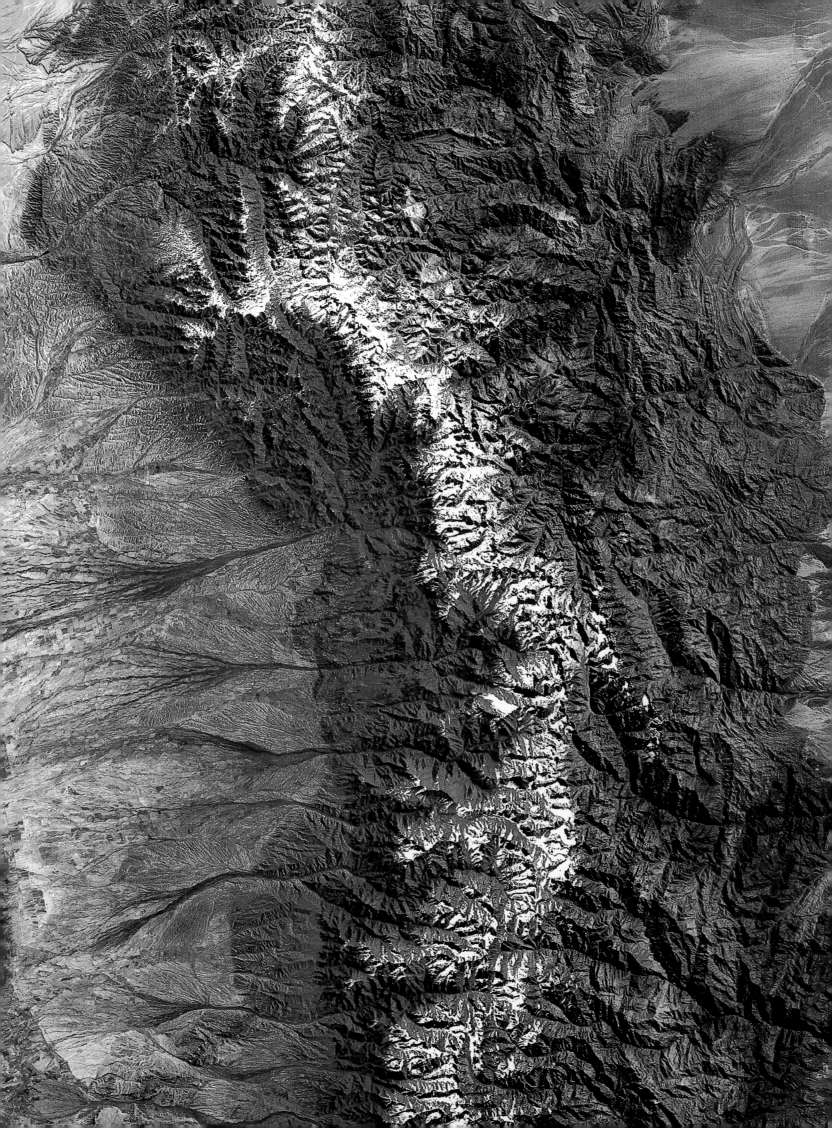

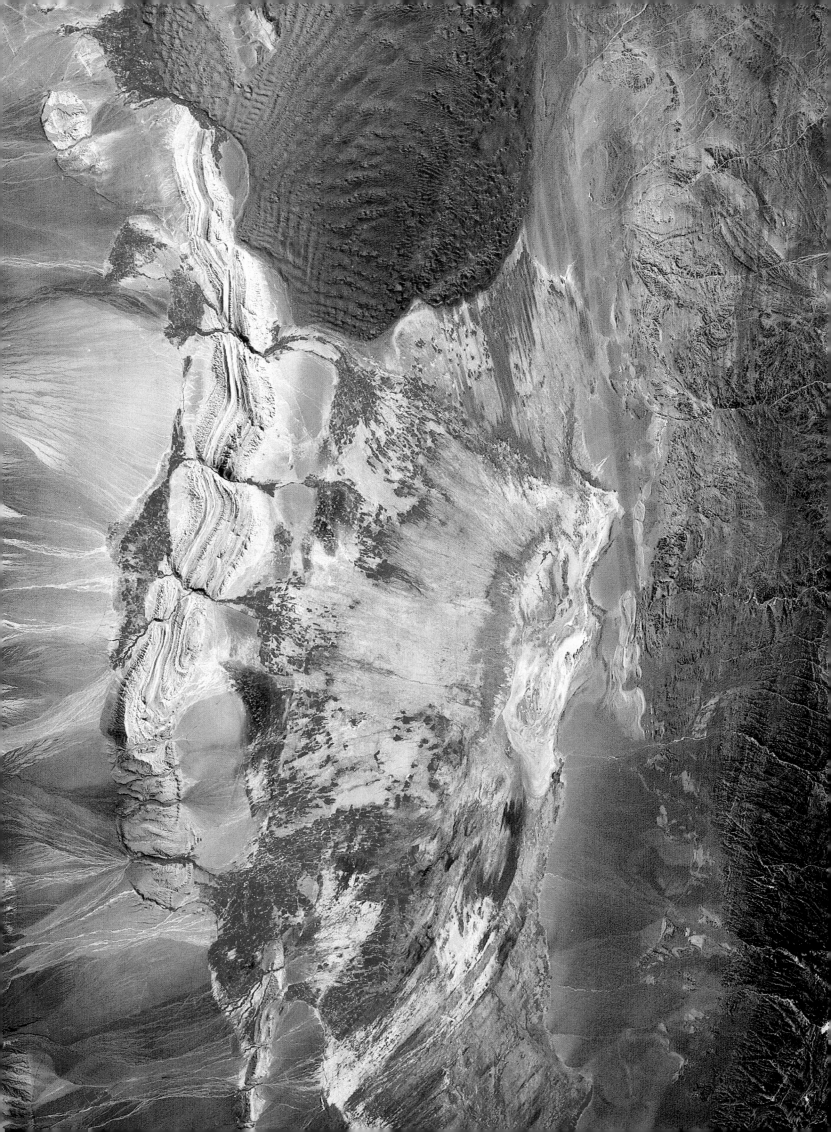

Lop Nor

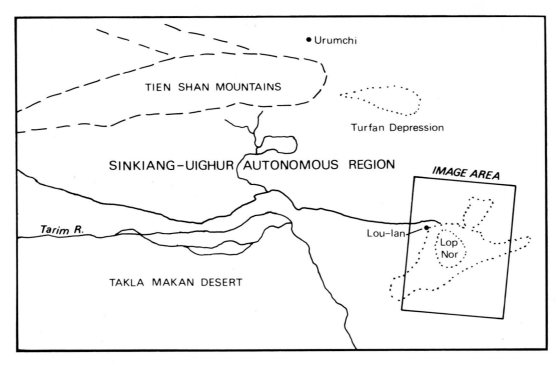

Lop Nor, also known as the 'Great Ear of China' for reasons this image clearly illustrates, is a salt lake and marshland at the eastern end of the Tarim Basin in China's Sinkiang-Uighur Autonomous Region (Xinjiang Uygur Zizhiqu). To the south and west lies the terrible desert of the Takla Makan, one of the world's driest areas where almost nothing, plant or animal, can live. Shielded from moisture by the whole width of the Soviet Union in the north and the Himalayas to the south, the Takla Makan forms an arid barrier between China and the west.

There are signs of vegetation on the image only in the north-west. The great swirls of the dried lake show grey-green amid white layers of sand and salt evaporations, each zone marking the level of the lake for a different year. In the centre is a darker area of moist sediments. In early January, when this picture was recorded, the region is very cold and the Tarim River frozen. Later, in March and April, the Tarim will carry a flood of water from the mountains to the west, and the lake will partially fill again, to flood the northern swamp.

In old Chinese and Greek writings Lop Nor is referred to as being south of Lou-lan, a road station for the Silk Road in use over 2,000 years ago. It is first mentioned in modern Western writings by Marco Polo, who reported passing through the 'Desert of Lop' on his journey to China from Venice via Kotan (Hotan) in 1271–5. However, he is probably referring to a different place from that described in the older records. In A.D. 330 the Tarim River changed its course and Lop Nor moved southwards. Then recently, in 1921, the river suddenly reverted to its old bed, returning Lop Nor to its classical site. The lake is doubly ephemeral, changing both its yearly appearance and occasionally its location.

The eastern side of the dry lake, which is flanked by grey and green sand dunes, is almost fifty miles across. Because of its remoteness from centres of population, the area has become one of China's principal locations for testing nuclear weapons.

Image scale and date: 1 inch = 8 miles, January 1973

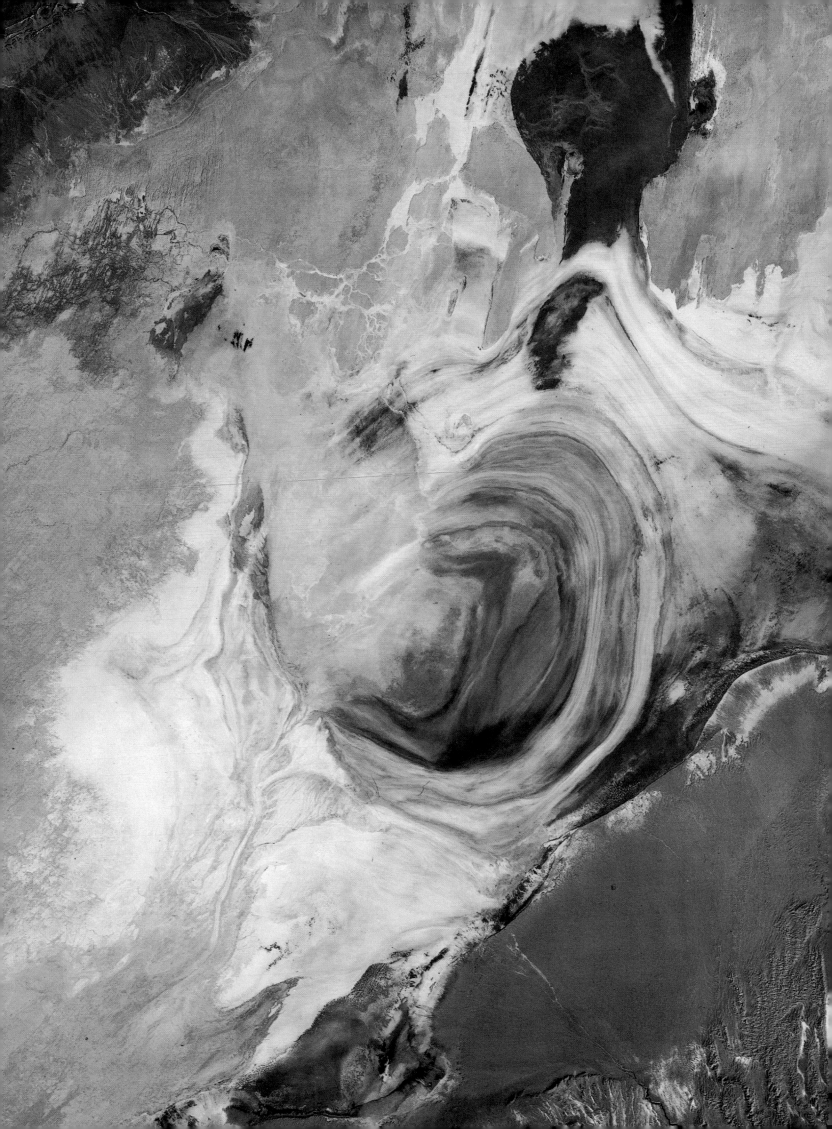

La Grange Bay, Western Australia

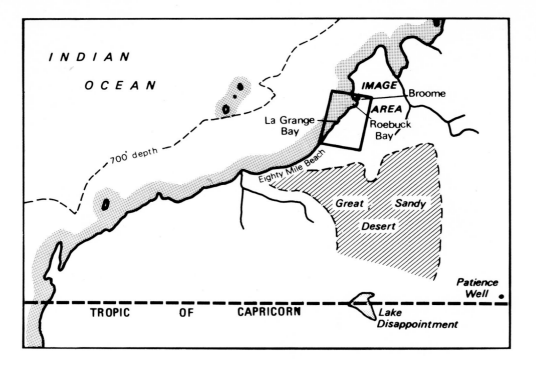

This is still one of the most barren parts of the world, with few plants, animals or people. The image is of a section of the north-west coast, where the seabed slopes in a gentle descent to the edge of the continental shelf almost 120 miles away. It shows the northern twenty miles of Eighty Mile Beach in the south to as far as Roebuck Bay in the north. White sand dunes are visible along most of this shoreline. The beach is flanked by vegetation (seen here as purple-red) inland at Roebuck Bay and along Eighty Mile Beach. The wonderful shades of blue seen off-shore are caused by churned sediments; the colour is darkest where the water is most clear.

This area is arid, and will not support most forms of agriculture. It is used mainly for grazing, and the resulting pattern of large fields can be seen on the north and middle parts of the image. This is a late autumn scene, recorded on 27 May, but even in the spring months of September and October vegetation growth is not very strong. The black, dark-brown and green areas in the north and centre are land that has been burnt to stimulate the growth of more tender grasses in the spring. The occasional heavy cyclonic storms that hit the northern part near Roebuck Bay do little to improve the supply of water. Two or three inches of rain will fall in an hour, but little of this will be held by the soil.

The town of Broome is visible on the southward-facing promontory at the north end of Roebuck Bay. It is a centre for beef processing, shipping, and pearl-fishing. Despite its small size, it is the chief port and town of north-western Australia.

In the south, the land is even less hospitable. It borders the Great Sandy Desert in the east. The long streaks on this part of the image are semi-permanent dunes, similar to those found in the ergs of the African Sahara. There are very few rivers in the area, and the names of the ephemeral ponds further south tell their own story: Lake Disappointment, Patience Well, Sahara Well, Adverse Well, Separation Well. The whole southern half of this picture is much like the African Sahel, in which cattle grazing and human settlement are barely possible.

Image scale and date: 1 inch = 8 miles, May 1975

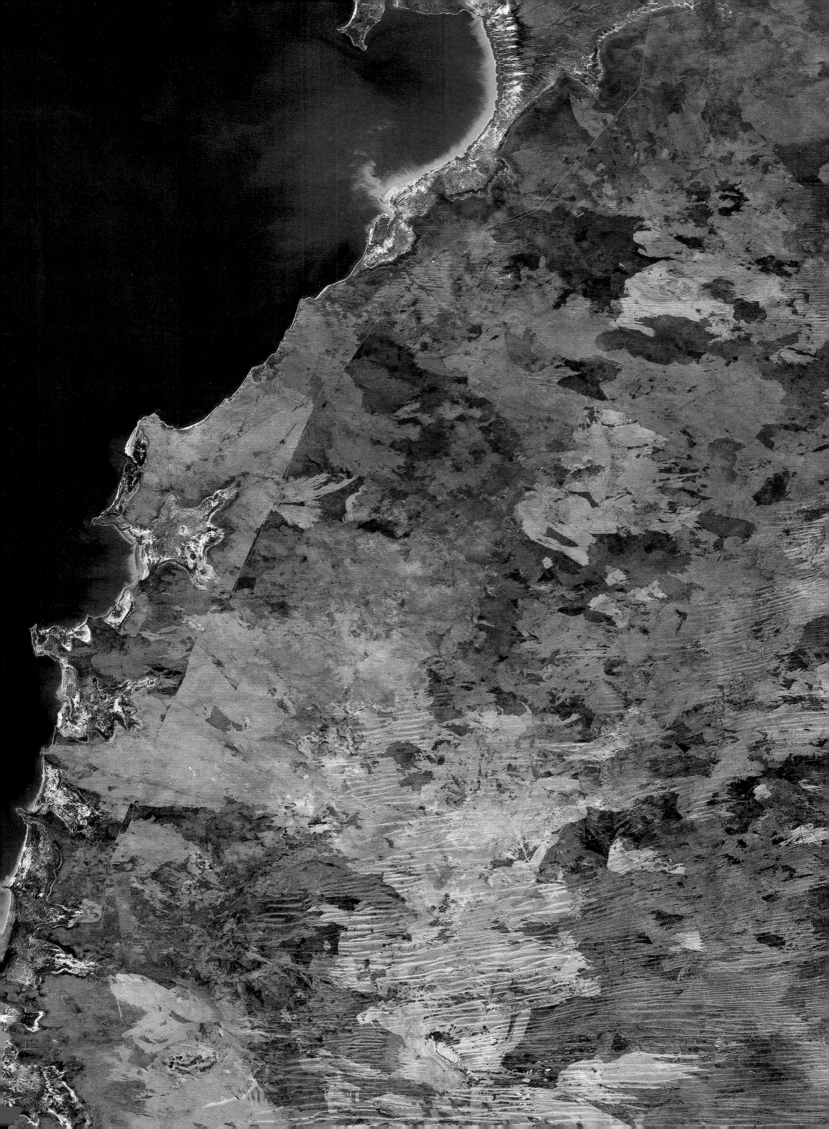

Fairbanks, Alaska

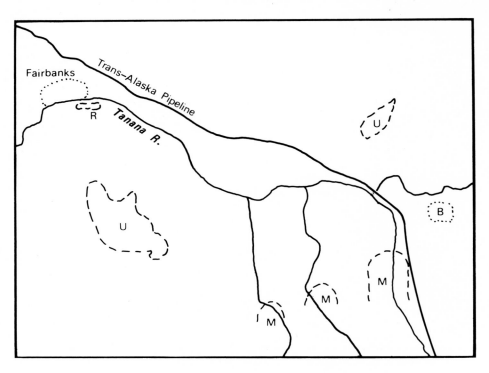

One hundred years ago, this area was generally regarded as uninhabitable wilderness. Extreme winters (70 degrees Fahrenheit below zero), meagre rainfall (12 inches per year), and short intense summers when the temperature can reach 90 degrees Fahrenheit combined to discourage development. In 1868, the purchase of Alaska from Russia for $7,200,000 was criticized by many in the United States as a senseless waste of public funds. Things have changed since then. The Trans-Alaska Pipeline, 800 miles long, is easily visible running down this image. The pipeline carried warmed oil from the Arctic Slope fields at Prudhoe Bay to the ice-free port of Valdez on the Pacific Ocean. If Alaska had nothing but its oil reserves they would pay the purchase price a thousand times over.

Much of the scene is covered with permafrost, and in the area north and west of Tanana River near the city of Fairbanks, south-facing and north-facing slopes are easily distinguished. The southern slopes receive more direct sunlight, permafrost has not formed, and the bright red of tall hardwood forests can be seen. On the north slopes, the ground is frozen and covered with dark and stunted black spruce. The area is constantly swept by forest fires, caused by lightning and man's activities. The result is a mosaic of vegetation types. Areas that have remained unburned for 200 years or more are marked **U** on the map. **R** indicates the sites of recent fires, where the vegetation is less than ten years old.

Although the area is dry and very cold, it is not infertile. During the summer months there are 18 to 22 hours of sunlight every day — this region is only 100 miles south of the Arctic Circle and continuous summer daylight. Crop growth can be rapid. The large cleared areas (**B** on the map) are part of an Alaskan barley-growing project. Conditions were once much milder here. Deposits of rich frozen organic silt (romantically named *muck* by the Alaskans) cover the upper part of the image, where low precipitation inhibited glaciation.

The moraines (**M**) show the furthest advance of Pleistocene glaciers. Placer mining in the area led to the discovery of a large number of bones between 9,000 and 150,000 years old, including those of mammoths, mastodons, sabre-toothed tigers, ground sloths, lions, and camels. One of Alaska's more curious industries in this century has been the recovery of these bones and their shipment to museums around the world. The earliest dating for human remains here shows that man was present at least 11,500 years ago.

Image scale and date: 1 inch = 8 miles, August 1976

N

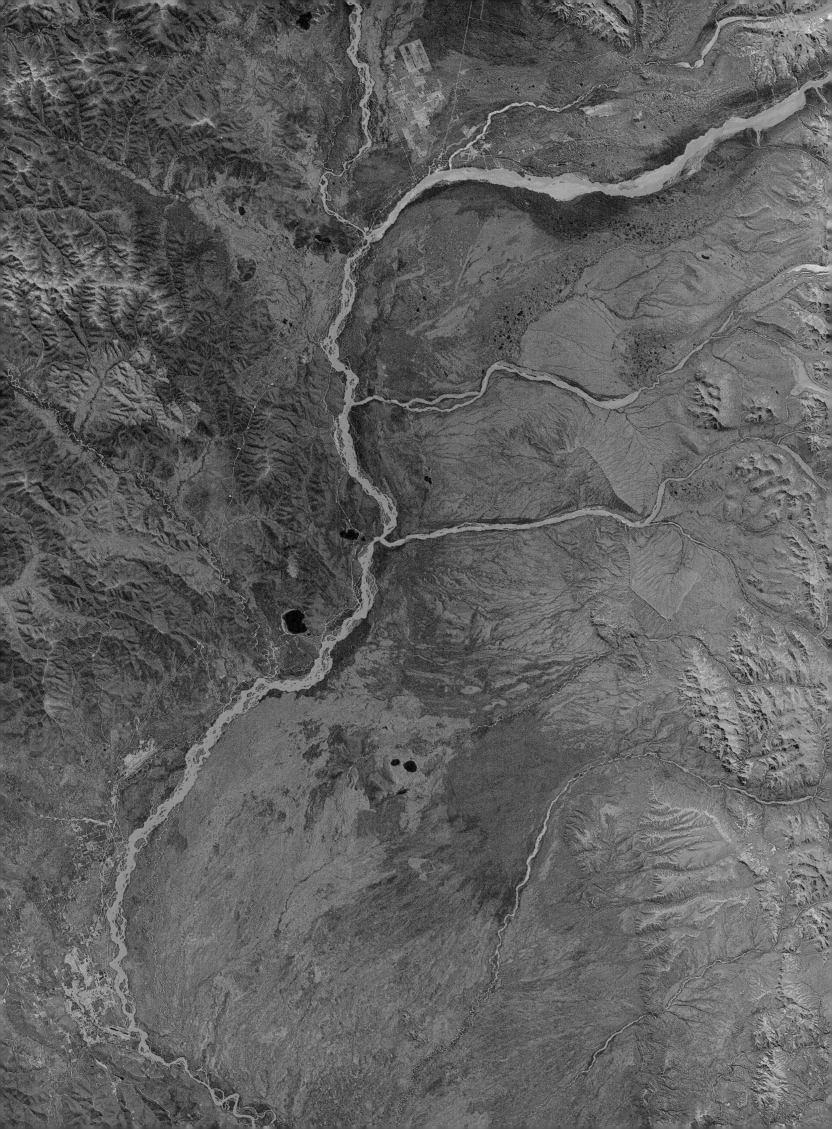

The Grand Erg Oriental

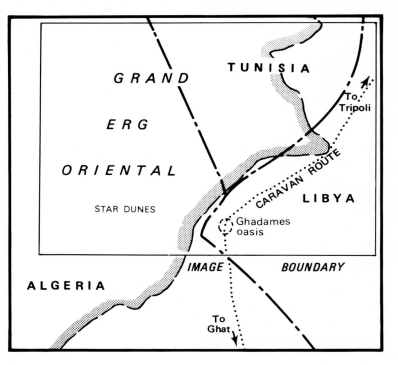

Desert dwellers can distinguish many different types of sand patterns, just as Eskimos can identify many forms of snow and ice. In the Sahara there are *elb* dunes, symmetrical ridges of sand that parallel the prevailing winds; *silk* or *seif* dunes, broken lines of ridges connected by arrow formations that point downwind; and *barchan* dunes, crescent forms that lie crosswind. This image shows yet a fourth type, a pattern of *oghurd* or star dunes, isolated hills of sand that are here half a mile to a mile across. They form the eastern edge of the Grand Erg Oriental, a desert area that runs west from the boundary of Libya with Tunisia and Algeria. The Libyan oasis town of Ghadames lies just beyond the edge of the dunes, ten miles from the Algerian border. It is a famous stopping point on the route from Tripoli on the Mediterranean to Ghat, 100 miles south of here. South and east of the dunes lies the extreme and stony desert of the Hamada de Tinrhert.

This image shows little of the characteristic red display of vegetation. It rains in this area only six days per year on average, giving a total rainfall of about 8 inches. The Grand Erg Oriental, like its partner the Grand Erg Occidental in Algeria, has few landmarks and no oases, and it has long been considered one of the most difficult areas of the Sahara Desert for travellers. Caravans avoid it, keeping to the east.

The ergs of the Sahara are usually described as 'shifting seas of sand' where dune patterns have no permanence. Landsat provides an easy way to test that statement, and in about ten years' time the rate and degree of dune movement should be clearer. Cloud cover, at least near Ghadames, is not often a problem. One might expect that changing winds would move dunes, but the eastern boundary of the star dunes must be stable, since Ghadames has been outside the erg and an oasis for travellers for hundreds of years. The edge of the Grand Erg Oriental to the south and east seems to be determined by altitude; it stops at about 1,000 feet on the plateau there. One explanation suggested for the shape of the star dunes is that they are formed by fixed rising atmospheric vortices, which implies permanence. Now, with space images available at eighteen day intervals right through the year, it may be possible to test that hypothesis.

Image scale and date: 1 inch = 8 miles, February 1976

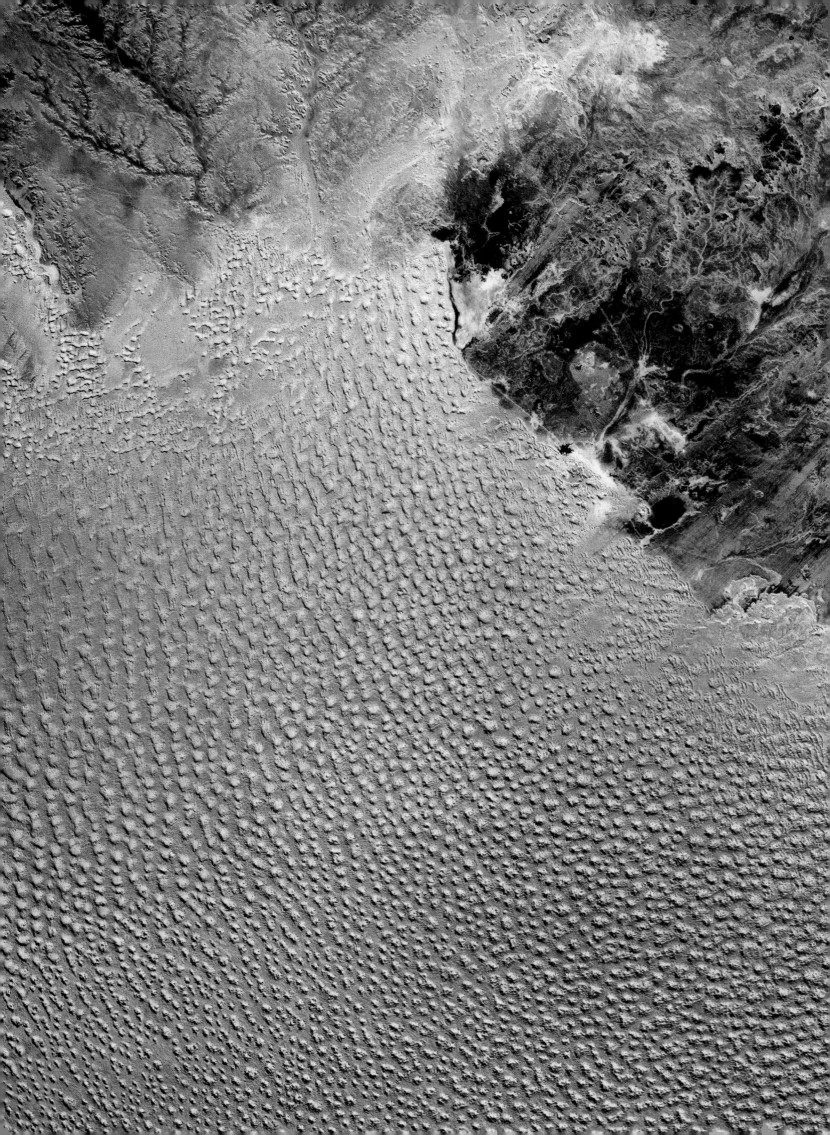

The Kimberley Plateau

The Kimberley Plateau lies in Western Australia, a broad tableland of 70,000 square miles facing the Timor Sea. This image is of its eastern part, where Western Australia and the Northern Territory meet.

Like most of the west of Australia, the region is made up of very old rocks. They form part of the Precambrian shield of the country and are usually heavily eroded. Since this area is also desert, with scanty vegetative cover, it offers an excellent example of the way in which detailed mapping of rock types can be done directly from a Landsat image, without supplementary aerial photography or other data. Ground samples are still necessary to confirm the derived maps, but they can be obtained far more economically than a complete geological survey of this remote and difficult land. The information that follows has been derived completely from the image and general geologic maps.

The scene shows a strong demarcation line running north to south through the image centre. This is the Hall's Creek Fault. To the east, flanking the Ord River, the rocks are sedimentary. We can map sandstones, shales, limestone, and massive sandstones and conglomerates (**S** on the map) on the basis of their colour and their texture. In the south-east corner lies the Antrim Plateau. Here sandstones and siltstones are covered with dark blue lava extrusions. Also at the bottom of the scene, and lying immediately east of Hall's Creek Fault, are the oldest rocks on the image.

These are Archeozoic and at least 2,600 million years old. In the far north, still close to the fault line, is the blue-grey of Lake Argyle. Like many of the 'lakes' of the Australian interior, this one has no water in it. Since it has no contours of darkening colour and therefore does not look even damp at the centre, it probably fills only a few times a century and otherwise is completely dry. The Bow River and the Ord River meet at Lake Argyle and the Ord flows on to the north, reaching the coast about 150 miles further on, at Joseph Bonaparte Gulf.

The western side of the Hall's Creek Fault is quite different in character. To the south are white sands, which give way to granites and migmatites west of the Bow River. These granites are recognizable from their texture, with patterns of fractures showing in random directions throughout the area. Sedimentary sandstones flank these granite outcroppings to both north and south.

This scene can be interpreted so well because of three complementary factors: the area is desert, so vegetative cover is minimal; the rock types are diverse enough to show appreciable differences in tone and texture on the image; and the flow patterns of the rivers provide clues to the relative hardness of the rocks over and around which they flow. All three elements are needed to make a convincing interpretation.

Image scale and date: 1 inch = 8.5 miles, August 1973

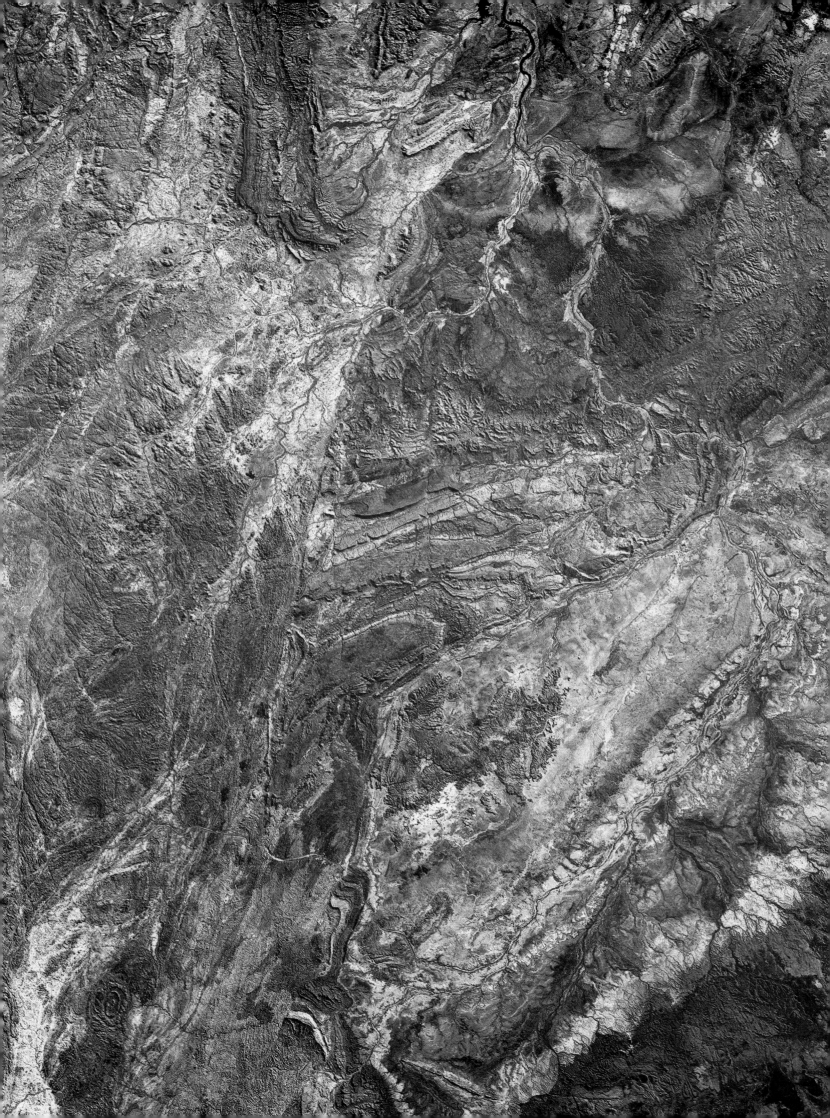

The Nubian Desert

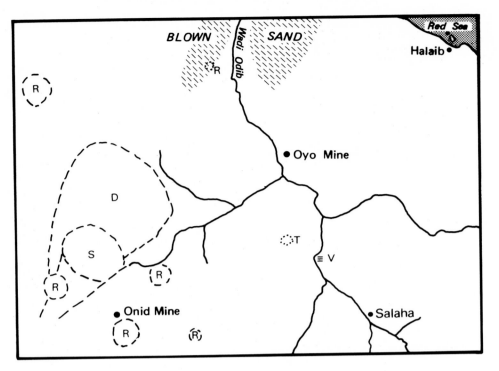

This image shows the north-east corner of Sudan, close to the border with Egypt. The capital, Khartoum, lies 400 miles to the south-west. The water body visible in the upper right corner is the Red Sea at the island of Halaib, roughly halfway between the Mediterranean and the Gulf of Aden. The lighter blue tones visible off-shore are growths of coral.

This region is in the eastern part of the Sahara Desert, and the first impression is of an area of dry sands and gravel, with hummocks of granite, limestone, and basalt. Rainfall is less than 4 inches per year, and the only vegetation lies at **V** (see map), alongside the sand-choked dry riverbed of Wadi Odib. The rest of the area can support only thorn bushes and scrub.

Ground mapping would tell us the general rock types, but it would not reveal as clearly the peculiar light and dark circular patterns that are scattered across this image. The large white area (**S**) is almost fifteen miles across, and lying over its southern extension is a darker area, showing as a perfect circle. This one is perhaps five miles across. There are many more, ranging in size from these giants down to small structures like the annulus (**T**), and others only a fraction of this. Features of this type on the surface

of the moon started an argument that lasted for centuries. Are they the result of internal or external agents, of volcanic action or meteors? The dark circle round the light area of **S** certainly suggests something external. It is, in fact, the result of volcanic action.

This region of the Nubian Desert is part of a Precambrian shield. Magma pushed its way up through conical fractures in the shield and formed a series of concentric spheroids of hard igneous rock. Erosion over the years has exposed the circular features that can now be seen. In some of these, known as ring dikes (**R**), the concentric structure is still apparent. Others appear as single extrusions of igneous rock, sometimes covered in sand. Tonal variations of the circular patterns reflect both composition and later cover. Dark areas suggest the presence of iron and magnesium (enough to colour the rocks but not enough to mine the area). Light areas are sands, seen in the middle of the image, in the dry wadis, and within the structure **S**.

With the possible exception of oil and gas in the far north-east, the area is poor in minerals. Only gold is mined, at Oyo and Onid. This region has been worked for gold since the time of the ancient Egyptians.

Image scale and date: 1 inch = 8.5 miles, September 1972

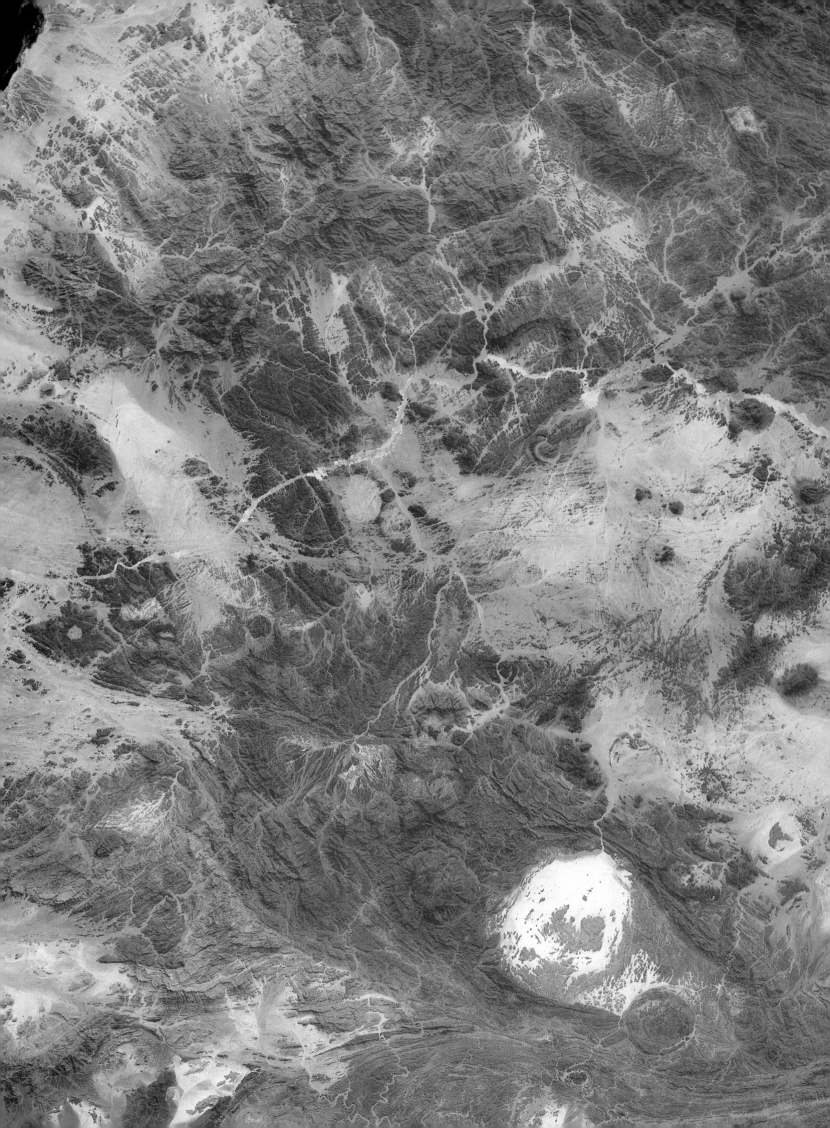

Saudi Arabia and the Red Sea Coast

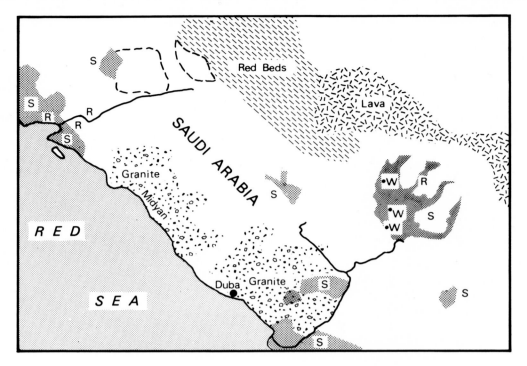

The Arabian peninsula can be divided into three almost concentric zones. The inmost one is the Nejd region, with numerous valleys and oases, fairly well populated. Outside this come the sand wastes of the An Nafud, Ad Dahna, and Rub al Khali. These are almost completely barren of plants, animals and people. Finally there is the outer circle of plateau and mountain, parts of which are, by Saudi Arabian standards, quite heavily populated. The image here shows a section of this last area, the coastal region that runs along the Red Sea just south of the Gulf of Aqaba.

Although not so barren and inhospitable as the Rub al Khali, the region is still true desert. Rainfall is only about 3 inches per year, and most of that falls in a few days (or even hours) during the winter, which does not usefully increase soil moisture. As a result, most of the vegetation that can be seen on the image lies near oases, often irrigated by well water (**W** on the map). These areas are recognizable from the small red patches of vegetation (**V**) that are scattered over the image. They are a negligible fraction of the whole scene.

More significant in terms of area are the white patches of sand (**S**), mostly towards the coast. Further inland a large region of very old sedimentary rocks (Cambrian to Ordovician) is visible as yellow on this false-colour image. They are in fact red-brown, deriving their colour from iron oxides. As they are eroded, they form a layer of sand that can be seen here as windblown streaks. A little to the south-east of this, a large patch of dark brown lava overlying the older rock beds can be mapped. Above this, in the upper right of the image, a broad bed of Devonian sedimentary rocks is visible, slightly lighter in tone than the lava.

The whole western coast shows sands and ranges of dark granite peaks that make up the area of Midyan. They form an almost continuous barrier between the Red Sea and the interior, broken only by the fine white lines of dry wadis. These mountains have valuable mineral potential. They used to be mined for gold, but these deposits are now exhausted. The future here lies in less exotic metallic elements such as barium.

Image scale and date: 1 inch = 8.75 miles, December 1975

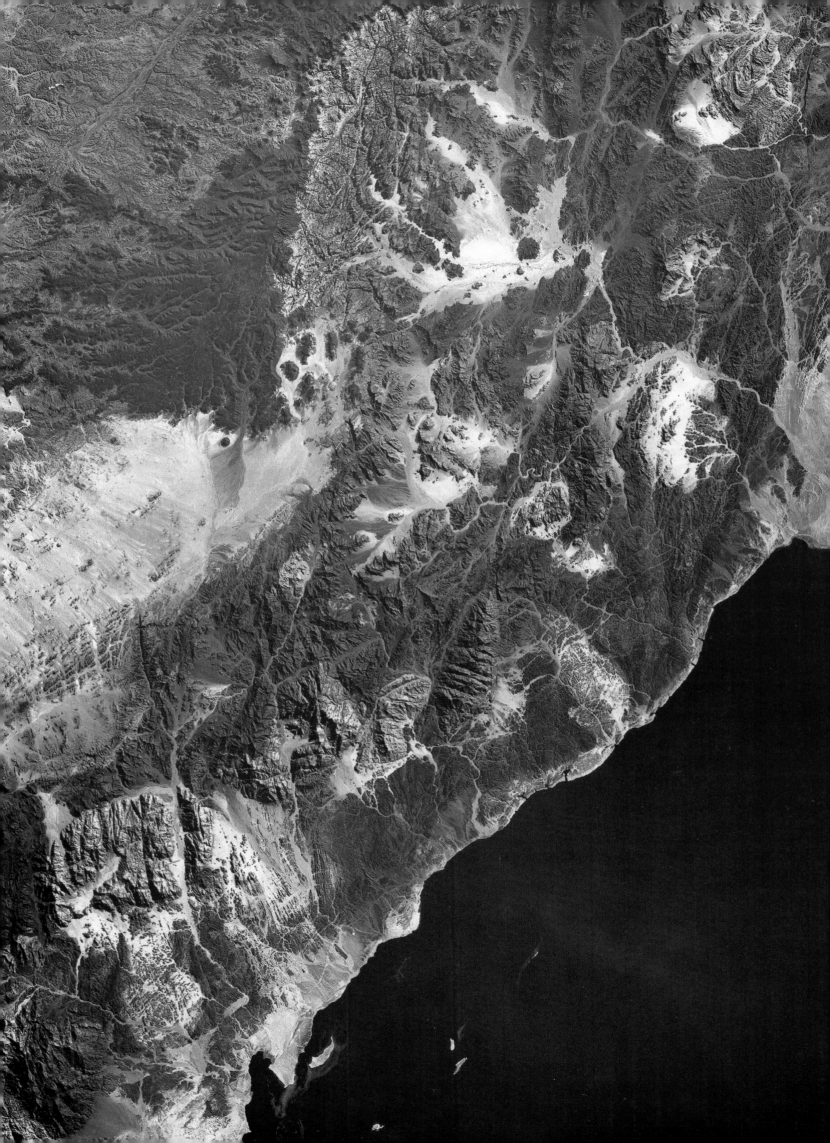

Lakes and Islands

With rare exceptions, the lakes and islands that appear in this book are either small and obscure, or only a fraction of them is displayed. The reason for this is that each Landsat frame covers about 13,000 square miles, which compared to the size of many of the world's well-known lakes is not such a large area. Take for example the Caspian Sea (called a sea, but land-locked and therefore truly a lake), which is 152,000 square miles; Lake Superior, 32,000 square miles; Lake Victoria, 27,000 square miles; Lake Baikal, 12,100 square miles; Lake Michigan, 22,400 square miles; Lake Tanganyika, 12,700 square miles. The fact that lakes are not conveniently rectangular or orientated to fit a Landsat image area further reduces the number that can be displayed within the frame of a single Landsat scene. The same goes for islands.

Nevertheless, the lakes and islands of the world are worth showing, even piecemeal. As we shall see, the Dead Sea (360 square miles) and the Great Salt Lake (1,900 square miles) are still evolving and changing size and shape, and the lakes of northern Canada reveal a great deal about conditions in that area many thousands of years ago. In the same way, the island of Lombok in the East Indies offers a striking display of the area's volcanic nature.

The Dead Sea

The main event that shaped the scene overleaf took place about 35 million years ago, when the Arabian peninsula split from Africa and slowly began to move north-west. The rift valley that this created runs south through Lake Tiberius (the Sea of Galilee), along the Jordan River valley, past the Dead Sea, and on to the Red Sea. The east side of the rift valley moves north relative to the west side at a rate of about two miles every million years.

The part of the Jordan River shown in the image is very low-lying. It is almost 700 feet below sea level in the northern part of the image, and drops all the way to 1,300 feet below sea level when it meets the Dead Sea. The widening of the river east of Jericho is evident on the image. The Dead Sea itself is shrinking steadily because of evaporation. The lighter blue areas (**P** on the map) at its southern end are shallow and murky evaporation flats, and in a few hundred years these will be completely dry.

Major cities are obvious as blue-grey blobs on the image. Jerusalem is sixteen miles due west of the northern end of the Dead Sea. Amman, the capital of Jordan, is due north of the scattered cirrus cloud that lies to the east of the sea, and Zarqa lies on the river north-east of the capital. Both these cities have been growing at a phenomenal rate. Amman now has a population of about 650,000 (three times what it was twenty years ago) and Zarqa has grown from 30,000 in 1960 to almost a quarter of a million in 1980.

The low level of the Jordan River valley gives it an almost tropical climate, but most of the vegetation (**V**) in the area lies near Nazareth, to the north, or over near Gaza, in the west. On the shore of the Dead Sea itself, the holiday area of En Gedi shows as a tiny spot of rich vegetation, which is watered by aquifers. There are orchards and gardens here amid the bleak desert.

The main road from Jerusalem to Tel Aviv is just visible as a fine white thread that runs west of Jerusalem. It is most easily seen at the very edge of the image, where it passes through bright red vegetated areas.

Image scale and date: 1 inch = 5.9 miles, February 1978

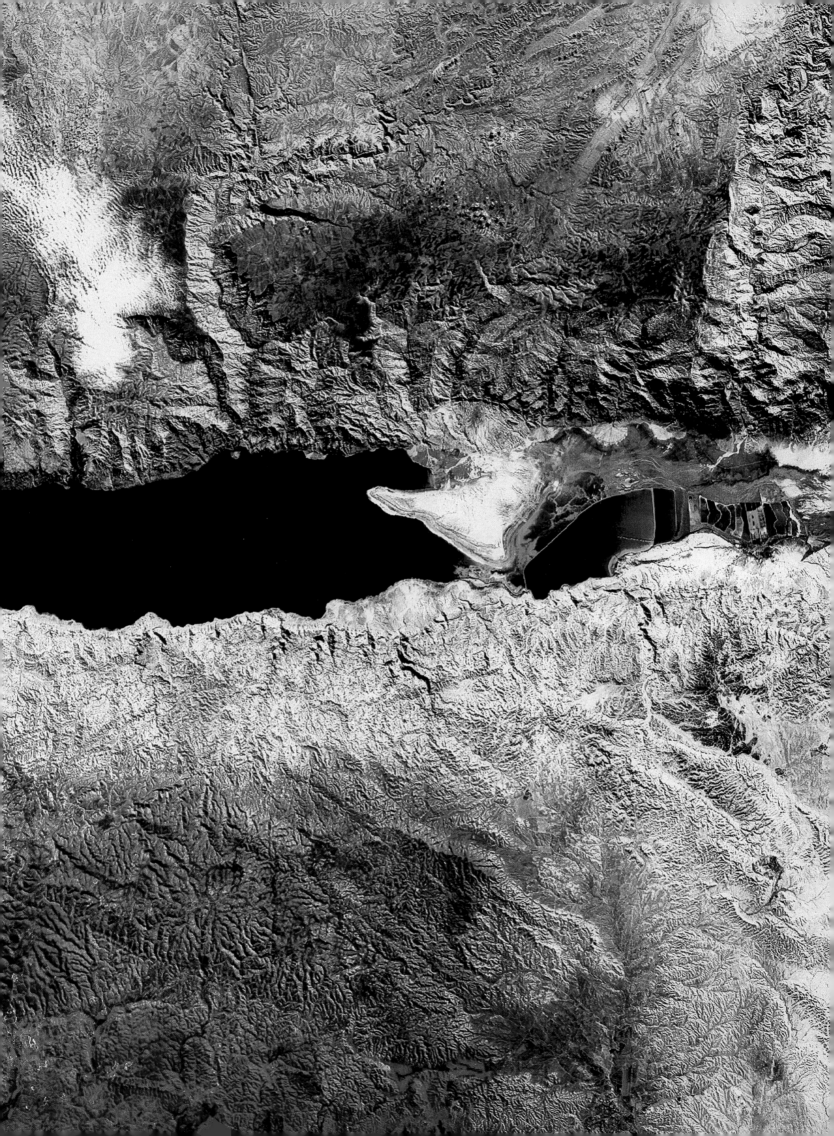

Lombok Island, Indonesia

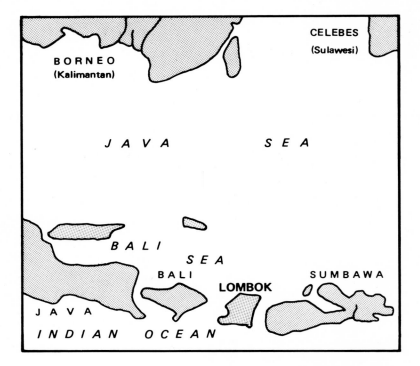

The Lesser Sunda Islands of Indonesia make up the eastern end of the great Alpine-Himalayan chain of mountain ranges. The mountains here are much lower than those of the Karakoram or Himalayan range, but they perhaps compensate for that by their unusual degree of volcanic activity. East of Java, which alone has thirty active volcanoes, there is a string of live craters all the way from Bali's Mount Agung to Mount Lewotabi on the eastern end of Flores Island.

The island of Lombok that fills this image is less well known than its western neighbour, Bali, but as this picture reveals, it is not without interest. The impressive volcanic peak of Gunung Rindjani is prominent in the north of the island, and the size and shape of its crater can easily be mapped from this Landsat image. The white areas near the crater are cloud, not snow cover. The peak rises to more than 12,200 feet and slopes away precipitously on the north side of Lombok. The island is only fifty miles across and the summit of Gunung Rindjani just ten miles from the sea. To the west lies the lesser peak of Gunung Punikan, about 5,000 feet high.

Mataram is the chief town and trade centre of Lombok. Nearby is the main port of Ampenan. Both places lie on the west, near the middle line of the north—south coast. Agriculture here and around the fishhook bay near the town of Lombok in the north-east is visible as mixed red and blue tones of growing fields and cleared land. The dense vegetation growing on the slopes of Gunung Rindjani indicates that although the volcano is classed as an active one, it has not erupted in the recent past.

The strait of Selat Lombok, west of the island, marks the edge of the Asian continental shelf. Between Lombok and Bali runs the famous 'Wallace Line', named after the naturalist Alfred Russel Wallace who claimed there was a biological boundary between the plant and animal species to be found in the Asian and Australian continental regions. The Wallace Line runs between Borneo and Celebes, and across the Java Sea just west of Lombok. The modern view is that this area is a transition zone, in which Asiatic plants and animals are gradually supplanted by the equivalent Australian species as one moves further east.

Image scale and date: 1 inch = 5.9 miles, July 1976

N

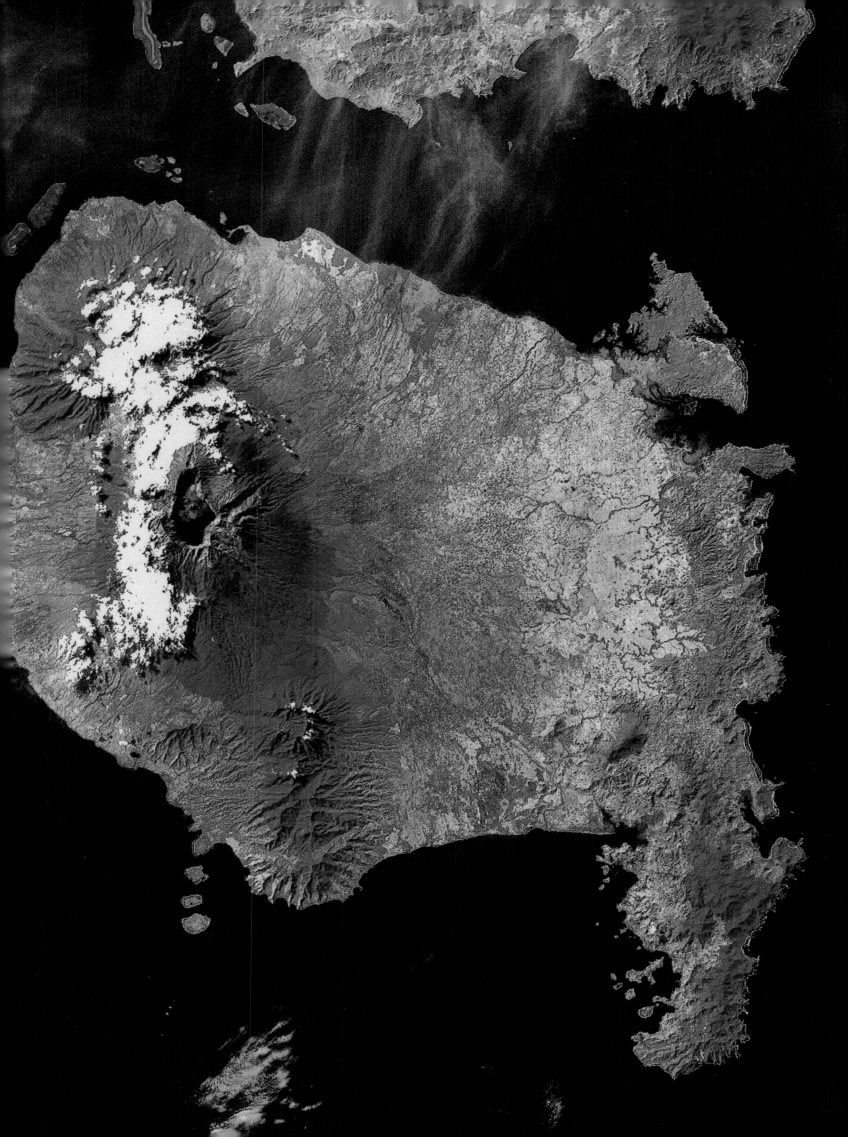

The Lakes of Northern Canada

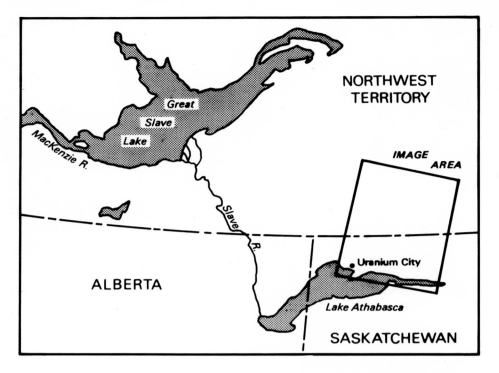

The area shown in this image lies on the continental block known as the Laurentian or Canadian Shield. The rocks are about 600 million years old. Long before the super-continent of Pangaea split to create Gondwanaland and Laurasia, the rocks of this Precambrian shield region were eroding to form the plain that survives there today.

This is the northernmost part of Saskatchewan, where it meets the Northwest Territory. Lake Athabasca lies at the bottom of the image. West of the area shown is the Slave River, which runs north and connects Lake Athabasca to the Great Slave Lake; the Mackenzie River carries the waters on from there and into the Arctic Ocean at Beaufort Sea.

This area of Canada has good resources of minerals, forests, and hydro-electric power. Cold weather and poor soil mean that the tree cover is pulp-quality conifer, mainly black spruce and jack pine rather than good timber. Uranium City on the north shore of Lake Athabasca is the site of a large pitchblende mining operation, and the lake provides trout and pickerel for one of Canada's important commercial fisheries.

Lake Athabasca, with an area of 3,060 square miles,
is one of a dozen large freshwater lakes in this part of northern Canada. Large lakes are the exceptions here; most of the region is covered by innumerable smaller lakes, right down to a few feet across, beyond the one-acre resolution limit of the image.

Clear and usually fairly deep, the lakes show on the image as black patches everywhere. Despite the age of the rocks in which they lie, they came into existence relatively recently. When the glaciers drove through this region during the last Ice Age cycle, they gouged deep into the shield and formed the lakes that are there today. The two linear patterns that show on the image, one east—west and the other roughly north—south, display the underlying rock structure and the southern movement of the glaciers.

Green and greenish-black patches are visible amongst the black of lakes and the red·of forests. They are burns of various ages, slowly growing another cover of forest. This part of Canada is thinly populated, and forest fires when they occur are impossible to control. A few degrees further north the trees give way to scrub and the Arctic tundra.

Image scale and date: 1 inch = 8.75 miles, August 1973

The Great Salt Lake

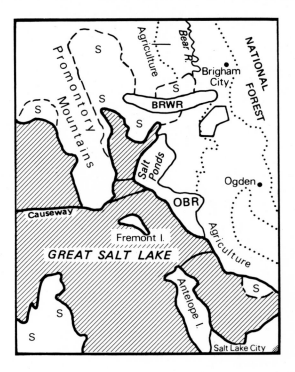

One million years ago a great freshwater lake covered most of what is now northern Utah. This was Lake Bonneville, 19,000 square miles of slowly evaporating land-locked water. Over the years it gradually shrank, leaving behind the dissolved mineral salts it contained, until today it covers an area of less than 2,000 square miles, known as the Great Salt Lake, one of the world's most saline water bodies. Its 25 per cent salinity is about the same as that of the Dead Sea, and is as high as it can be without lake-bed salt deposits being precipitated.

This image shows the southern end of the lake, with Salt Lake City at the extreme bottom right corner. In addition to the light blues and whites of commercial salt ponds, the lake's high saline content is revealed by the large bright white salt flats on its shore. These saline deposits of sandy clay (**S** on the map) are too salty to permit any form of plant life. The water body to the right of the lake is man-made and less saline; it has partial vegetation cover on its surface. Near its middle, the lake is crossed by a thirty-mile railway causeway which changes the amount and quality of new water reaching different parts of the lake and is the reason for the obvious colour difference in its upper and lower parts. The causeway runs east to meet the downward spur of Promontory Mountains, which show the pink of a light growth of vegetation at their southern tip.

Fremont Island and Antelope Island are both used for cattle grazing. The bridges and causeway that extend to the eastern shore are clearly visible on the image.

To the east, the lake shore becomes more fertile. Well-drained alluvial soil permits good farming all the way from Salt Lake City through Ogden to Brigham City in the north of the picture. Brigham City is a wheat-growing centre of Utah; fruit and sugar are other principal crops. Further east the land rises steeply to the Cache and Wasatch National Forests, their more rugged slopes clearly distinguishable from the agricultural lowland.

A number of areas of the lake shore unsuitable for agriculture have been made wildlife refuges. They include the Ogden Bay Bird Refuge (**OBR**) and the Bear River National Wildlife Refuge (**BRWR**). The delta of the Bear River enters the lake at the upper right.

Northern Utah contains one other notable reminder of the ancient Lake Bonneville. Fifty miles to the west of the image area lie the Bonneville Salt Flats, whose firm, even surface have made them a favourite site for assaults on the world land speed record. Their appearance is much like the salt flats visible in this scene.

Image scale and date: 1 inch = 8.5 miles, October 1978

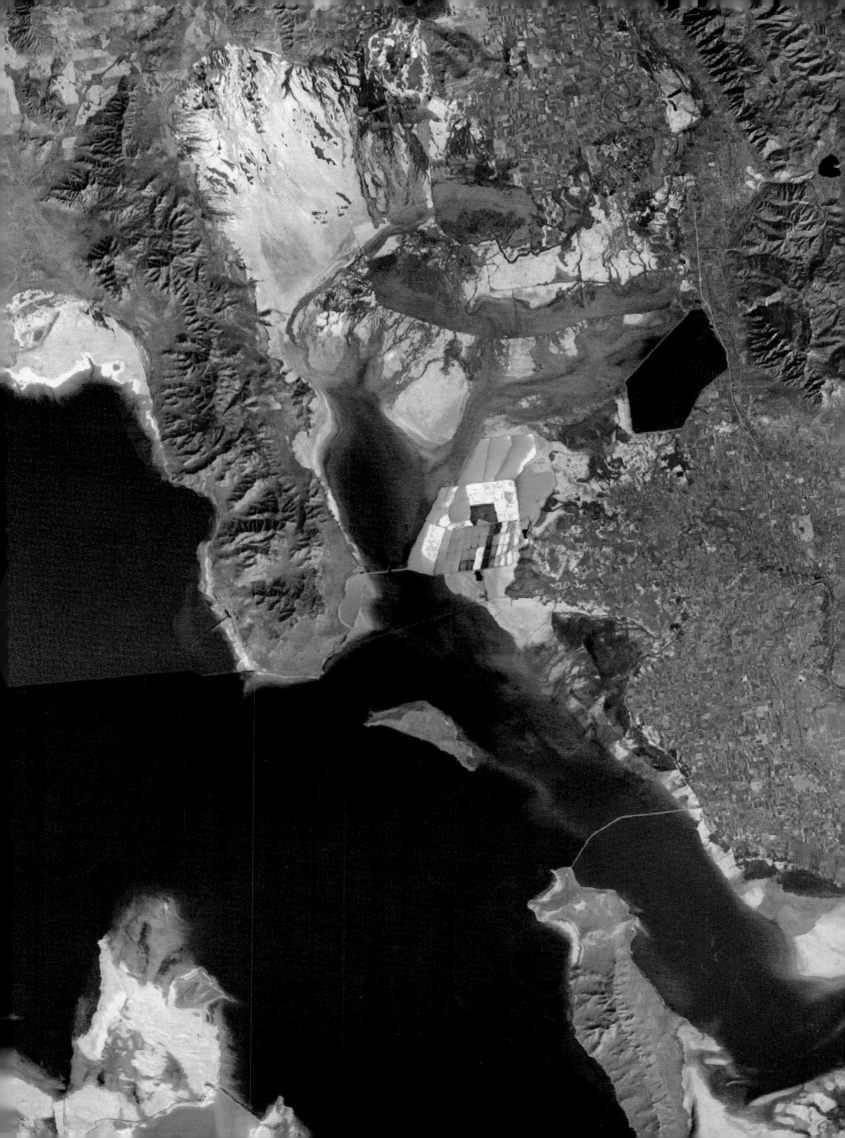

Eastern Zaire and the Lualaba River

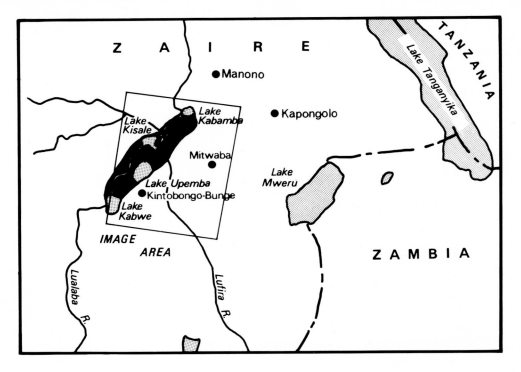

Zaire is one of the largest countries in Africa, covering an area of more than 900,000 square miles from the mouth of the Zaire River in the west to Lake Tanganyika in the east. This picture shows part of the easternmost province of Shaba, where the country borders Zambia and Tanzania. The centre of the image is about 250 miles north of the Zambia-Zaire border.

Only about 1 per cent of Zaire's arable land is currently under cultivation. The country's economy depends almost totally on the export of copper, cobalt, uranium, and industrial diamonds, which are found mainly in the Shaba hills that border Zambia.

A striking black and red area is displayed on the left-hand part of this image. Though it appears puzzling at first, its nature can be deduced. The black areas have the characteristic appearance of deep clear water. The bright red indicates a solid mass of healthy vegetation, quite different in appearance from the vegetation visible in the right-hand part of the picture where growth is not so dense and the colour therefore more orange. The thin black lines of rivers that enter this area from the north and east maintain their colour even within the vegetated region.

The logical conclusion is that this is a huge swamp, 1,500 square miles in area, containing stagnant lakes. This deduction is borne out by survey maps of the area. There are four large lakes – Upemba, Kabwe, Kisale, and Kabamba. The Lualaba River runs through the swamp and continues north to become the Zaire River 100 miles further downstream. There are differences between this image and large-scale maps of the region, which could mean that the lakes and rivers change slightly or, equally likely, that the broad coverage possible with satellites gives a more accurate view than other methods of mapping.

East of the swamp are vegetated hills, but no towns large enough to show on the image. Agricultural activity can be inferred from the large greenish-black burned areas just east of the centre. They surround the town of Mitwaba, one of four significant settlements in the area. The others are Kapongolo, Manono, and the majestically named Kintobongo-Bunge.

Image scale and date: 1 inch = 8 miles, June 1973

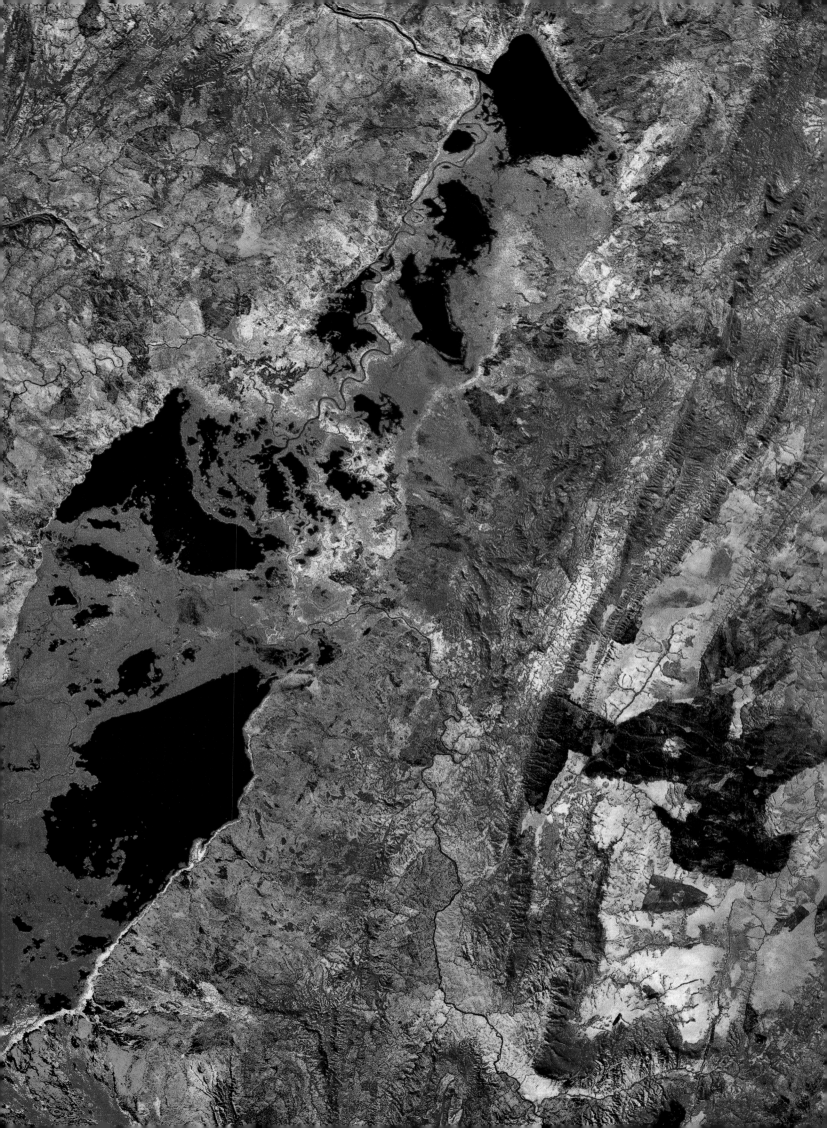

Hispaniola

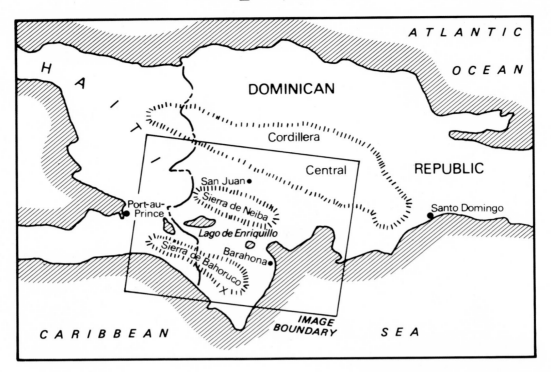

Hispaniola is one of the largest islands in the West Indies, its area of 29,400 square miles exceeded by only Cuba. Discovered by Columbus during his first voyage west (the *Santa Maria* went aground here and was abandoned), Hispaniola was the location of the first colony in the New World. Today it comprises two separate states, Haiti in the west and the Dominican Republic in the east. The border between them runs roughly north to south on the left-hand side of this image, which shows the southern part of the island.

Although Haiti is the poorer and more densely populated country, with the same population as the Dominican Republic (4.7 million people) living in less than two-thirds of the land area, there is no visible difference in land use. Most of the island is still densely forested, with timber (mahogany, logwood, cedar and lignum vitae) an important national product, though uncontrolled cutting in Haiti has destroyed some of the forest.

The scene reveals a good deal of geological structure in the red forested areas, particularly in the northeast. This is part of the Cordillera Central of the Dominican Republic. It is the highest mountain range

in the West Indies, rising to 10,400 feet. Further south are the ranges of Sierra de Neiba and Sierra de Bahoruco, both of which have peaks up to 8,000 feet. These ranges, the Cordillera Central in particular, show evidence of the complex fault patterns of the island. One major fault line, the Hispaniola Lineament, runs up the eastern coastline past Barahona and intersects the mountain range at the right-hand edge of the picture.

The bright blue lakes in the lower part of the picture are land locked; Lago de Enriquillo is 150 feet below sea level. The green-white area of a salt flat to its south is mined for salt. All the lakes lie in a low valley, the Cul de Sac, that runs from Barahona to Port au Prince, the capital of Haiti.

Below the Sierra de Bahoruco the green crossed pattern of a large bauxite mine (**X** on the map) can be seen. Bauxite, together with iron, copper, and some gold and silver, are the country's main exports. The principal crop sold abroad is sugar; cane is grown all the way along the south coast, particularly the thirty-mile stretch from Barahona to Santo Domingo, the capital of the Dominican Republic.

Image scale and date: 1 inch = 8 miles, December 1973

N

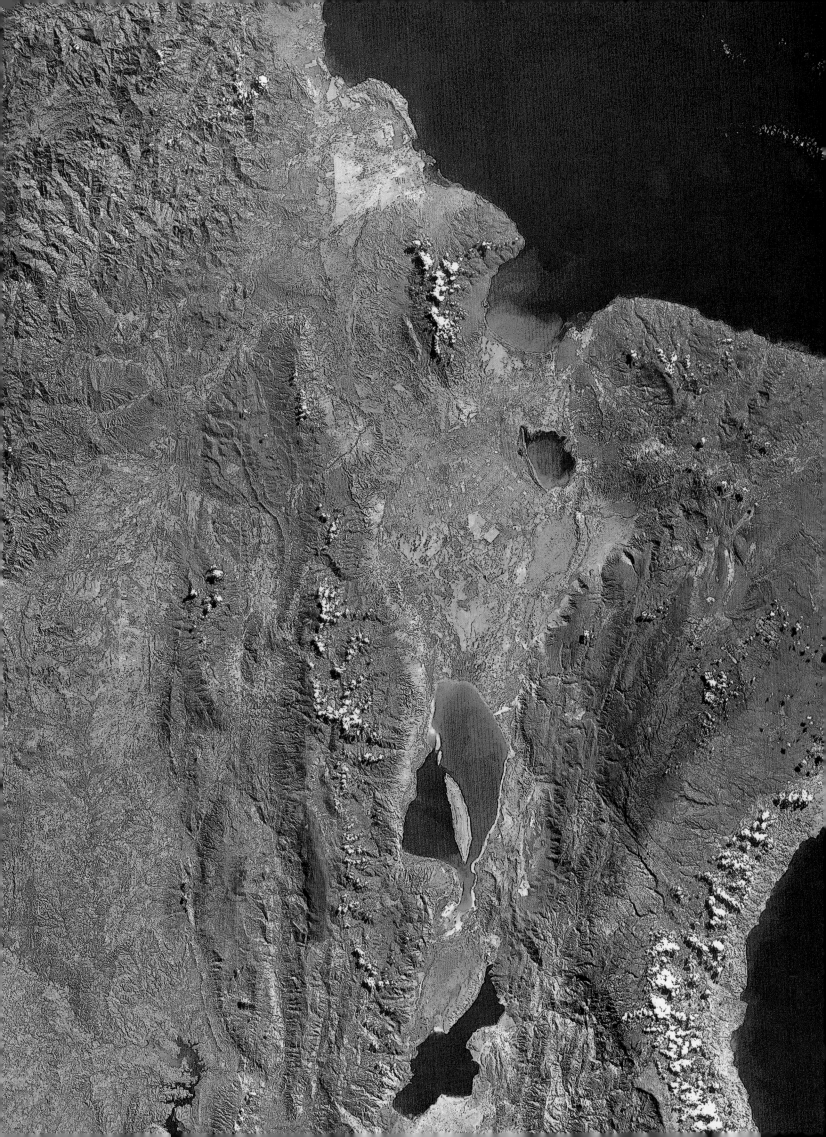

Forests and Plains
and some processing techniques

Most of the images shown so far have been constructed using only three of Landsat's four available bands of information: the yellow, red, and second infra-red. The first infra-red band, with a wavelength 0.70 to 0.80 micrometres, has been omitted completely. Usually, the false-colour image made from three bands is quite adequate for analysis of the scene. However, there are exceptions, and this section takes a look at some of them and sees what special processing can do to help.

Areas of the world that have few visible marks of human activity are often also inaccessible and therefore poorly mapped. In such cases, satellite images offer an attractive tool for initial reconnaissance, and mapping at scales under 4 miles to the inch. The production of such maps is usually easy when desert surfaces are involved, but in heavily overgrown regions accurate delineation of rivers and drainage systems, and distinguishing temporary agriculture from permanent features, is often difficult. This is when other data combinations and special processing is needed.

A Landsat scene is stored in a computer as arrays of numbers, with the brightness of each spectral band in each picture element of a scene given a value between 0 and 255. These arrays can be adjusted in various ways to produce more useful images when the brightnesses are transferred onto film.

First, and most elementary, the colours in the final image can be varied by altering the assignment of brightnesses that makes up each spectral band. Use of the computer to do this provides much more flexibility than is possible with usual photographic processes. For example, a different operation can be performed on each picture element, assigning brightness based on some test of the data. An example of this appears on page 117; the image is of an area in the United Arab Emirates, where we were interested in the water as well as the land.

If simple colour changes in one band are not enough, more complex operations are possible. Spectral bands can be added to each other, picture element by picture element, or they can be subtracted, multiplied, or divided. General combinations of the four bands are feasible, and each band can be multiplied by a different factor when they are combined. The image on page 105 shows how special band combinations known as eigenimages are useful for separating agriculture from natural foliage. Page 113 illustrates how an unusual combination of pairs of bands enables drainage patterns to be mapped in an area that is heavily vegetated and has a complicated topography. These unusual operations are of most value in forested areas. But as the example on page 67 showing part of the Namib Desert makes clear, their usefulness is not confined to such regions.

The more unconventional forms of processing are not used lightly. More elaborate processing requires more computer time to produce the image, and interpretation of the unfamiliar scene is much more difficult.

The Brazilian Interior

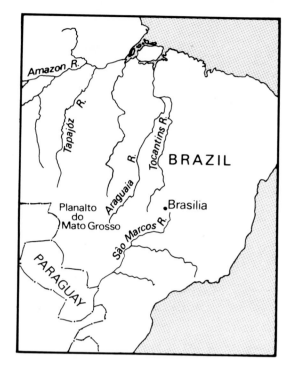

Brasilia is a planned city, 560 miles north-west of Rio de Janeiro. Since April 1960, when it was designated the future Brazilian capital, its population has grown to close to a million. The purpose in setting Brasilia so far from the coast was to stimulate the development of the country's interior, but after twenty years of effort the countryside around the city is still largely undeveloped. The western edge of the scene overleaf is 100 miles south-east of Brasilia, but there are no towns large enough to be visible, no roads, no signs of urban development.

In an area like this it is difficult to deduce much about human activities using standard false-colour images. Although river drainages stand out quite well in the standard image on page 104 as red tendrils of vegetation across the upper part of the scene, not much information is visible on agriculture or cleared areas, which simply appear in shades between dark green and a lighter blue-green. The Landsat information needs to be presented in a form that provides better discrimination between different ground surfaces. One way to achieve this is through principal component images, also called eigenimages, which use all four of Landsat's possible wavelength bands.

Some details may be lost in an eigenimage. The one reproduced on page 105 does not have the drainage pattern detail visible on the standard image. But it does have more diverse colours, and some of them are very significant. For example, on the far right, just below half-way down, there is a spot of bright blue that is unlike anything else in the picture. A close inspection reveals that it is a pattern of planted fields. The standard image shows no difference between that patch of crops and natural vegetation further north. In the same way, cleared areas show on the eigenimage as patches of dark blue, and grasslands or eucalyptus plantations as orange. They are both green on the standard image.

Before we can really make use of this new type of image, 'training' areas are needed — places where we know what is on the ground. These can be just small samples; once they have been drawn, the assignment of a class of ground cover to the whole of the rest of the image can be done quite easily. In fact, analysis of the image can be done by computer. The user specifies the training area and its ground type, and the computer produces, without further human intervention, an image in which every part of the scene has been assigned to its appropriate ground class; and it can process five, ten or twenty different bands of information, such as images recorded on several different days, simultaneously.

N

Image scale and date: 1 inch = 8 miles, July 1975

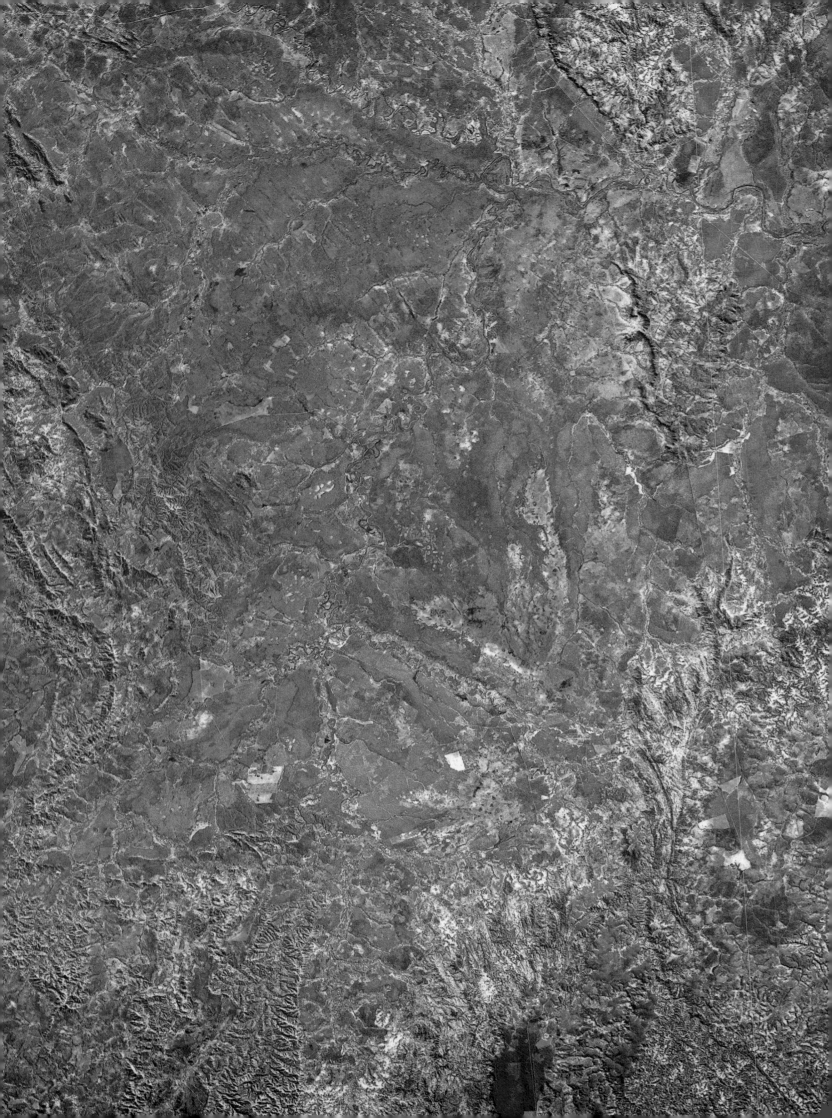

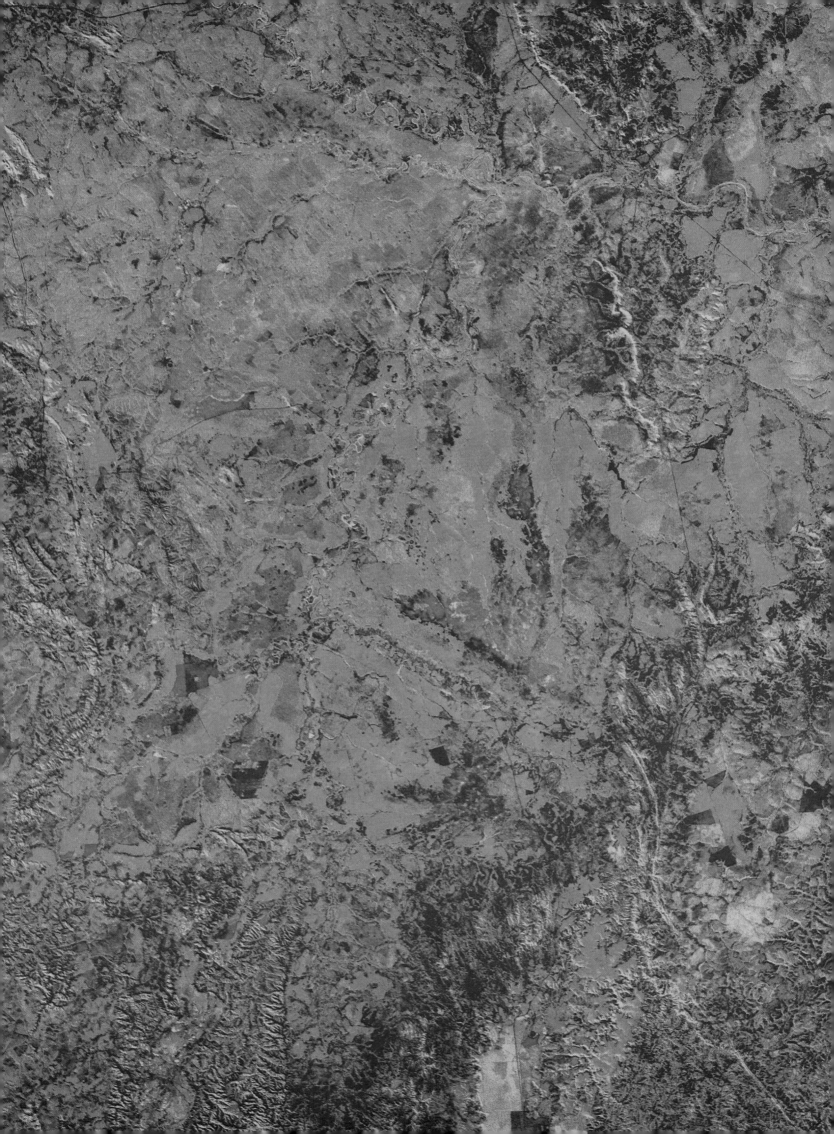

British Columbia and the Fraser River

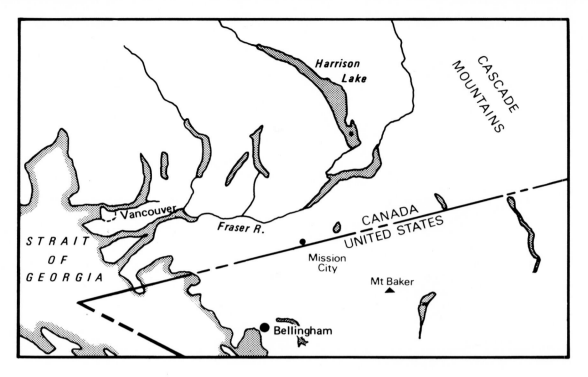

The border between the United States and Canada runs along the 49th parallel, close to the bottom of this image. On the extreme left is Vancouver, Canada's third biggest city, foremost western port, and western terminus since 1887 for the Canadian Pacific Railway. The city lies on the Strait of Georgia, just visible at the bottom left, and the Fraser River runs west as a blue ribbon from the mountains. The black strips are lakes. It was the discovery of gold here in the 1850s that stimulated the development of the whole area.

South of Vancouver and extending as far as Mission City on the U.S.–Canada border is a low-lying agricultural plain, the delta of the Fraser River. The soils are up to 1,000 feet deep. However, it is clear that further inland and to the north the country is much higher because we do not expect to see snow at sea level in June, when this image was recorded, at 50 degrees north. This raises the question whether satellite images can be used to provide information on altitudes. The Landsat spacecraft records images of areas directly beneath it. Thus the only chance for a stereoscopic view occurs in the limited overlap that comes from successive days' images, where a small part of the surface is common to each of the two pictures. But the difference of viewing angles is so small that good assessments of height are not really possible.

This scene points out the value of snow cover. Just the right amount, as in this picture, delineates the peaks and valleys beautifully. The topography of the whole area can be defined, from the eastern hills down to the plain on which Vancouver stands. At northerly latitudes, when the sun is low on the horizon, a light dusting of snow reveals the lines of geological faults.

Two things must be allowed for when drawing a map from an image like this: snow lingers in shadowed valleys, and it persists longer on north-facing slopes. These facts must be taken into account when the contours are plotted.

Image scale and date: 1 inch = 8 miles, June 1974

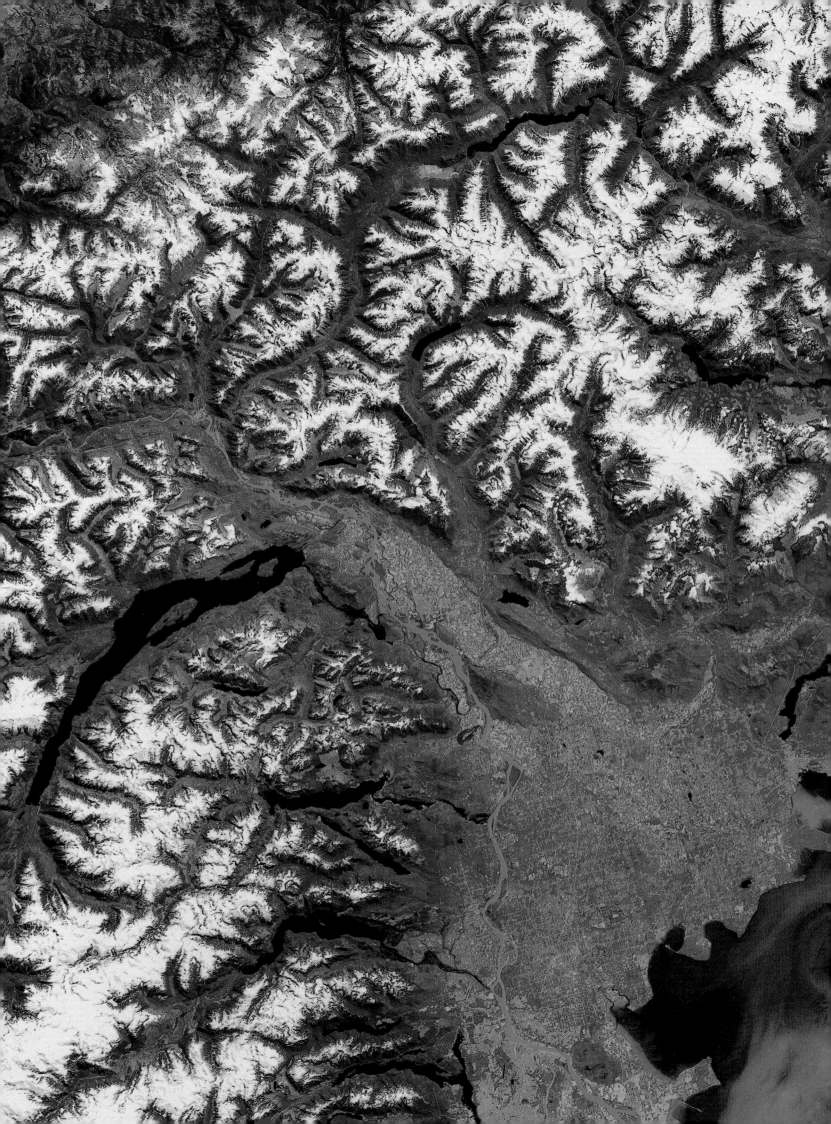

Geological Mapping from Landsat

This area has not been identified here because it is the subject of active mineral exploration. The image shows a region where conventional maps are outdated, and where geological maps in particular are unreliable. Although satellite images show only the ground surface, they can be used to define the geology of an area. Sometimes the season of the year determines whether or not an image is useful in this respect.

The wriggling mass of red threads seen here are streams and rivulets and their surrounding vegetation. The green background is soil and dry grass. In this part of the world, the rainy season begins in late October. The date of the image is 21 October; the dry season is ending, and the mountains to the west are providing the large number of east-flowing streams in the floodplain shown on the image with the wet season's first run-off. Most of the water runs to the larger river visible as a blue line on the bottom right. The timing for acquisition of this scene was crucial. One month earlier the small streams would not have had the fine lines of vegetation seen along their banks. One month later the vegetation would have been everywhere as dense as it already shows in the western mountains.

Now for the key observation: each east-flowing stream is full of meanders, readily plotted from the vegetation. The number of changes in direction varies as we move east across the image. The 'meander frequency' correlates with the underlying rock strata. The streams back up behind slightly higher areas caused by rising thrust plates and associated folding. By plotting meander frequencies for different streams, thrusting and folding trends running from north-east to south-west can be inferred. The result is a Landsat-generated map of geological structure showing continuing folds and thrusts up to forty miles further east than geological maps of the area indicate.

Until there is some form of ground check, the statements made here remain speculative. However, while this particular example may be open to question, the general principle is not.

N

Image scale and date: 1 inch = 8 miles, October 1972

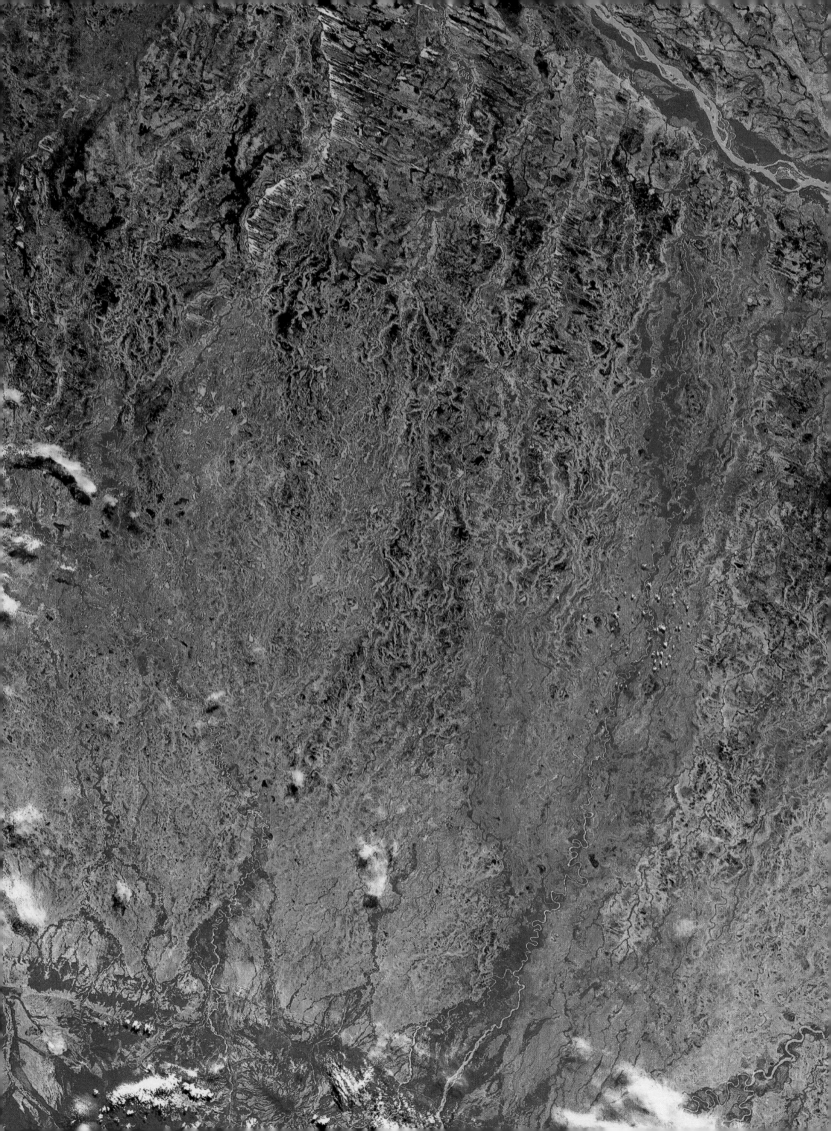

North Tanzania

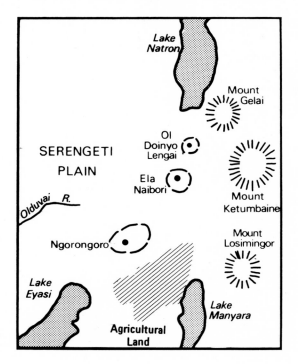

Lake Natron, the blue-white area at the northern edge of this scene, lies on the border between Tanzania and Kenya. Like Lake Eyasi further south, it is a 'soda lake', rich in sodium and potassium carbonates. The third prominent water body in this part of Tanzania is Lake Manyara, a salt lake. The triangle bounded by these three contains one of the most diverse and interesting parts of the African continent.

In the left centre of the scene, the Serengeti Plain shows as a great area of blue-green country. It holds one of the world's greatest concentrations of animal life and is now mainly a game reserve. The plain gives way in the south-east to bright red forest areas with Ngorongoro crater, itself a famous home of African wildlife, at the centre. Ela Naibori lies to the north. Both volcanic craters hold lakes, seen as blue-black on the picture. Between Ela Naibori and Lake Natron rises the blue cone of Ol Doinyo Lengai, the 'House of the Gods' to the Masai. The volcano erupted in 1960, producing carbonates, and there are only slight traces of vegetation visible now north of the main peak as tiny red dots.

The forested mountains on the right of the scene are Mount Ketumbaine, Mount Losimingor, and Mount Gelai. Each is less than 10,000 feet high, with Mount Gelai just under at 9,000 feet. Kilimanjaro, Africa's highest mountain, lies just off the image, eighty miles to the east of Ketumbaine.

The north-south trend of the Great African Rift Valley is very easy to see on this picture; it runs from the east shore of Lake Natron straight down to Lake Manyara. The forests west of the Rift are the home of the Manyara lions, the only members of this species that normally climb trees. Further to the west is a broad area of dark green agricultural land that at this time of the year is largely fallow.

Just above Lake Eyasi on the left side of the image lies Olduvai Gorge, a dark red and blue streak. It was here that Louis and Mary Leakey discovered the early human remains of *Homo habilis* and *Australopithecus boisei*, which dated man's emergence almost 2 million years ago, much earlier than previous estimates. Later discoveries at Olduvai Gorge, Lake Natron, and Lake Turkana, which is 350 miles to the north, support this.

Image scale and date: 1 inch = 8.3 miles, January 1976

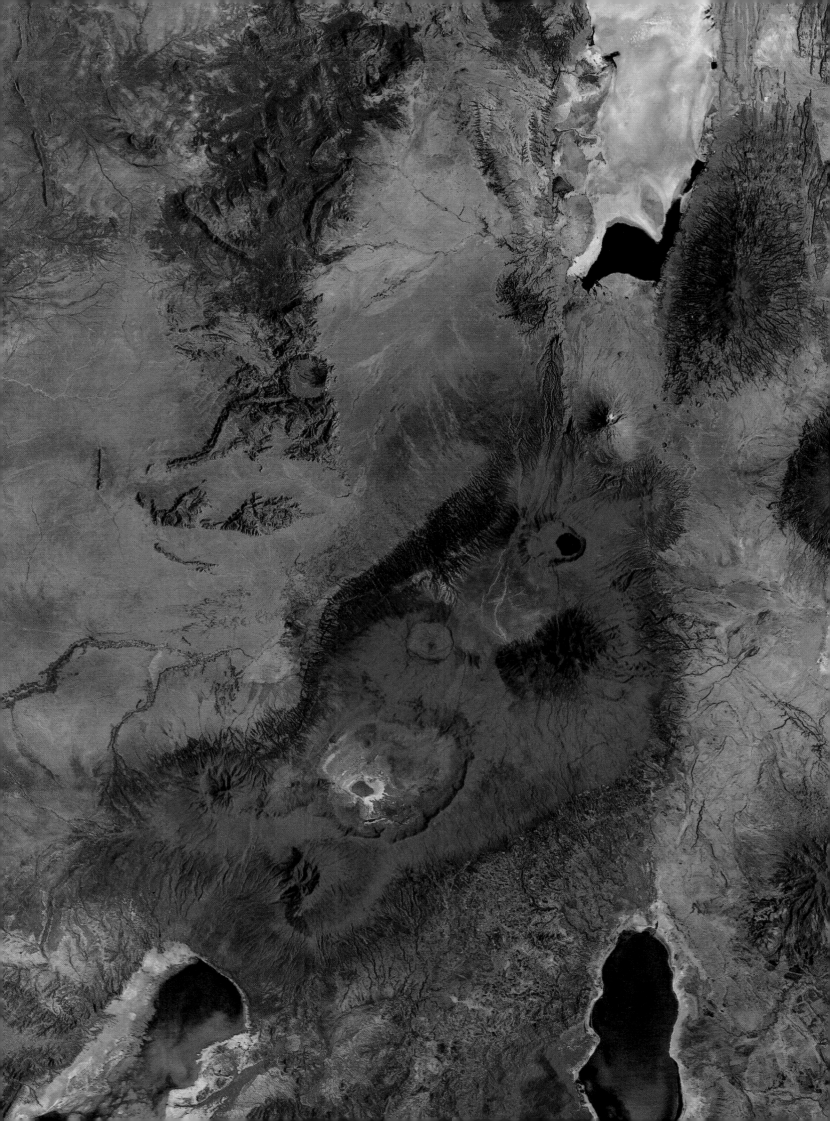

The Mato Grosso

Mato Grosso, the 'great woods', is a state of west-central Brazil, a huge area of almost half a million square miles.

This part of the world is little developed. No towns or roads are visible, and on the standard false-colour image shown on this page all that can be seen is dense red vegetation and blue-grey soil. This is not very useful for defining rivers and valleys and understanding the area's geology. The special processing techniques mentioned on page 102 were therefore used and the result is shown opposite.

The chief purpose was to obtain information for good river drainage maps rather than land cover and rock types. A special form of pseudo-ratio image was generated. The method can be thought of as an unusual form of contrast adjustment that works with pairs of Landsat spectral bands rather than with single bands. All the picture elements in the image with the same overall brightness (i.e. the same sum of brightnesses in two bands) are first grouped together; then within this group the differences in the brightnesses of the two bands is increased so that the resulting brightnesses span the full available range of contrast. The result is a new picture, one band of the pseudo-ratio image. In this image, the pseudo-ratio operation was performed first for the yellow and the first infra-red band, to create one new spectral band; then for the red and second infra-red, to create a second one. Finally, the two new bands were combined to form a colour picture. The result gives a first-rate enhancement of the draining patterns.

Prior to 1971, all the available maps of this area were of doubtful accuracy. The area was so large, and the canopy of vegetation so dense, that quite substantial streams could remain unnoticed in aerial photographs. To remedy this, the Brazilian Government in 1970 undertook Project RADAM, an air radar survey of the whole Amazon basin. The radar images were able to penetrate the vegetation and the first reliable mapping of this area was performed. It is encouraging to find that in most places the results derived from special processing of Landsat images are in good agreement with those of the radar survey.

Image scales and date: 1 inch = 8 miles (above: 1 inch = 27 miles), October 1972

112

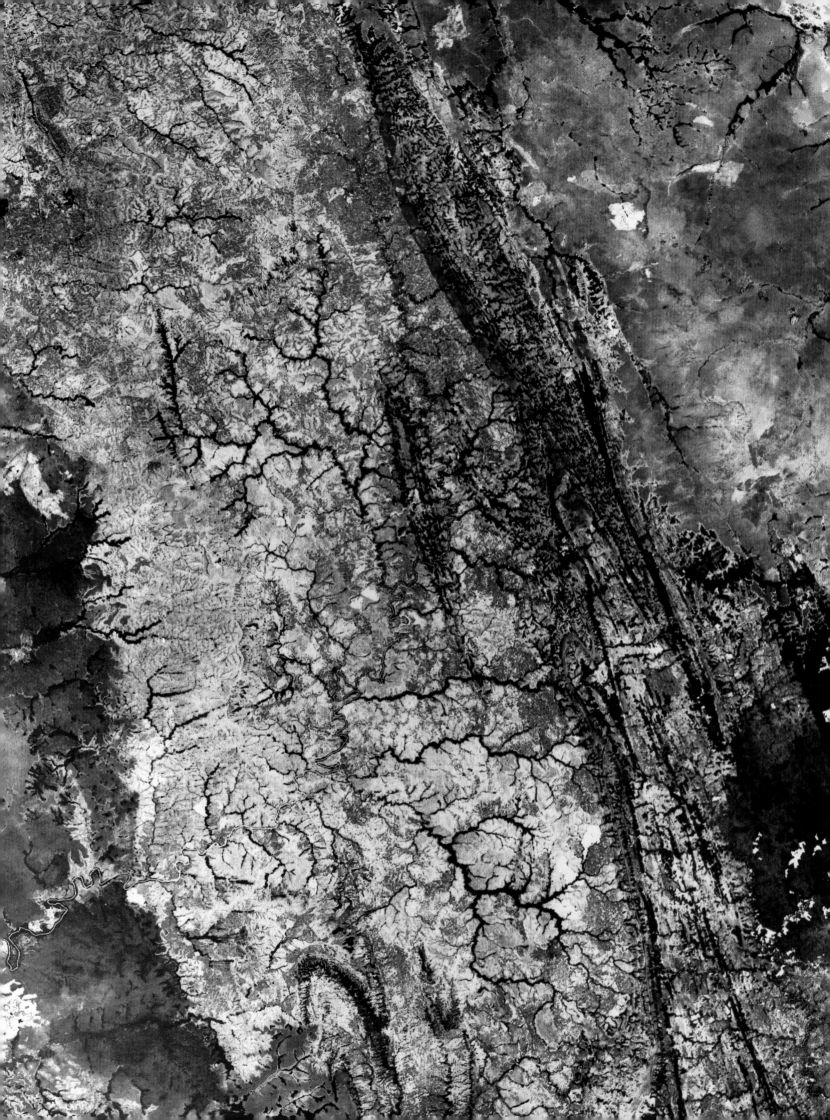

Vietnam and the Gulf of Tongking

Hanoi lies about 150 miles to the north of this image, which shows the Gulf of Tongking; the border with Laos is in the south-west quadrant of the picture.

The blue of Tongking Bay, heavily sedimented, and what looks like a wide expanse of shore line, is followed further inland by vegetated hills. The first conclusion might be that the shore area is sand, barren and unproductive, and that people live away from it, in the forested hills. The opposite is actually the case. The low blue plains are inhabited by something like 2,000 people per square mile, the uplands thirty or less. One of the main reasons for this distribution of population will not show on Landsat images, or even on the highest resolution aerial photographs. It is a small insect, *Anopheles minimus*, and it carries malaria.

The mosquito larvae develop in the upland streams. As a result, the people prefer to remain in the crowded lowland plains, cultivating them intensively. Inland from the sandy beaches (**1** on the map) is a broad area of alluvial soil (**2**), and it is on this that the main crops of the region − dryland and wetland rice − are grown. The largest production area is around the port of Vinh, extending north and south as far as the cities of Huong Son and Anh Son at the edge of the hills.

This is a January image. The main harvest takes place in December, and the spring crop has not yet appeared. In the low plains area, the high population requires that two or even three crops per year be planted in the same fields. By contrast, the few inhabitants of the uplands of the Annam Mountains and on the border of Laos practise a quite different method of agriculture, termed the *ray* system. It is much more primitive, a clear-and-burn technique, which results after a few years in the soil becoming depleted, making it necessary for the people to move on to farm a new area. The main crop is dryland rice, with some coffee. Cleared and burned areas show on the image in the uplands as small spots of blue.

Although most of the hills are forested, it is second growth. The *ray* technique for upland agriculture is steadily harming the hills, causing erosion, loss of soil, and a slow decrease in the fertility of the region.

As population pressure drives more people to the uplands, the rate of forest loss will increase. Already, there are large cleared areas in the south-west, where the blue tones indicate widespread loss of forest lands. And despite almost continuous warfare and economic upheaval, the population has risen from an estimated 27 million in 1957 to almost 48 million in 1979.

Image scale and date: 1 inch = 8 miles, January 1976

N

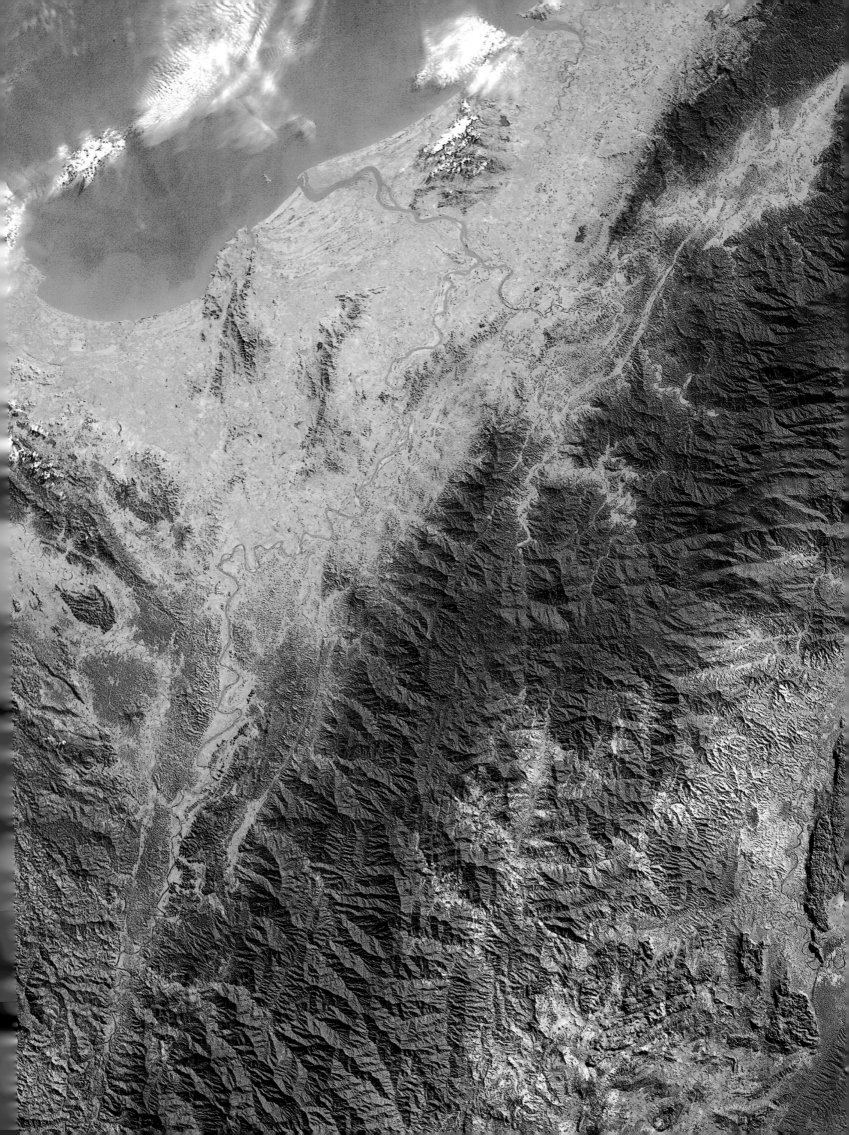

The United Arab Emirates

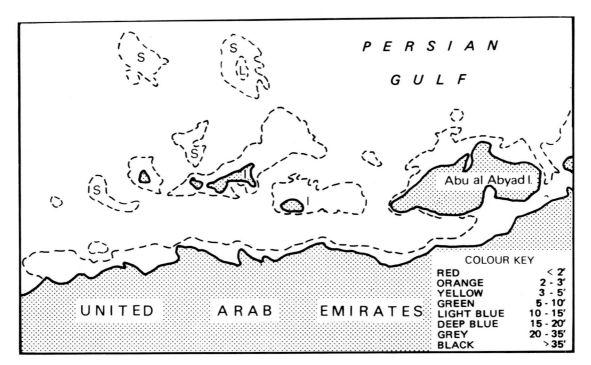

This image covers part of the shoreline and off-shore area of the United Arab Emirates, about thirty miles west of Abu Dhabi. This whole area is suspected of being rich in oil. The land is a potential source, but the oil may be off-shore, which means that the underwater contours are of considerable interest, too.

Landsat sensors are of limited use in looking at areas of water. If the waters are deep and clear, the signal received by the satellite shows black. Only if water is shallow or full of sediment will any detail show, and even then it will normally be shades of blue and green, difficult to evaluate or relate to the depth. Also, if a colour adjustment is performed on the image to gain greater detail in the water, less will be obtained on land.

A possible solution to the problem is reproduced here. Water is almost totally opaque to infra-red light; so infra-red bands of Landsat data can be used to test the image, picture element by picture element, to discover what is water and what is land. Once this is done, the computer can be instructed to process all land elements in the usual way and produce a standard-looking image of them. At the same time, colours are assigned to different water depths, which are established by the water's brightnesses in the yellow band (in clear water this correlates well with water depth). The overall picture that results looks like a usual image for the land, but the water-covered area shows contours.

The land shown here is a desert scene, and not a particularly striking one. Off-shore are colours corresponding to the water depth, from red (very shallow), through orange, yellow, green, light blue, dark blue, grey, and black (deep water).

The off-shore islands (**I** on the map) look, as they should, like land areas, but surrounded by beaches. In addition, shoals (**S**) are visible that are all below the water line, and also a lagoon (**L**) within a shoal. The overall correlation of colours with existing contour profiles of the seabed confirms that what is visible is the floor of the offshore area, not simply a distribution of sediments above it.

Image scale and date: 1 inch = 6 miles, October 1978

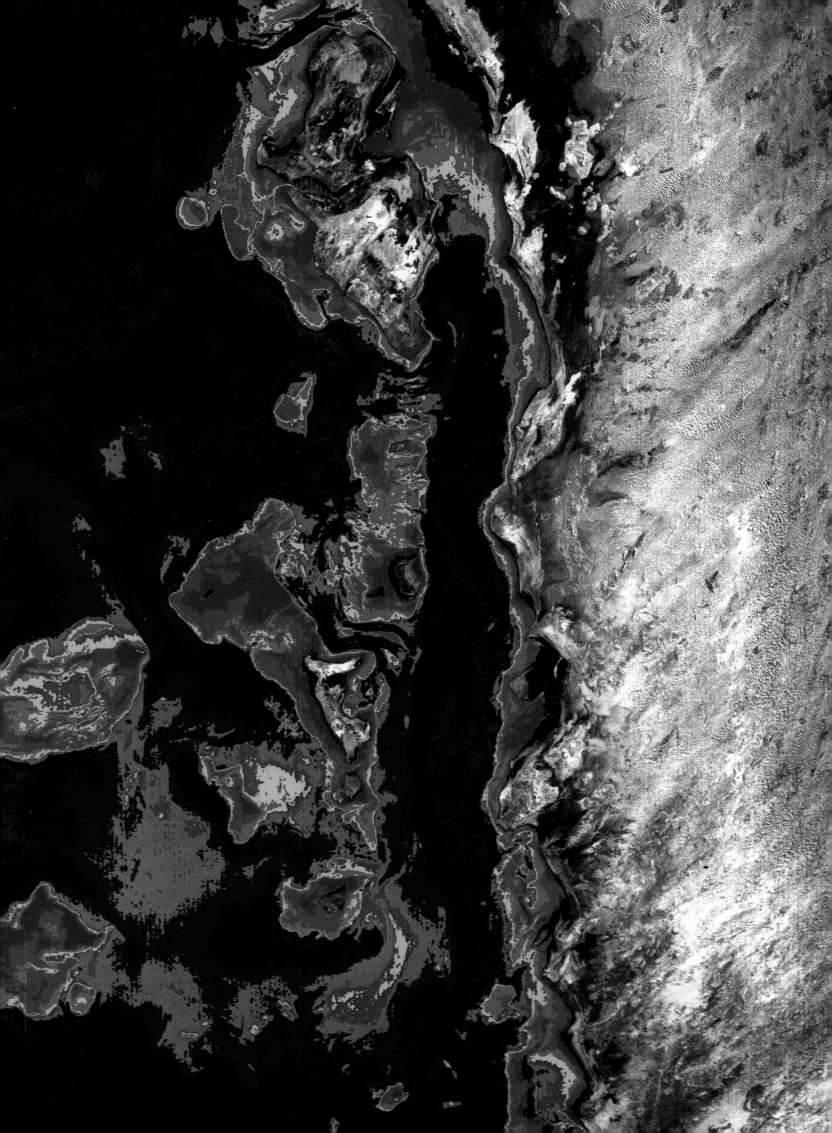

Bays, Capes & Harbours

Air travel has a lot to answer for. It has made journeys across and between continents quick and easy — and boring. One airport arrival lounge is much like another. After a glimpse of the ground during the final approach, there is not usually much to see when the aircraft has landed. Certainly, we may not wish to return to the old days, when storms, seasickness, and scurvy were unwelcome travel companions. But something has been lost now. Until half a century ago, seasoned world travellers of every era carried pictures in their mind's eye of a hundred special places. The great bays, capes, rivers and harbours were always fascinating: San Francisco Harbour and the passage through the Golden Gate; the skyline of Manhattan; Singapore Roads, alive with junks and trading praus; Rio de Janeiro, with lightning storms stalking the bay; the passage to the East along the pink granite mountains that flank the Red Sea; the foggy English Channel, echoing with the warning cries of ships and lighthouses; the winter Atlantic, silent icebergs sliding past.

To a nineteenth-century traveller, however, a landmark like Cape Horn was not a *sight*. It could not be. It was a name and a set of experiences (often unpleasant ones). The traveller could never see the Cape as a whole. The maps that fill atlases were acquired piecemeal, by patient men roaming the surface of the earth like ants on an apple, unable to perceive more than the tiniest part of the whole.

We are the first generation to see images of the whole earth; the first to see the Horn of Africa, Cape Cod, the Inland Sea of Japan, Chesapeake Bay, or the Sinai Peninsula, entire, as a single unit, as they looked at a particular moment. If space images have done nothing else, the perspective that they have given us of the earth would justify their existence. And the new and lofty viewpoint, apart from practical utility, offers its own pleasures.

San Francisco Bay

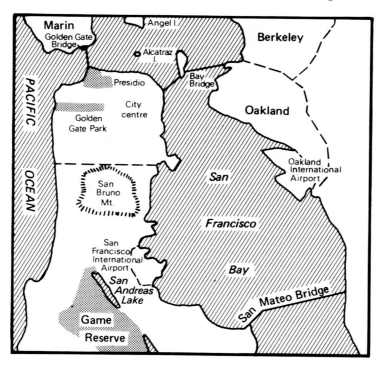

For two hundred years, San Francisco has enjoyed a reputation as one of the world's finest harbours. The image on the following pages shows why.

The city of San Francisco is the blue peninsula to the left of the picture, heavily urban with residential and office buildings. Across the bay to the east lie Oakland and Oakland Airport, with the Bay Bridge between the cities visible as a thin blue line. To the north is the Golden Gate, the narrow strait that connects the bay with the Pacific Ocean. The Golden Gate Bridge runs from San Francisco to Marin County and Sausalito.

South of the city, the San Andreas Lake provides a reminder that this peninsula sits right on a famous geological fault line and suffered a disastrous earthquake in 1906. The San Andreas fault continues south-east from the lake as a dark line on the picture, passing south of the blue-grey urban areas of San Jose and Palo Alto at the end of the bay. The colourful areas of water here south of the San Mateo Bridge are salt evaporation ponds.

Between the San Andreas fault and the Pacific lie the Santa Cruz Mountains, red with oak and chaparral. These mountains, like the coastal range to the east, will become dry later in the year and their vegetation will fade to a drab grey-green. At the same time, the irrigated valley of the San Joaquin River in the upper right of the picture will change from its blue and red mixture to a continuous swath of red, as early crops grow and mature.

The small bay just west of the San Joaquin valley shows a curious line of short blue dashes in the water. They are Liberty ships, relics of the Second World War, now in long-term storage in the unlikely event that they will have some future use.

Many familiar landmarks lie close to the centre of San Francisco. The twelve-acre island of Alcatraz, a prison no longer, is a small blue dot in the bay between the city and Angel Island. South of Alcatraz, the jetties of Fisherman's Wharf stand out into the bay, and the city streets show their criss-cross pattern. The long red rectangle of Golden Gate Park is just to the south, and what looks like a park below the Golden Gate Bridge is Presidio, a U.S. Marines post. The red area of the San Bruno Mountain further south marks the city boundary. San Francisco Airport appears a little lower down, jutting out as a distinct cross into the waters of the bay.

Image scale and date: 1 inch = 6 miles, May 1973

N

The Horn of Africa

The Somali Republic is the easternmost country in the African continent, jutting out into the Arabian Sea with the Gulf of Aden to the north and the Indian Ocean to the south. The north-east tip of Somalia forms the distinctive shape of the 'Horn' of Africa, shown on this image. The coastline to the right of the picture continues to curve gently eastwards for a few more miles, to become the eastern point of Africa at Ras Hafun peninsula, just off the image.

The pale pink tinge that suffuses the browns over the middle of this scene indicates that the area is rather arid and unvegetated without being total desert. The pinker zone ends in a well-defined line, and north of it, in the triangle formed by Alula, Ghesselei, and Cape Guardafui, true desert conditions exist, with much reduced plant life.

The increase in fertility in the central uplands is mainly the result of increased rainfall, which runs from 20 inches per year above 4,000 feet down to less than 3 inches on the coast of Cape Guardafui. As the colour of the image would suggest, the hills are very close to the coast at Cape Shenaghef, which enjoys correspondingly higher rainfall. Elsewhere on the coast is the bright white of sand areas (**S** on the map), at Cape Guardafui, Ras Binnah, and Filuch.

The image shows no signs of fields and agriculture. The people are pastoral in this area, relying on camels, sheep, cattle, and horses that sustain themselves on the plateau vegetation. Apart from the grasses, the high land between Cape Shenaghef and Durbo in the west supports acacias, gum trees, and euphorbias. The soil in the whole area is generally poor, with rapid evaporation of rain causing caking with salts, and overgrazing and occasional torrential rain leading to rapid soil erosion. The white dendritic patterns on this October image are watercourses, most of them dry gulches and wadis at this time of year. The lower part of the picture from Botiala to El Gal to Saladegh is a lower and drier area, which gives way in the south-west to another upland plateau rising to 7,200 feet at the edge of the scene.

Somalia is one of the poorest nations on earth; it is ironic that its name is thought to derive from the Arabic *zu mal* – 'the possessors of wealth'. Perhaps this will become true in the future. The country has mineral resources, still undeveloped, of tin, iron, bauxite, titanium, and uranium, and international interest in prospecting there runs high. The country's position at the head of the Gulf of Aden also gives it strategic significance.

Image scale and date: 1 inch = 8 miles, October 1978

N

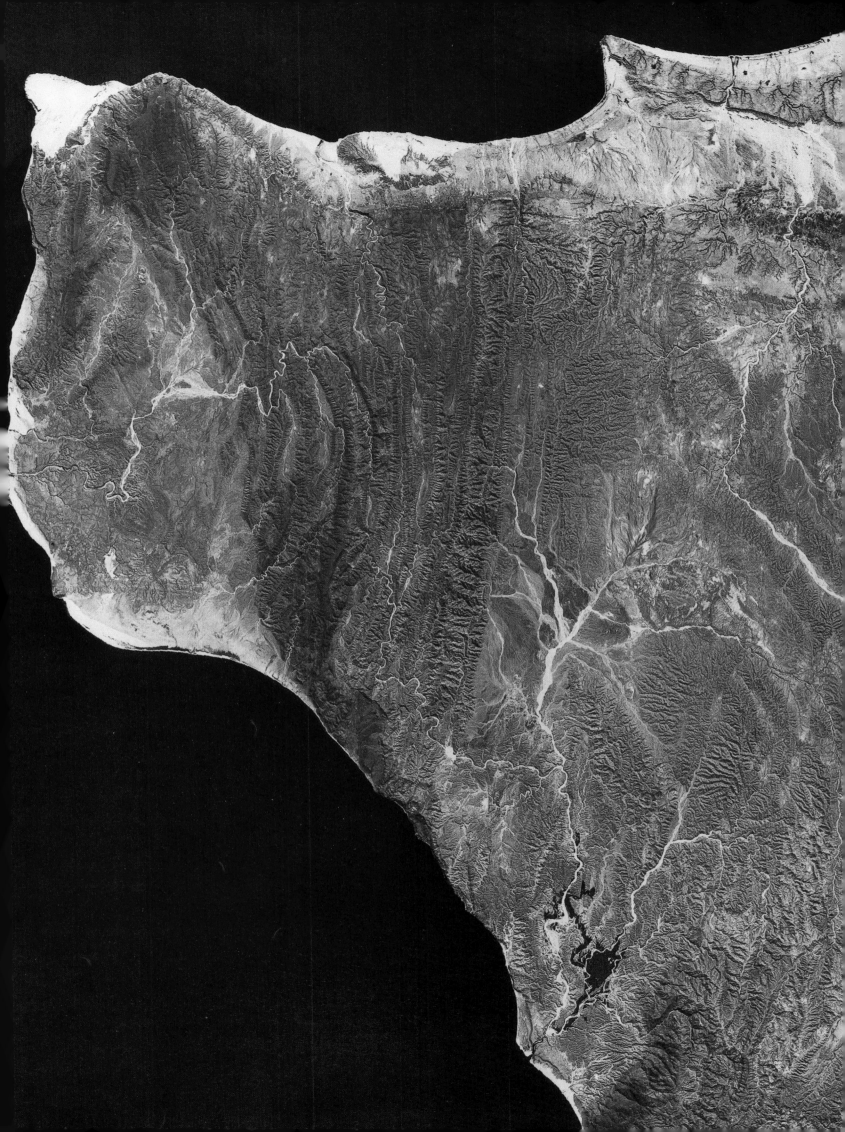

Osaka and the Inland Sea

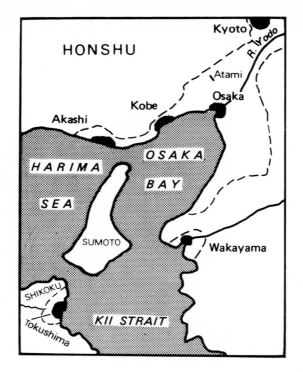

Japan's Inland Sea, the *Seto Naikai* or sea without straits, runs 300 miles from Shimonoseki in the west to Osaka in the east. It is bounded by Shikoku Island to the south, Honshu to the north, and Kyushu to the west, and it was created by the faulting and subsidence of Japan's seismically active surface.

This image shows Osaka Bay and the eastern end of the sea. The broad areas of blue-grey on this scene point to a tremendous concentration of population and industry. Osaka is Japan's second largest city, with 2.8 million people, and it is surrounded by other industrial centres. The main city stands at the northern end of Osaka Bay, in the delta of the Yodo River whose main outflow to the bay is clearly visible on this image. Osaka is intersected by numerous rivers, seen here as thin black lines, and crossed by hundreds of bridges. Only a couple of these, across the Yodo River itself, are visible on the image.

Urban growth extends from Osaka in all directions. North-east lies Kyoto, once the capital of Japan, for which Osaka served as the seaport. To the west is Kobe, the largest port on the Inland Sea. West of it, as a continuous strip of urban blue, the development goes all the way to Akashi, while in the east Osaka extends almost to Wakayama and the strait to Sumoto Island. The 'islands' of blue-grey that are visible on this eastern shore of Osaka Bay are great man-made wharves. There are few details to be discerned within this continuous urban development, but Osaka Airport at Atami can be detected as parallel blue streaks with a faint pink border of vegetated area.

The island of Sumoto standing between Osaka Bay and the Harima Sea has so far escaped extensive development, mainly because many areas on it are part of the Seto Naikai National Park. North of Sumoto, on the mainland of Honshu, the red vegetated area directly between Kobe and Akashi is similarly protected.

The volume of pollution generated by the industrial ring of Osaka Bay places a great burden on the Inland Sea. The cleansing influence of the Pacific Ocean through the Kii Strait is vital to keep the inland waters pure enough to support the active fishing industry. Even with this, however, fishermen report a familiar pattern: catches are falling as pollution gradually increases.

Image scale and date: 1 inch = 7.1 miles, April 1978

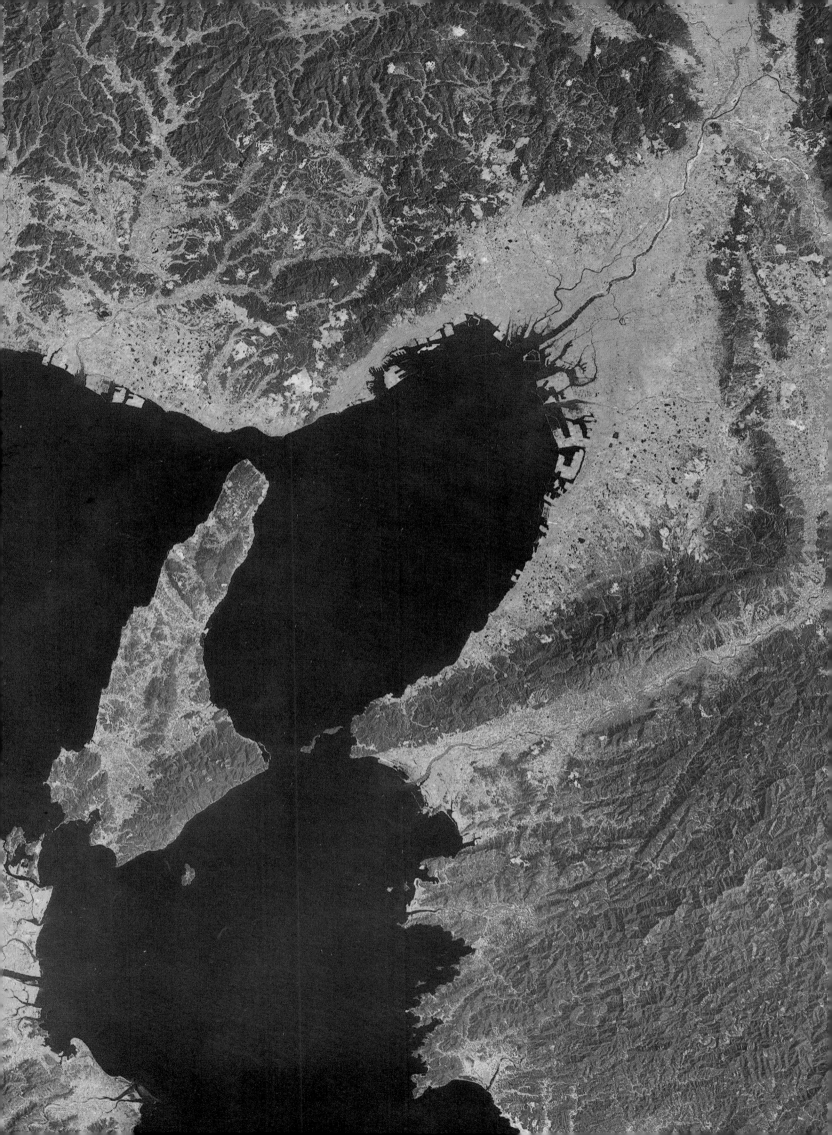

The Sinai Peninsula

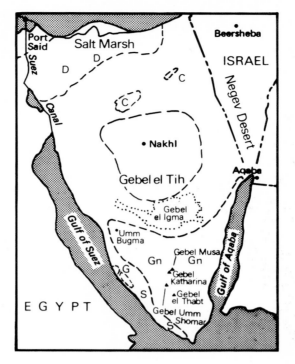

The picture of the Sinai Peninsula on pages 128–9 is a mosaic. Like the Chesapeake Bay scene on pages 130–1 and southern Libya on page 146, it was created from several separate Landsat images by matching them at suitable boundary areas.

Creating a mosaic of this type presents two main problems. First, it may not be possible to obtain images that were recorded close in time because cloud cover or other constraints interfere. As a result, changing sun angles and atmospheric conditions lead to images that have different tones and colours. Careful photographic processing of each Landsat frame will compensate partially for these differences, but matching colours will still be a problem.

Second, when several Landsat images are pieced together, they do not fit exactly. This is quite natural. The earth is a sphere, but it is being represented on a flat piece of paper. This is not a problem with a small area, say as large as a single Landsat image, but the earth's curvature becomes much more noticeable when creating a mosaic.

The Sinai Peninsula picture is made up of eight separate Landsat images. The effects of earth curvature are tolerable, but the problem of tonal matching leads to some 'boundaries' that represent the process of making a mosaic rather than true tonal changes on the earth's surface. The reason for creating a mosaic is that it gives a uniquely broad view of the geology and structure of the whole of a large region, showing changes of surface and terrain that cannot be grasped from a succession of single Landsat scenes.

The area shown extends from the Suez Canal and the Nile delta in the west, to the Gaza Strip and the Negev Desert in the east. It covers an area of about 30,000 square miles, a triangle bounded by the Mediterranean, the Gulf of Suez, and the Gulf of Aqaba. The inset is an enlargement of the Suez Canal, including a portion of the Nile delta in the west.

Beginning in the south-west along the Gulf of Suez, there is a narrow plain of smooth grey tone (**S** on the map) between the mountains and the sea. This is sedimentary rocks of recent origin, ending in the north at Wadi Feiran, where pinkish-grey cliffs rise from the shoreline. The cliffs are red granite (**G**) and their presence here and elsewhere to the south give the Red Sea its name. Inland, extending across to the Gulf of Aqaba and with a clear line separating it from the shore rocks, is a darker pattern of grey and brown. This is Precambrian material (**Gn**), gneisses and schists with intruded masses of granitic rock. The highest part of the peninsula is in this area, including the granite peaks of Gebel Musa (Mount Sinai) (7,495 feet), Gebel Katharina (8,651 feet), Gebel Umm Shomar (8,482 feet), and Gebel el Thabt (7,997 feet). The whole region shows as dry with precipitous peaks and gorges. The few inches of rain that fall each year run off as torrents and are not enough for agriculture.

North of here is an area of finer grain and lighter tone – the Gebel el Igma, the highest part of the gravel-covered limestone plateau that makes up the centre of the peninsula, Gebel el Tih ('The Wandering'). The braided pattern of wandering riverbeds choked with gravel shows in an unmistakeable set of light lines over the whole area.

Further north, beyond Nakhl, are outcroppings of Cretaceous older rock (**C**), which gives way in turn to a broad tract of light tan dunes (**D**), some as high as 300 feet, along the Mediterranean coast. They extend from the Suez Canal, past the growing salt marshes on the shore, on as far as the Negev Desert.

The Sinai Peninsula is far more valuable than its barren appearance might suggest. Beneath its arid surface are oil, phosphates, iron, gold, manganese, titanium, and kaolin.

Image scales: 1 inch = 15.3 miles (inset: 1 inch = 7.6 miles)

The Chesapeake Bay

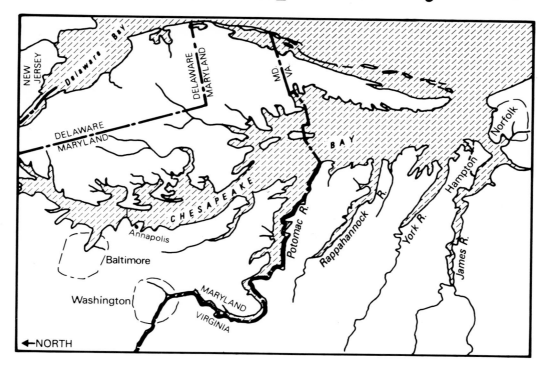

'Heaven and earth never agreed better to frame a place for Man's habitation.' That was Captain John Smith's reaction when first he explored and mapped the Chesapeake Bay in 1608. It is easy to understand his enthusiasm. He found a huge and fertile area, 2,500 square miles of shallow brackish water, full of fish and well protected from the Atlantic Ocean. The bay's 8,000 miles of shoreline were covered with vegetation and its rivers and inlets provided hundreds of easy landings.

The image of the great bay on pages 130–1 is a mosaic of four different Landsat scenes, all acquired on two successive days in October 1972. The overall impression of the bay makes it clear that this is a drowned river valley, slowly sinking below sea level. Many of the islands in the bay are eroding; approximately 100 square miles of land has been lost in the last century. In the long run, 20–30,000 years from now, the sediments that are visible as light blue tones on the image will be deposited, the trend will reverse, and the bay will fill to form a huge river delta.

This projection assumes that in that time nothing will modify the natural course of events. But as this scene makes clear, since Captain Smith's time people have already made drastic changes to the whole area. The most obvious ones are the areas of intensive urban development that are visible as blue-grey patches in many parts of the picture. Baltimore at the top of the image, Washington to the left, and Hampton and Norfolk in the south are urban centres each housing over 1 million people. In addition to these main concentrations, hundreds of thousands more homes lie along the Potomac, Rappahannock, York, and James rivers. Disturbance of the land for homes and industry adds masses of sediment to the natural flow that reaches the bay. One estimate reckons that each new house built around the bay contributes an additional four tons of sedimentary outflow.

A second significant change from the situation in 1608 can be seen most easily on the eastern shore, the 'Delmarva' peninsula where Maryland, Delaware and Virginia each control part of the land. The numerous light blue patches amongst the red vegetated fields are newly harvested areas. The run-off of pesticides and fertilizers into the rivers that feed the bay have produced great changes in the water quality, with significant loss of fish and shellfish. The catches of shad, striped bass, crabs, and oysters are diminishing year by year.

With the population of the bay area projected to double and more in the next forty years, the pressure on wildlife living conditions will inevitably become worse unless very positive measures are taken to control the effluents that enter the bay. A few years ago, the dumping of the insecticide Kepone into the James River closed part of that area to all fishing. The vulnerability of the whole bay to human activities has been clear ever since.

There is other information on this image that is worth noting, since it illustrates some of the resolution properties of Landsat images at this scale. The Chesapeake Memorial Bridge leading from near Annapolis to the Delmarva peninsula is just visible, even though it has a width much less than the minimum field of view of the satellite. The bridge stands out because it is a high contrast object, a bright line against the dark water background. However, much larger ground features, such as the Baltimore-Washington International Airport, south of Baltimore, cannot be seen. They are large enough, but they cannot be separated from the general urban clutter in the area.

N

Image scale and date: 1 inch = 11.8 miles, October 1972

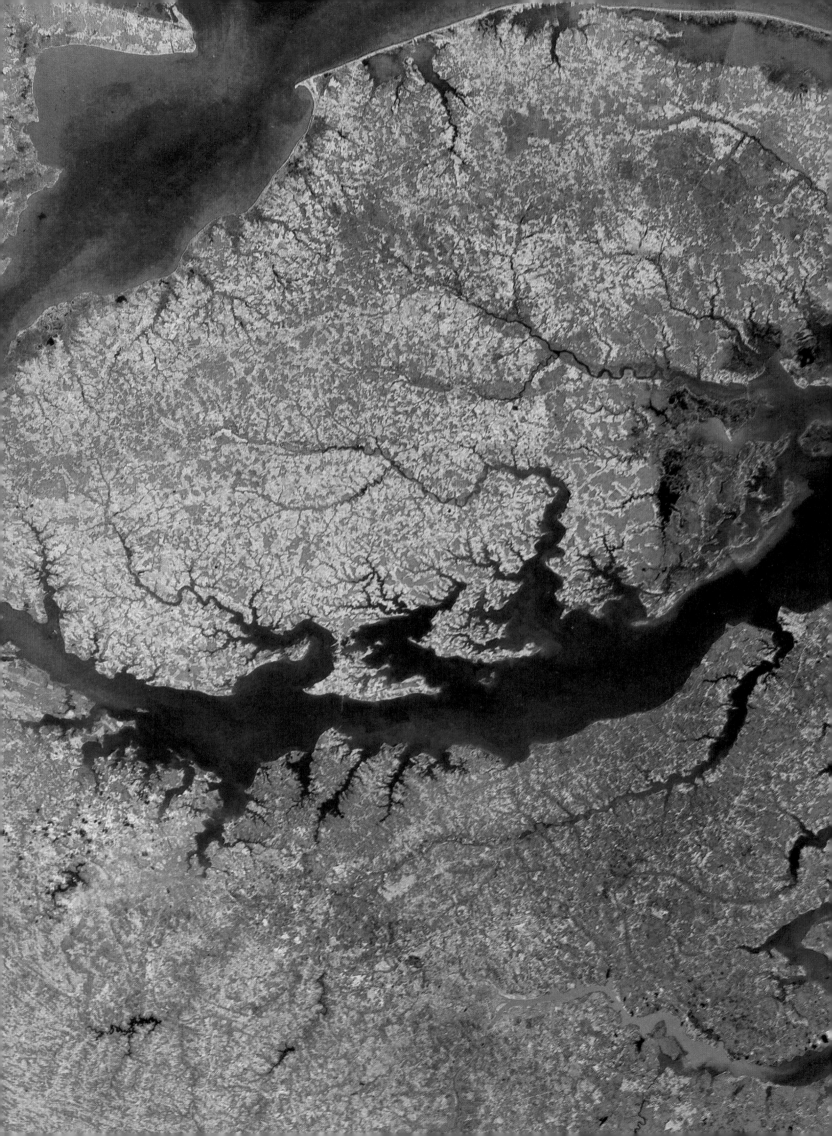

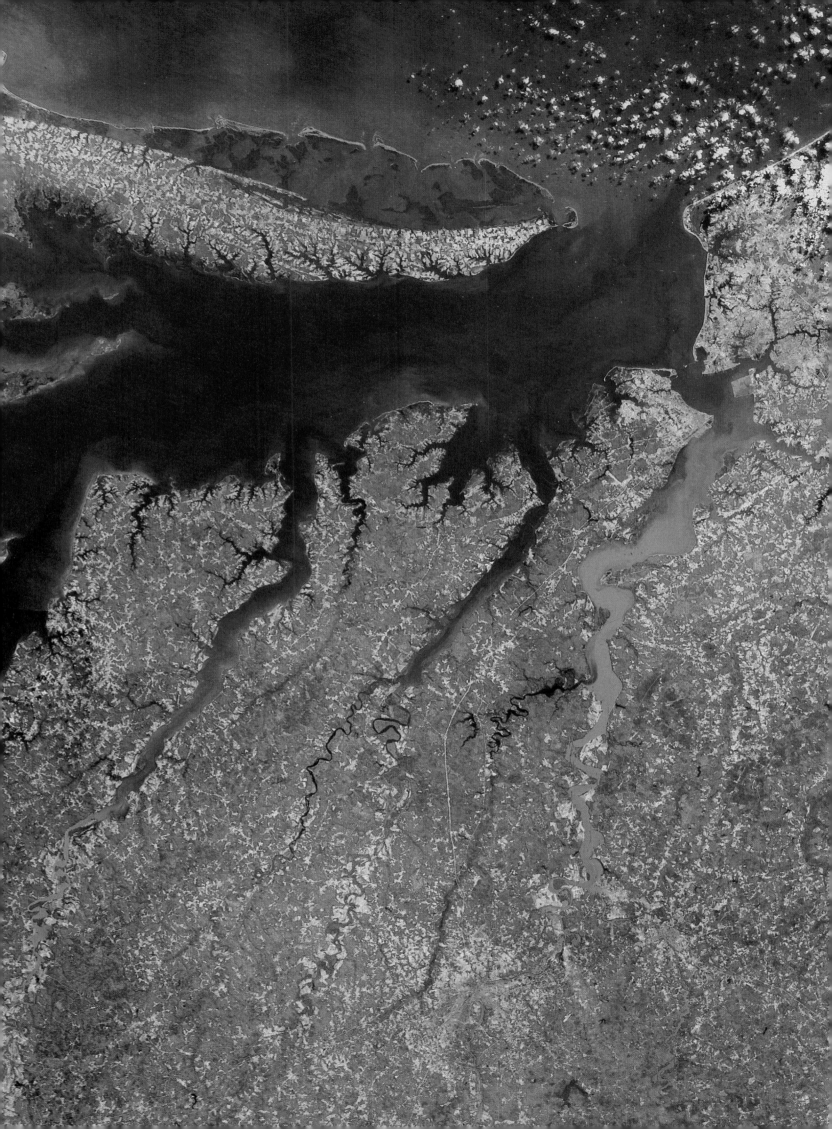

The Gulf of Chihli

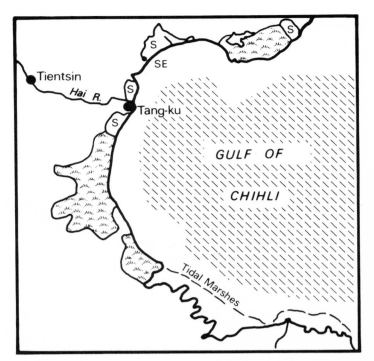

Images obtained by earth resources satellites lack the resolution that is needed for military surveillance work. Aircraft, small ships, tanks, and troop columns are too small to be seen, still less identified, using a Landsat image. What Landsat can offer in place of extreme detail is a good broad view of a large area. If we are interested in development and change at a city or county level, the power of such a synoptic view can be surprising. The image shown here offers an example. It is of the city of Tientsin (Tianjin) and the Gulf of Chihli (Bo Hai).

Tientsin lies in northern China, a city seventy miles south-east of Peking. It is a major industrial centre, and it has grown rapidly over the past thirty years to its present population of 4.4 million people. The city joins to the bay via the Hai River, and the feeder port of Tanggu is on the bay itself, twenty miles from Tientsin.

From the time of the United States trade ban with China in 1950 until the resumption of diplomatic relations in 1973, detailed U.S. maps of the Chinese mainland were often out of date and inaccurate. The map on this page was taken from a medium-scale map (1 inch = 16 miles), made in the middle 1960s and giving the best publicly available information at that time. The differences between this map and the 1976 Landsat image are striking. The whole northern profile of the Gulf of Chihli has changed. On the image, the huge salt ponds and evaporation pools (**S** on the map) are more numerous and are in areas that were previously swamp. At the same time, other swampy areas have been drained and are now useful land. In the south, reclamation has reduced the area of greenish tidal flats and solidified the tidal marshes. Notice that the star shape of the great salt evaporator on the west shore of the bay is still there, and easily visible on the image (**SE** on the map).

Inland, the city of Tientsin has grown substantially, extending as a dark patch further along the Hai River towards the bay. Canals and inland waterways have become more numerous.

The splendid blue-green of the whole bay is due to its shallow and turbid water. The Yellow River discharges into it just south of here and adds a heavy load of sediment. This sediment is not easily dispersed, since east of the image area the northern shore curves round the line of the bay to become the Luda Peninsula, leaving only a narrow strait between the bay and the Yellow Sea.

The pattern of brownish dots visible on the lower part of this image is electronic noise, introduced when the image was first received at the ground station.

Image scale and date: 1 inch = 8.5 miles, March 1976 N◀

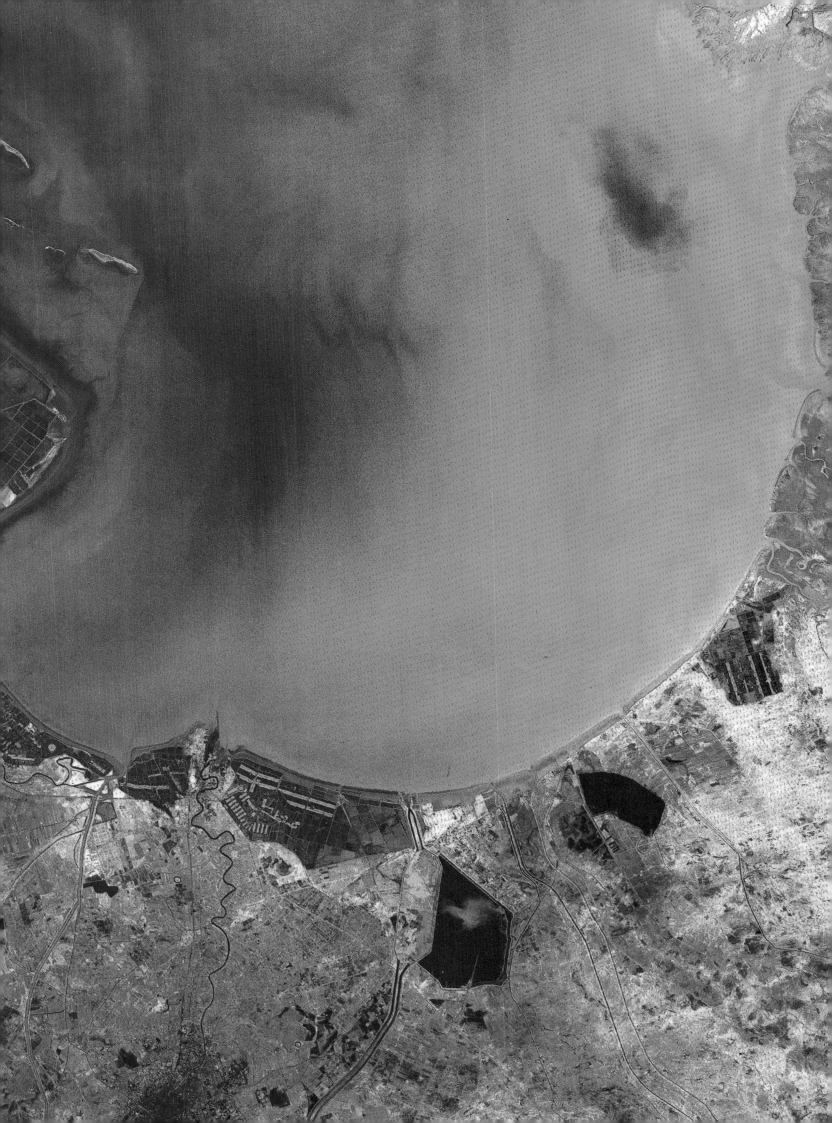

Manila Bay and Luzon Island

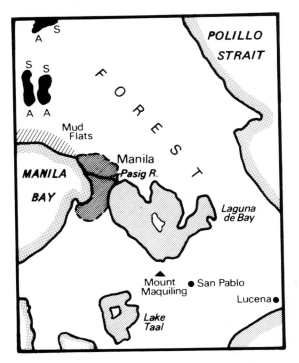

Manila, the largest city and principal port of the Philippine Islands, lies on the south-west side of Luzon Island, the largest and most northerly of the Philippine chain. The city is on the eastern edge of Manila Bay, where the bay's almost complete circle of land affords it excellent protection from the stormy South China Sea. With a population of over 3 million, Manila spreads inland for several miles and is easily seen near the middle of this December image. The official capital of the Philippines, Quezon City, is a suburb north-east of Manila, with nothing visibly separating it from the main city area.

The wharves of the city's ports are easily seen on each side of the blue thread of the Pasig River connecting Laguna de Bay, bright blue with sediments, to Manila Bay. Further north on the bay there are mud flats, grey-green on the image, where the world's largest commercial fish-ponds are located and show a granular pattern. To their north is the bright red of intensive agriculture (**A** on the map), principally paddy rice and sugar cane, interspersed with swampy areas (**S**).

The Philippine Islands are one of the world's leading producers of timber, with more than 34 per cent of the islands' area devoted to commercial forests. These can be seen east of the central valley as a continuous region of bright red, higher than the central plain, which is only 100 feet or so above sea level. Further to the south, below Laguna de Bay, is the city of San Pablo, and at the extreme right-hand edge of the image the city of Lucena. Both show as bluish patches on the picture.

South of Manila is the dark water of Lake Taal, a drowned volcanic crater with a small island in the centre. The island is an active volcano and last erupted not long ago, in 1965. The whole of the Philippines, situated on the western side of the volcanic Ring of Fire that circles the Pacific, is seismically very active, and another dormant volcano, Mount Maquiling, lies just south of Laguna de Bay.

Off the east coast of the island, past Polillo Strait, the seabed drops away sharply to the Philippine Trench and water three miles deep. East of this there is no land mass until southern Mexico, 7,000 miles away.

N

Image scale and date: 1 inch = 8 miles, December 1972

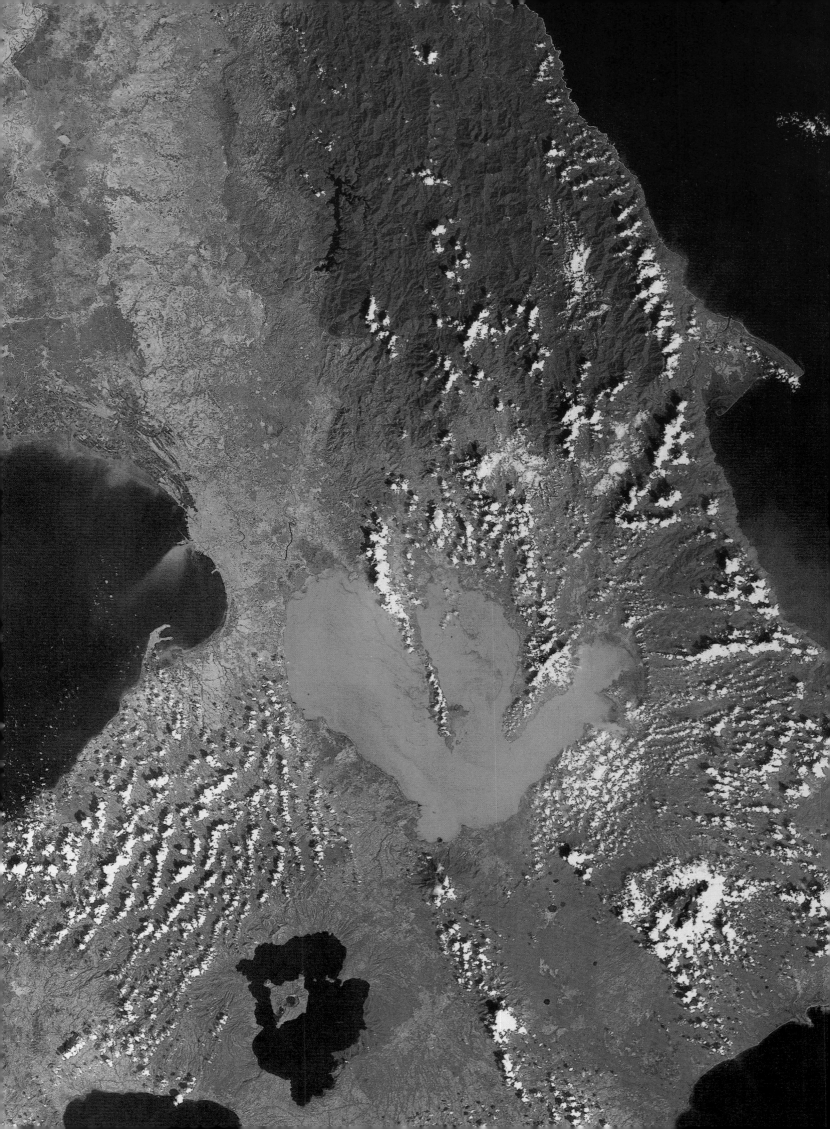

Teller Bay, Alaska

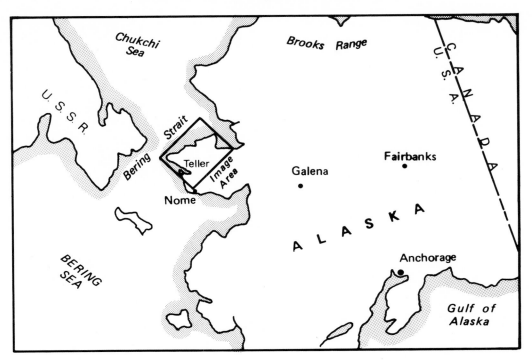

The striking cape on this image, as unmistakeable in shape as Cape Cod, lies north of a fine natural harbour that is well protected from ocean storms. It should be easy to place, but few people know it. The remote location in western Alaska, almost on the Arctic Circle, makes this promontory and harbour much less familiar than, say, San Francisco. Teller, which is on the image but not visible, lies east of the tip of the cape on the southern coastline of the bay.

The high latitude and the icy currents of the Bering and Chukchi Seas make the area perennially bleak. The average annual temperature is well below freezing, summers are cool, and permafrost is almost continuous over the image area. Off-shore on this midsummer (4 July) image, outside the long gravel spits and bars created by strong north-flowing currents, is a blue island of relict pack-ice.

The region is too cold for true tree cover. Open tundra vegetation covers the frozen surface, tussocks and reindeer lichen interspersed with willow and birch shrubs. The stunted trees provide the brighter reds visible along protected valleys and water courses through most of the scene. Bright blue-white areas extending north from the south coast of the cape are limestone bedrock. In the central part of the image, prominent thrust faults produce the clear boundaries that we see between the eastern edge of the limestone and the vegetated red areas of metamorphic rocks. Further north, the coastal lowlands are dotted with thaw lakes, the summer home of vast numbers of nesting migratory waterfowl.

Not surprisingly, the region is sparsely populated. Less than 1,000 people live in the whole scene area. The Eskimo natives live in five villages, one of which, Shishmaref, lies on the blue area of gravel spit near the top of the image. It has been severely damaged many times by storms in the Chukchi Sea, but the residents resist moving to higher ground inland since this would place them further from whale and walrus hunting grounds. Since 1971, about a quarter of the land here has been returned by the U.S. Government to the Eskimos. This should lead in the 1980s to major new development since the region has gold, tin, and geothermal power, as well as herds of reindeer.

This part of the world has great archeological significance. Within the last 100,000 years, fluctuating sea levels have accompanied worldwide ice ages. The Bering Strait has been exposed a number of times to provide a land bridge between Siberia and North America, across which have come many animals, including man. The last time that the land bridge was drowned by the rising sea was 10–11,000 years ago. The present 55-mile width of the Bering Strait offers evidence that we are now living in a warm inter-glacial period, but no one is sure whether we are still in the long-term warming trend or are already on the long fall to another Ice Age.

N

Image scale and date: 1 inch = 8 miles, July 1974

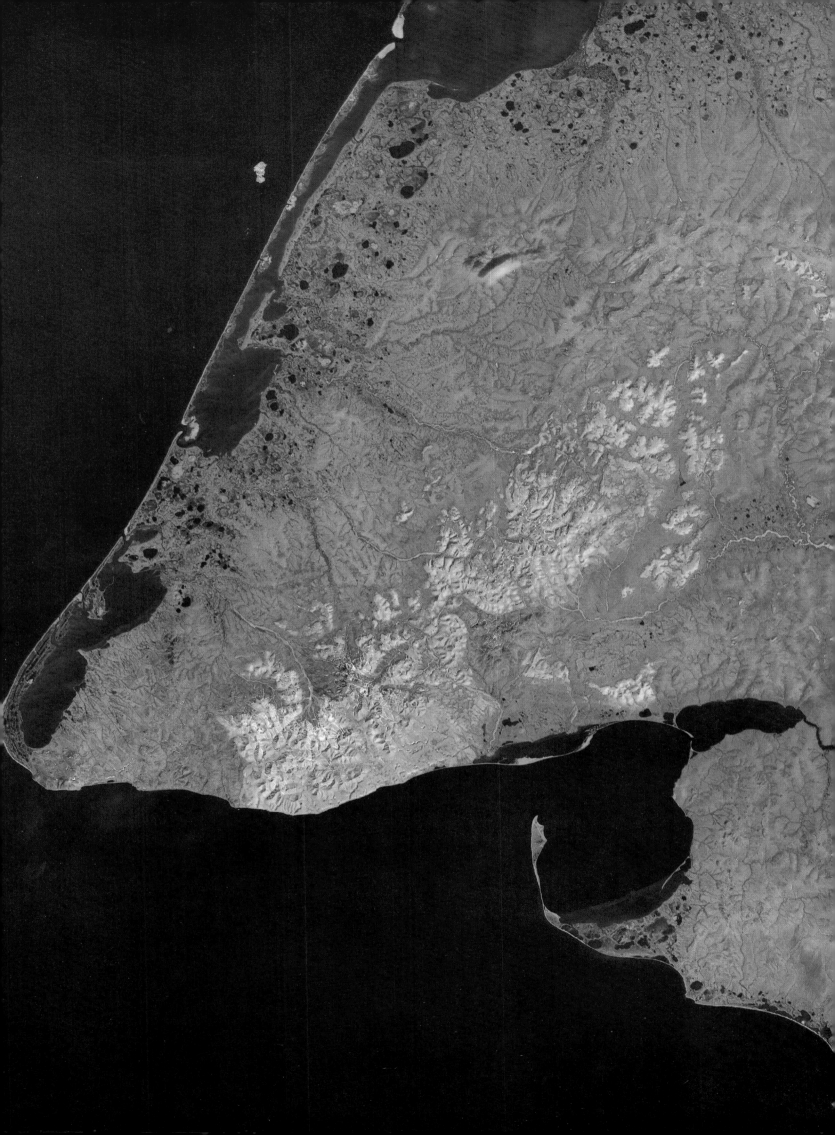

Cape Cod

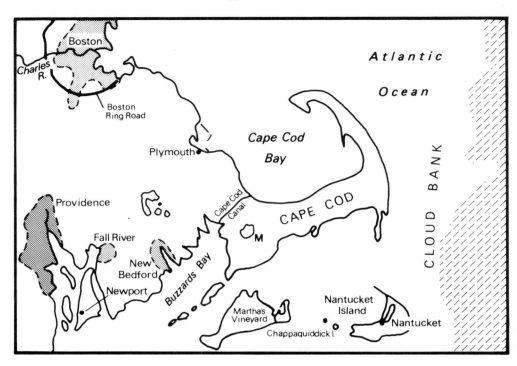

The scene on the following pages is dominated by the unmistakeable hook of Cape Cod, the easternmost part of Massachusetts. Although the Cape is a popular summer holiday area, most of the rest of this scene is heavily urban. Built-up areas show as blue on the image. Boston and its suburbs (see map) cover many square miles of the northern scene, while Providence, Rhode Island, Newport, and New Bedford show clearly along the southern shoreline. There also appears to be a town in the western part of Cape Cod, but this is Otis Air Force Base and the neighbouring Camp Edwards military reservation (**M** on the map).

The Boston Ring Road circles the city and is visible in places as a faint blue-white line. It is easiest to see south of Boston, where it runs through red vegetated areas. The whole road network of south-east Massachusetts shows well on this scene as a tracery of blue-white lines.

The Charles River runs east through Boston and opens into Boston harbour on the upper left of the picture. The wharves and jetties of the harbour can be seen as a set of fine vertical 'teeth' where the river runs into it. Further south, the Cape Cod Canal, also known as the Welland Canal, connects Buzzards Bay

and Cape Cod Bay to make the peninsula an artificial island.

Numerous ponds, natural and man-made, show as black irregular spots all over the scene. The names of the largest of these offer evidence of the native Indian influence: Assawompset Pond, Great Quittacas Pond, and Snipatuit Pond.

Logan Airport in Boston is just outside the image area. However, smaller airports on Martha's Vineyard and Nantucket Island show as well-defined blue crosses.

The image was viewed by the Landsat spacecraft on 6 July 1976, 200 years and two days after the American Declaration of Independence. The scene is appropriately historical. The Pilgrim Fathers arrived in the *Mayflower* at Plymouth, in the centre of the picture, on 11 December 1620 (old calendar date, 21 December). Herman Melville and Captain Ahab began their mystical quest for the Great White Whale at Nantucket at the south-east corner of the picture. On a more sombre note of recent history, the island of Chappaquiddick is visible at the eastern end of Martha's Vineyard.

N

Image scale and date: 1 inch = 5.4 miles, July 1976

The Musandam Peninsula

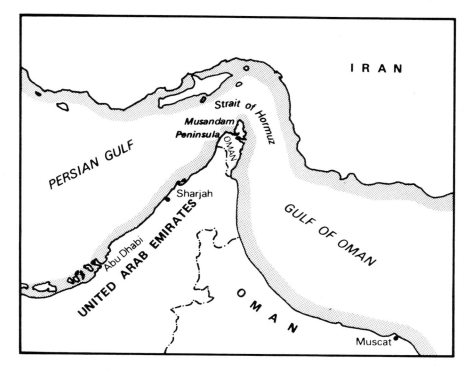

The northern end of the Musandam Peninsula is part of Oman, separated from the main body of the country by the United Arab Emirates. The peninsula juts north towards Iran, providing a division between the surrounding waters of the Gulf of Oman on the east and the Persian Gulf on the west.

The image on pages 142−3 displays the rugged nature of the central peninsula. There is a rough terrain of mesozoic limestone, broken at the northern tip into a pattern of islands. Despite the outposts of red-displayed vegetation, there seems to be little here to hold the attention, no cities or fertile plains. That was the prevailing view of most of the world until twenty years ago. Then two factors combined to alter this evaluation: extraordinary amounts of oil were discovered to the west (in Abu Dhabi, Kuwait, Bahrain, Sharjah, Qatar, and Dubai), exciting the notion that similar discoveries might be made in the Musandam Peninsula itself; and the peculiar strategic potential of the peninsula was recognized, lying as it does in the narrowest point of the Gulf, the Strait of Hormuz, just north of the image area. The latter point is apparent on the image inset, where Musandam approaches to within thirty-five miles of the coast of Iran. Oil from Iraq, Kuwait, Qatar, Bahrain, and the United Arab Emirates, and most of Iran's oil, must travel through the Strait of Hormuz.

The area is largely barren inland. Rainfall is less than 10 inches per year. In the south-east corner of the image, where the brownish limestone gives way to a yellow pattern of sands over Tertiary period sediments, a classic pattern of coalesced alluvial fans is visible, sloping gently down towards the sea. Rainfall reaching the ground in the centre of the peninsula is absorbed there and surfaces close to the outer edges of the fans, where there is abundant vegetation. The same effect is visible in less

spectacular fashion on the lower right of the image. The dark-brown areas on the extreme lower right of the image and on the image inset are ophiolites, the largest exposed complex of these old crustal rocks anywhere in the world.

Close examination of the smoother parts of the land-sea interface on the main image reveals a slightly jagged step-pattern along north−south coastlines. These do not represent real features of the earth's surface, but rather the limitations of the Landsat system. In most of the images used in this book, scales of display have been chosen that conceal the digital nature of Landsat data. As the image is displayed at larger and larger scales, that digital nature begins to show itself. First there is a graininess and lack of smoothness in the image, then finally the individual picture elements described at the beginning of the book start to become visible.

Roughly speaking, a Landsat image will look like a normal, high-quality photograph until a scale of four miles to an inch is reached. If the picture is blown up further, to two miles to the inch, definite graininess appears. At one mile to the inch each picture element from which the image is constructed measures one-twentieth of an inch square, and these can be seen and counted. Even at three inches to the mile, where a full Landsat scene would be a picture about twenty-nine feet square, the image can still be useful in interpretation work; but it no longer looks anything like a normal photograph.

The largest scale images to be found in this book are this scene, Al Kufrah oasis, the glaciers of Mount Everest, and the special high-resolution image of Washington that is shown on pages 158−9. In all four, the image is beginning to resolve itself into separate picture elements.

N◄┼

Image scales and date: 1 inch = 3.8 miles
(inset: 1 inch = 26 miles), July 1976

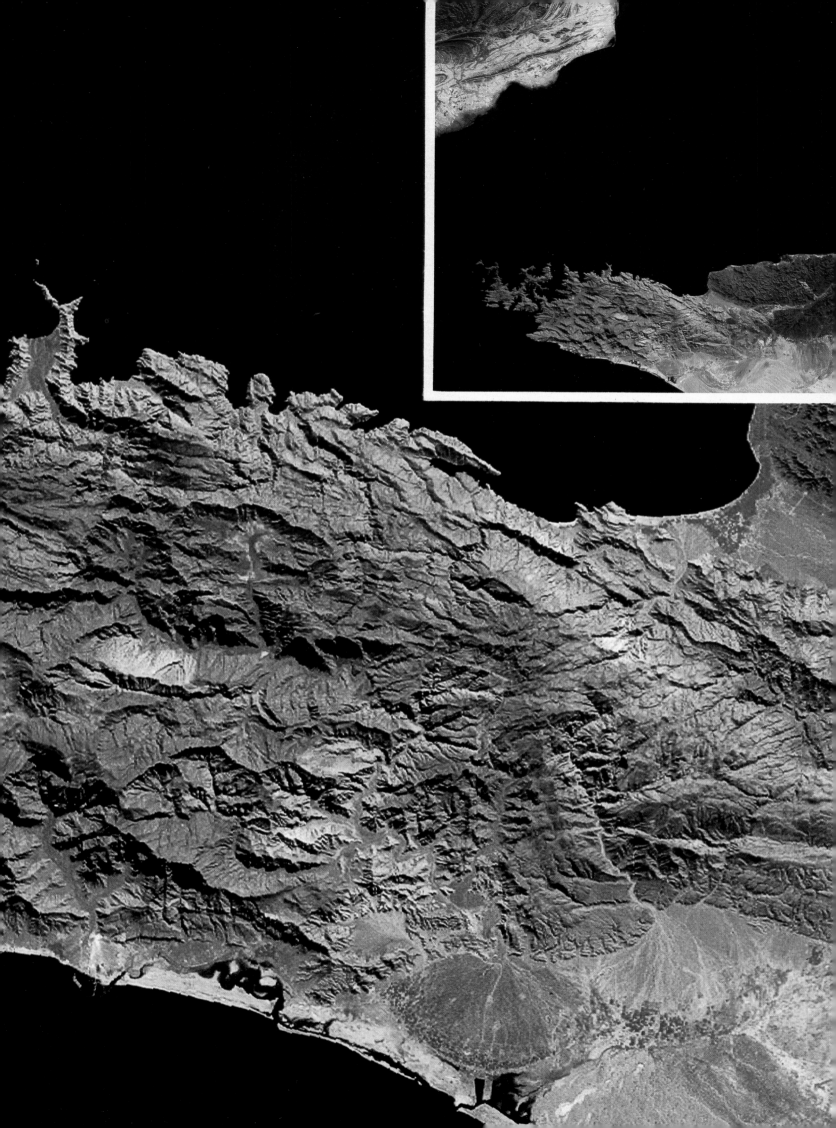

The Signs of Man

The emphasis in this book has naturally been on what we can see on space images. However, there is a great deal that cannot be seen with Landsat's ground resolution of a couple of hundred feet. Compared with what we can obtain from medium quality aerial photography, information from Landsat is coarse-grained and lacking in detail. From aircraft we can see individual houses, roads, and drainage ditches, and we can count trees and cars. This is useful information, presently inaccessible to civilian satellite systems. But aircraft and spacecraft such as Landsat both have their different places in earth surveys.

Aircraft coverage of an area is expensive — anything from a few pennies a square mile to dollars a square mile, depending on the system flown; earth resources satellites (even allowing for the initial cost of satellite development and launch) cost fractions of a penny per square mile of coverage. Aircraft can give us a very detailed look at a particular place; Landsat can give us coverage of huge areas in one pass of the satellite. Aircraft can be timed to take advantage of breaks in cloud cover; Landsat sees specific places at fixed times, and may be thwarted by cloud cover. Aircraft can (at great expense) give us images every day, or even many times a day; spaceborne systems such as Landsat have a repeat period of many days, too long for some natural phenomena. Aircraft have the advantage of flexibility and can give pictures from different heights, at a variety of scales and resolutions; Landsat images are always taken from the same height, at the same time of day, and with the same viewing angle, and have the advantages of consistency and uniformity.

The use of aircraft in earth resources is like the use of a car for transportation. We can go when and where we choose. Landsat is like a public transportation system. It runs along a fixed route according to a fixed schedule, and it costs a lot less. Pursuing that analogy a little further, Landsat will find increasing use in resource analysis only if it possesses the virtues of a good public transportation system. It must be guaranteed to run. Currently, the Landsat system has no back-up spacecraft, and only one spacecraft of the first three launched is now fully working. The next launch is not scheduled until the end of 1982, so we may have a significant gap in the service.

Usually it is possible to predict fairly accurately what will and will not be visible with Landsat's resolution, and plan aircraft coverage accordingly. But there are surprises. Evidence of man's activities is most often displayed through the presence of regular patterns of agricultural fields, and in the blue-grey spread of urban areas. The images that follow show other examples — and some of them would be evidence of mankind on earth even if Landsat's resolution was greatly decreased.

In the search for life on other planets, it has been asserted that the signs of intelligent life on earth would not show in space photography with a resolution worse than a couple of hundred yards. If the existence of certain patterns is accepted as evidence of intelligence, the images that follow prove that the assertion is incorrect.

144

Southern Libya and Al Kufrah Oasis

Libya is one of the biggest countries in Africa. Its area of 680,000 square miles puts it in fourth place, behind Algeria, Sudan, and Zaire. A Landsat mosaic of the whole of Libya runs into the problems of geometric distortions mentioned on page 126. Whereas the distortions in the picture on pages 128–9 are tolerably small, Libya would need a hundred Landsat scenes to make the mosaic, and the difference between the spherical earth and a flat representation of it are considerable.

The mosiac on the following page shows the southern part of Libya. It covers only one-fifth of the country, but extends more than 600 miles on the ground. Piecing together the different Landsat images to make this extended coverage calls for care in matching, and there will still be some distortion at the boundary between image areas.

Disregarding the effects of image matching, the impression given by the picture is one of almost complete desolation. There are many rocky ridges and great sweeps of sand, represented in enough detail that a Landsat mosaic of this kind can make a good substitute for a map in aerial navigation. But it does not look like a place where anything lives. There are no tell-tale red signs of vegetation.

That impression is not completely accurate when we take a more detailed look. Most of the image is desolate, free of all signs of plant life, but in the north-east quadrant there is a curious pattern, like the tiny figure of a running dog built up of small red dots. The pattern is dwarfed on the mosaic, but on the ground it is quite substantial – nearly twenty miles across. The enlargement on page 147 reveals what we are seeing. The feature is an oasis, shown on maps as Al Kufrah, and the pattern is irrigated agriculture. The crops are watered using centre-pivot irrigation, whereby a long arm with holes pierced along its length rotates about a fixed centre to distribute water in a circular pattern.

Each field visible on this image is over half a mile across. There is clearly no surface supply of water, which is being drawn from underground by a system of wells. Different fields show crops at various stages of maturity, from the bright red of first young growth to the dark red of plants ready for harvest. Some fields show growth at only their outer boundary, and to the left new sites are ready for planting, showing the field centre points but no crops yet.

This image demonstrates the direct effect that plant life can have on the weather. Clouds in this part of Libya are a rarity; but there is a white cloud with its dark accompanying shadow standing just north of Al Kufrah, a result of transpiration from the growing crops beneath. With a little help from humans, that cloud moisture can be precipitated out to fall to the earth. If we can do this on a wide scale, the whole area of the mosaic could one day be as productive as the fields of Al Kufrah.

Image scale: 1 inch = 34 miles
(enlargement: 1 inch = 3.4 miles)

N

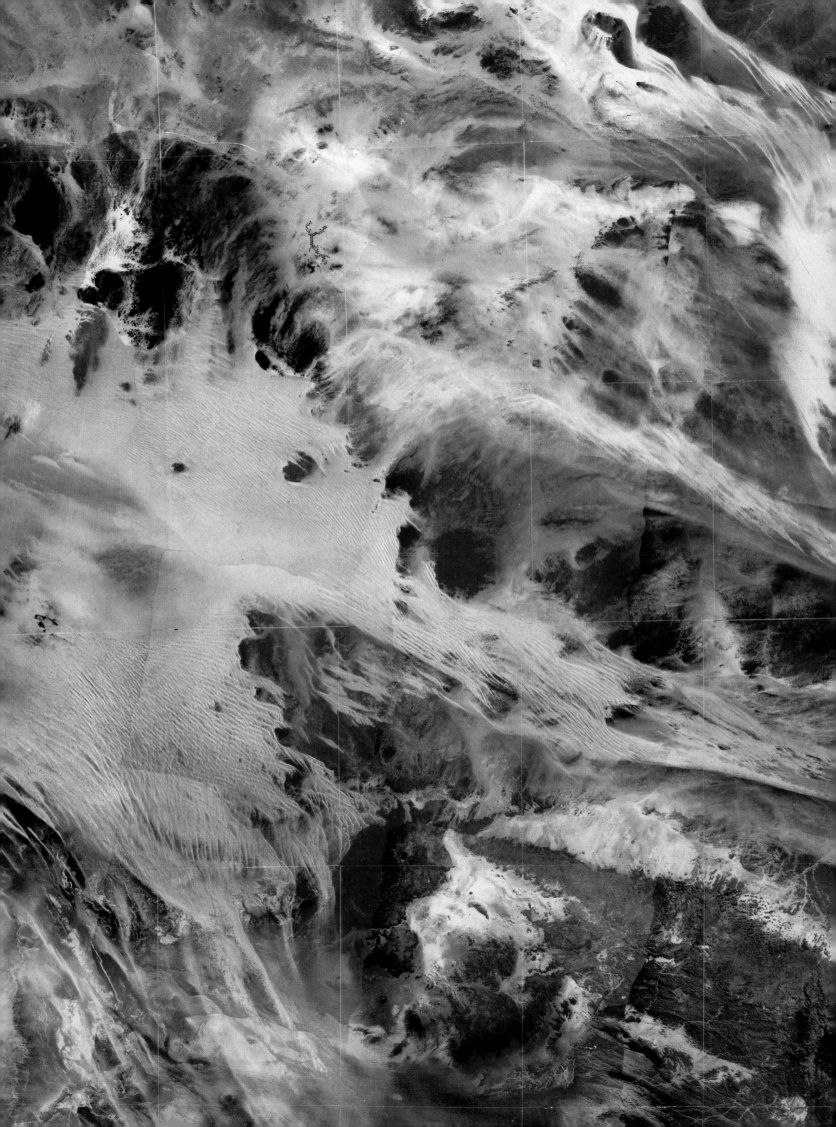

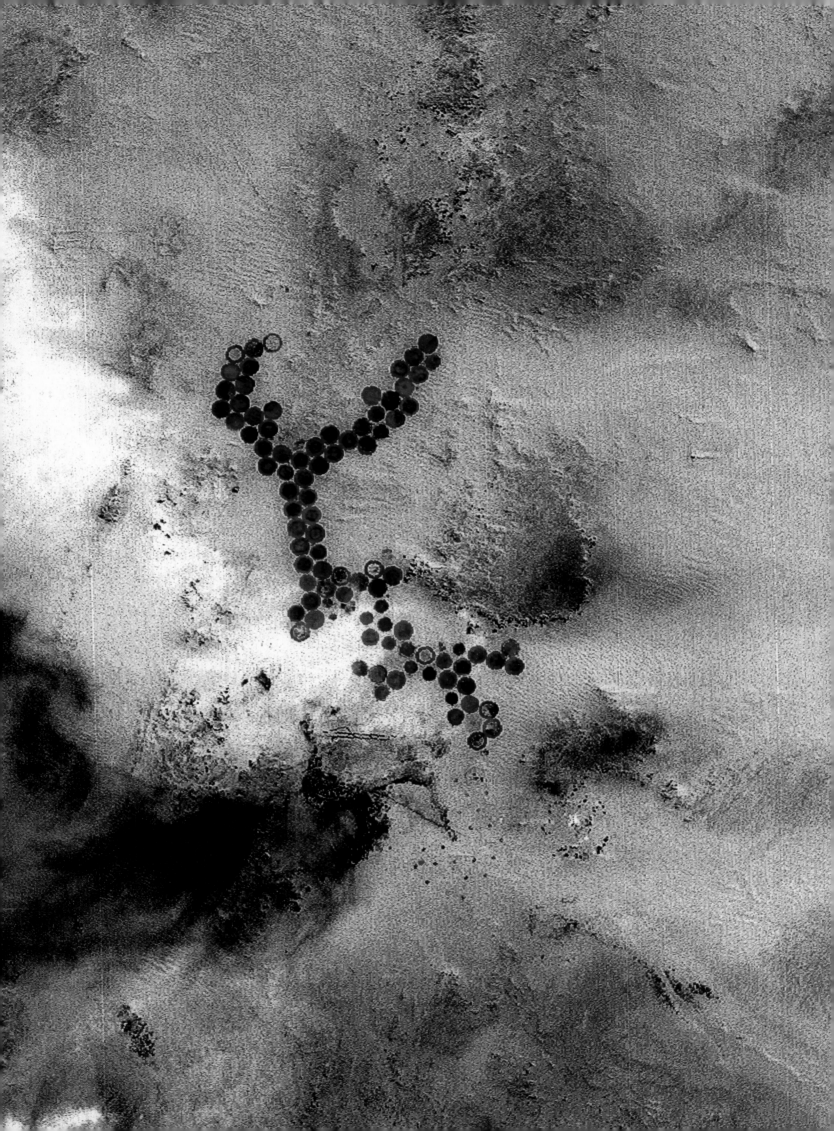

Upper Volta

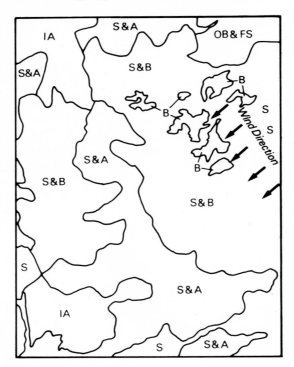

Upper Volta is one of the world's poorest countries and not one where bridges, dams, agricultural organization, or other signs of man's handiwork would be expected. But man has clearly left his mark on the area covered by this image of Upper Volta, Ghana, and Benin.

The regions labelled **S** (see map) are savannah and savannah woodlands, still in their natural condition. Any area that has some other tone than this warm reddish-brown has seen modification by humans. The regions of intensive agriculture (**IA** on the map) are noticeably lighter in tone. Mixed savannah and agriculture (**SA**) is of an intermediate colour.

The most striking element of the scene, however, is the extensive and numerous set of dark areas (**B**), almost perfectly black, that lie in the central part of the image. They could be mistaken for water bodies, except that on their right they often begin on well-defined lines and seem to be wind-driven leftwards across the image. They are in fact burns, an integral part of land use practised here.

Burns clear the land and encourage the growth of new vegetation, and they also help to control ticks and other pests. The burns begin in November after the end of the rainy season and continue through December and January. They extend for many miles, and at their peak the whole countryside seems to be ablaze and lies under a thick pall of smoke. By the spring, the black areas of the burns will have extended over the whole centre part of the image. Planting of rice, millet, sorghum, peanuts, and other root crops can begin. Regions marked **S&B** show a mottled pattern of burns and savannah, and in the upper right of the scene is a mixture of old burns and bare ferruginous soils (**OB&FS**). The older burns have weathered to a dark green. Although rotation of the crops in the usual sense is not practised, it is common to allow areas to lie fallow for a year or two before they are replanted. Even so, this slash-and-burn method is gradually reducing the fertility of the soil, and the people of Upper Volta face a slowly decreasing food supply.

Two reasons for burning each year after the end of the rainy season have been mentioned. There is a third one. The people obviously enjoy the excitement of setting alight and watching the fires. Appropriately, this scene was recorded by the Landsat spacecraft on 5 November 1975 – Guy Fawkes' Day as it is celebrated in West Africa.

N

Image scale and date: 1 inch = 8 miles, November 1975

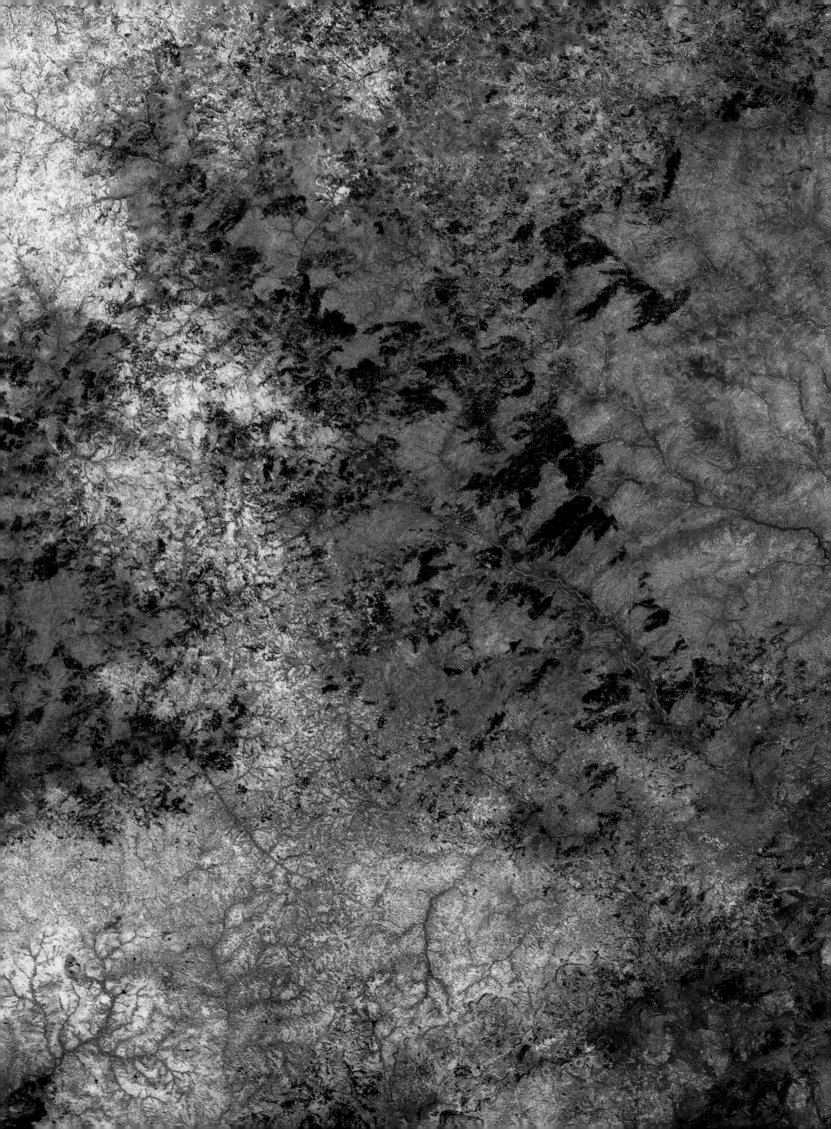

The U.S./Canada Border

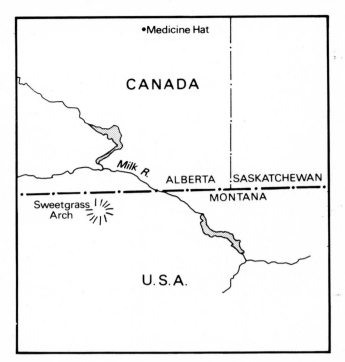

Sometimes national borders follow natural boundaries such as rivers, coastlines, or mountain ranges. Sometimes they are artificial constructs that, like the equator or the meridians of longitude, have no physical reality.

The border between the United States and Canada, which across the whole western half of the continent is coincident with the 49th parallel of latitude, is a boundary of man's devising. It comes as rather a surprise, therefore, to see that this wholly imaginary line is clearly visible on the ground.

The area of this scene is where Montana meets the Canadian provinces of Alberta and Saskatchewan, in the central great plains, eighty miles south of Medicine Hat. Most of the land here is a great level expanse that 100 years ago was covered with forage grasses and still is seen in some northern parts of the image, visible as dull greyish tone. The grasses are quick to mature and by mid-July their growing season is already over. Here and there isolated mountains stand up from the surrounding plains. One of these, Sweetgrass Arch, is on the extreme left of the picture. The hills capture much of the available rainfall and they support woods, mainly of Douglas fir and Ponderosa pine, that give them their bright red appearance on this September scene. The rest of the area is already looking dry by now.

South of the border the natural growth of the plains has been replaced by agriculture, mostly winter and spring wheat and barley. With a rainfall of less than 16 inches a year, this is a marginal region for the growth of small grains and it is necessary to adopt special farming methods. The natural cover of grasses is able to bind the soil, but when it is ploughed it crumbles to a fine dust and suffers wind erosion. To prevent this, strip farming is used, in which every field is divided into narrow swaths of alternating fallow and crop land. The fallow land builds up moisture that will be used the following crop year, permitting soil to be retained and grain to be grown in areas that would otherwise be too dry.

In contrast to this, on the Canadian side the land is still used mainly for grazing. There are signs of soil loss there, the result of past practices, but now it is fenced prairie.

The swaths of ground in Montana are not all of the same width, and they provide an interesting measure of the amount of detail that can really be seen on Landsat images. For this scene, computer processing has been done to emphasize the edges of the fields and strips. Swaths with a width of less than fifty yards or so cannot be seen on the image.

Image scale and date: 1 inch = 7.1 miles, September 1976 N◄┤

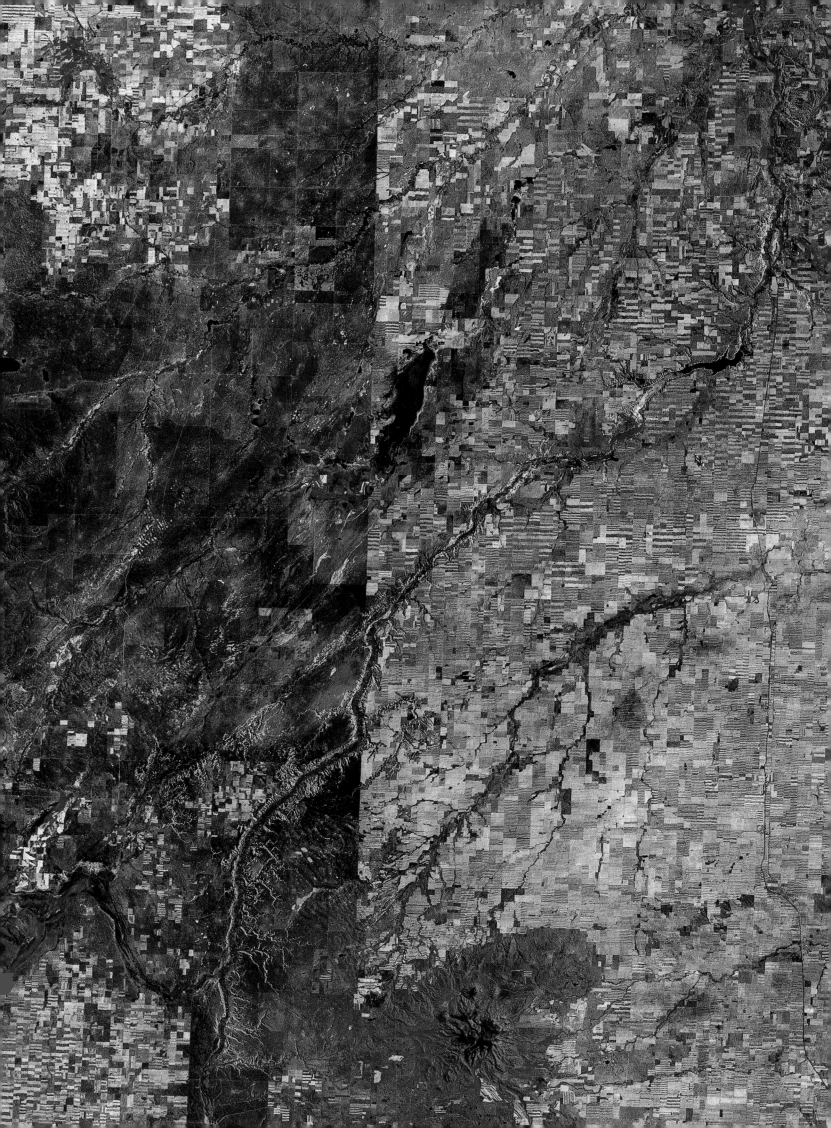

Stirling Range, Western Australia

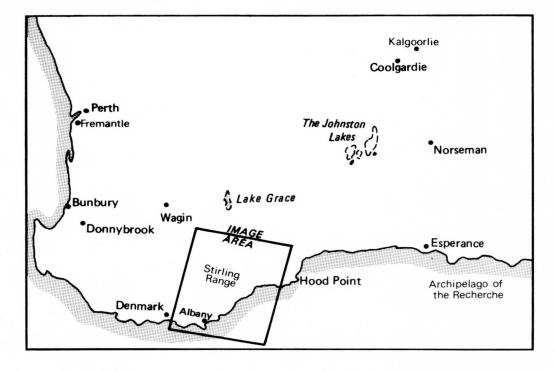

Straight lines on the earth's surface are not common in nature, and squares and rectangles even less so. Stirling Range, the central feature of this image, forty miles across and ten miles deep, would reveal human activity even if Landsat's ground resolution were ten times poorer. Parts of its boundary look as though they have been laid down on the image with a ruler.

This is part of the southern coast of Western Australia. Perth and Fremantle, the capital and main port, lie 250 miles to the north-west. Perth has a population of 700,000 people and is Australia's fifth largest city, but the region shown on this image holds less than one person per square mile.

This part of Australia is Precambrian shield and has extensive mineral deposits. It was the discovery of gold at Coolgardie (1892) and Kalgoorlie (1893) north-east of here (see map) that stimulated the development of the whole area and brought in thousands of miners. However, by 1910 gold production was diminishing. Agriculture was turned to as an alternative means of support, even though shortage of water is a problem. The 'lakes' on this image show as blue-white ovals; like most lakes of Western Australia, they are usually dry and fill only in the winter (July and August) rainy season.

The total rainfall varies from about 20 inches per year on the coast to perhaps 11 inches per year in the northern part of the image. However, since it falls in the winter months it permits the cultivation of winter wheat and some barley, planted in March and April and harvested in October. Close to the coast, fruit and vegetables are also grown. This March 1979 image shows the land with just the first tinge of red-displayed vegetation showing in the northern fields. Because the population is low, highly mechanized farming is necessary, with large fields for both cereal production and sheep-raising. The latter occurs mainly north-west of Albany and Denmark.

The natural ground cover of this part of Australia is mallee scrub, mainly dwarf eucalyptus with some acacias. In the Stirling Range, where steeper terrain discourages farming, the land has been left with its natural cover, to produce the striking red rectangle that we see here. Over all this area, rabbits are a problem, and the boundary between cultivated and uncultivated land is delineated by mile after mile of rabbit-proof fencing — said to be impassable to all small animals (except possibly rabbits).

N

Image scale and date: 1 inch = 8 miles, March 1979

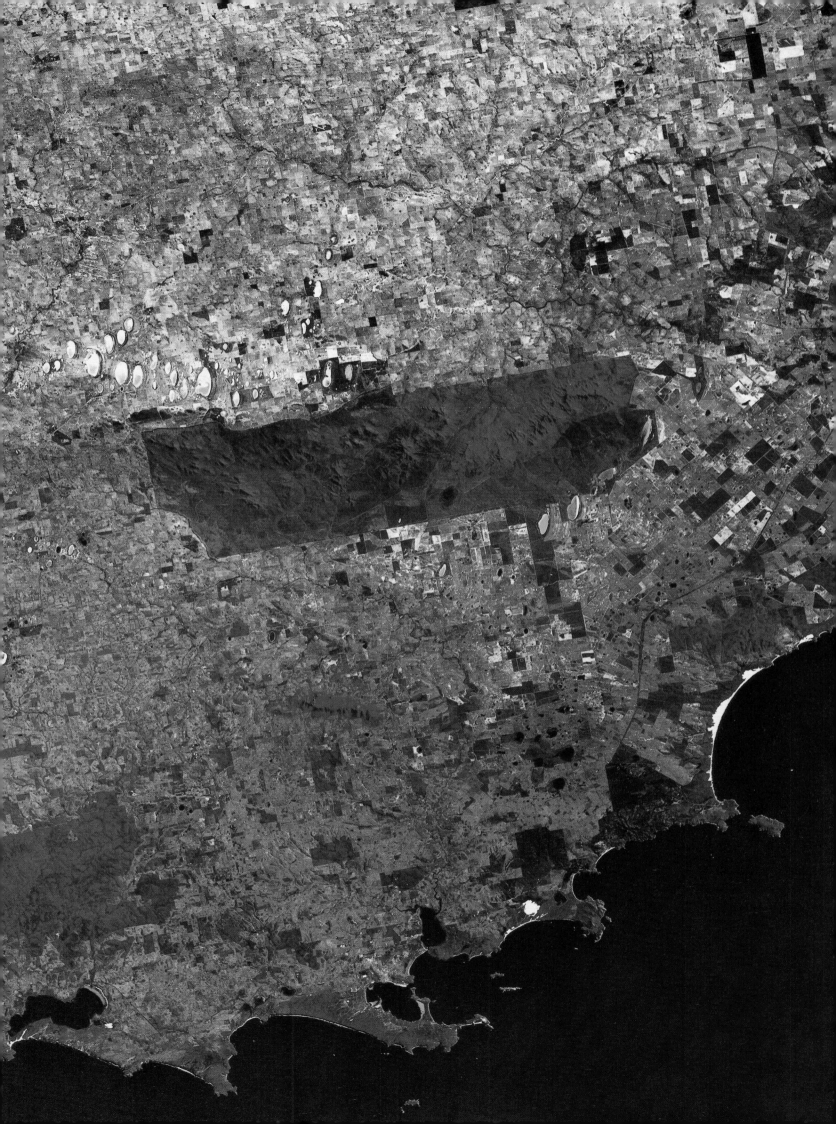

Zaltan, Libya

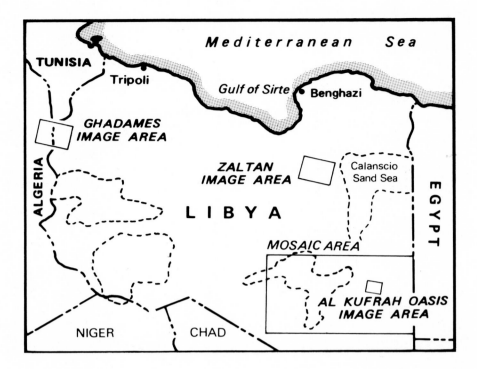

This image shows the part of Libya that was known as Cyrenaica until the country was unified in 1949. The area lies south of Benghazi, and about 150 miles from the Gulf of Sirte. Until 1957, its main claim to fame was its oases. A string of them runs south-east from the Mediterranean, in a long, winding valley that is nowhere more than a few hundred feet above sea level. It includes the oases of Bir Rassam, Awjilah, Jalu (both these last two are visible to the upper right of this image), Faredgha, and Siwa. The whole region seems to be an ancient marine inlet from the Mediterranean that became silted up in Pliocene times, 2–5 million years ago. It was the only fertile region in the north Libyan desert, producing dates, olives, almonds, figs, and grapes. Then, in 1957, the first major petroleum discoveries were made.

Libya changed in a few years from a poor country to one of the world's biggest oil producers. Some of the most productive areas for oil are found to the east of Zaltan, which lies in the white and tan sandy area on the left of this picture but is not visible. East of Zaltan are the dark spots of major fields and production centres looking like spiders in a large web. The white strands stretching across fifty miles of desert are the connecting network of truck routes, car routes, and over- and underground pipelines that link these fields to the coast and to each other.

Image scale and date: 1 inch = 8 miles, October 1975

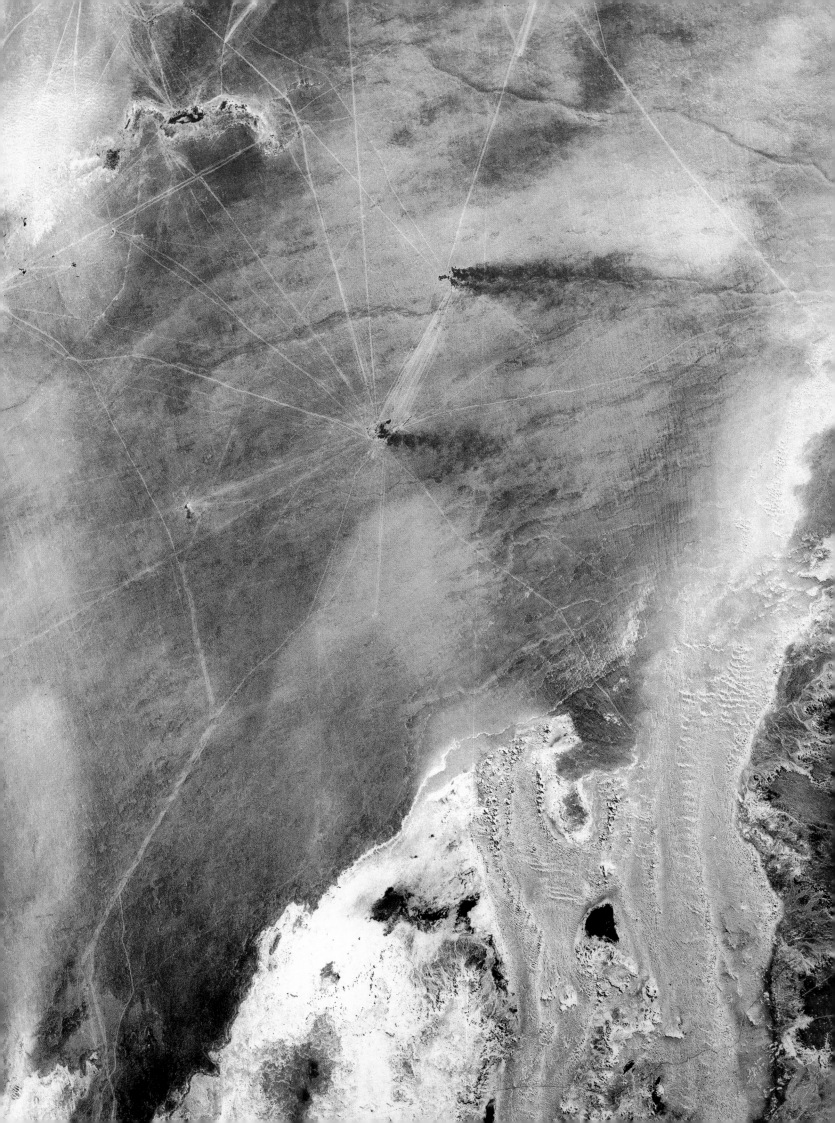

A Look at the Future

The first earth resources satellite was launched in 1972. Impressive as the results have been, they come from a tool still in its infancy. The next decade will bring new satellites and new instruments on board them, and at least some of them are close enough to realization to describe. But first, let us see why we need them.

Landsat sees areas on the ground that are an acre or larger; no houses, no individual trees, no drainage ditches. For forest inventories, the foresters would like to be able to see and measure individual tree crowns, which would imply a capability to see objects on the ground no more than perhaps five yards across; cartographers would like stereoscopic coverage so that scene relief can be observed and measured; geologists would like an imaging radar system. Agronomists would like radar, too, in order to be able to obtain pictures when the weather is cloudy. Urban analysts need to be able to see and count each separate house and street.

It will be technologically feasible to satisfy these requirements. Resolution from space, at least in principle, can be very good. It will be possible to see objects as small as a foot across, and that limit is imposed by the turbulence of the atmosphere, not by the optical systems we might build. To receive, record, and manipulate the signals coming from the sensors at such high resolution would involve an enormous data processing problem, but computer hardware and software is advancing at a very fast pace.

The next generation of earth resources spacecraft stops far short of the one-foot resolution that might in principle be achieved. The successor to the present Landsat spacecraft, termed Landsat-D, will carry a new instrument called a Thematic Mapper. It will provide pictures with 30-yard field of view (about half the present scanner) and will add new spectral bands of longer wavelength, including a thermal infra-red sensor with 130-yard resolution. No examples of such pictures are available yet (the satellite is scheduled for a 1982 launch) but we can get an idea what they will look like by combining scanner images from the present Landsat spacecraft with images from the Return Beam Vidicon on Landsat-3 that takes black and white pictures with about 35-yard resolution. Computer tapes from this instrument have only recently become available, so the product shown on pages 158−9 is still experimental. Even so, it represents a striking improvement over the usual scanner images (the black crosses on it are calibration marks, not ground features). The area is Washington D.C., and it can be compared with the usual Landsat image by looking at the Chesapeake Bay mosaic on pages 130−1 where the scanner image was used.

In 1984, the French space agency plan to launch S.P.O.T. (Système Probatoire d'Observation de la Terre), a satellite which will give colour images at 20-yard resolution, and black-and-white images at 10-yard resolution. It will also be able to swing the observing instrument away from the vertical on successive passes, and so produce stereoscopic image pairs.

A spaceborne imaging radar, flown experimentally on the SEASAT-1 satellite, is likely to fly again by the mid-eighties, and the Japanese and Soviets have also announced an intention to launch their own unmanned earth resources satellites. By 1990, it seems certain that there will be sensors in orbit that view the earth with a resolution of 10 yards or better, in many spectral bands including the cloud-piercing radar wavelengths.

The more powerful observing instruments will be matched by an increase in our ability to make use of the data they send. The methods used now for analysis of Landsat data are quite different from what they were in 1972 and 1973. This technology is also in its infancy.

The time is approaching when we will be able to conduct full prospecting operations for minerals from space-derived data. By the year 2000 a latter-day Andrew Marvell will be able to find the rubies of the Indian Ganges without leaving Humberside. Our remote eyes in space will gather data in wavelengths far beyond what human eyes can see. It will be fed directly to ground-based computers without human intervention, and from that automatic analysis will come drought warnings, forest inventories, land use reports, crop forecasts, flood alerts, earthquake predictions, and resource summaries.

This, and more, will be technologically possible within the next twenty years. That is not the real issue. Knowledge comes, but wisdom lingers, and as usual the uncertainty will still be down here on earth. Data will flow from the next generations of earth-sensing satellites in ever-increasing amounts, and we will be given reports of the earth as it is and not as we imagine it to be. We must organize ourselves to use that new knowledge.

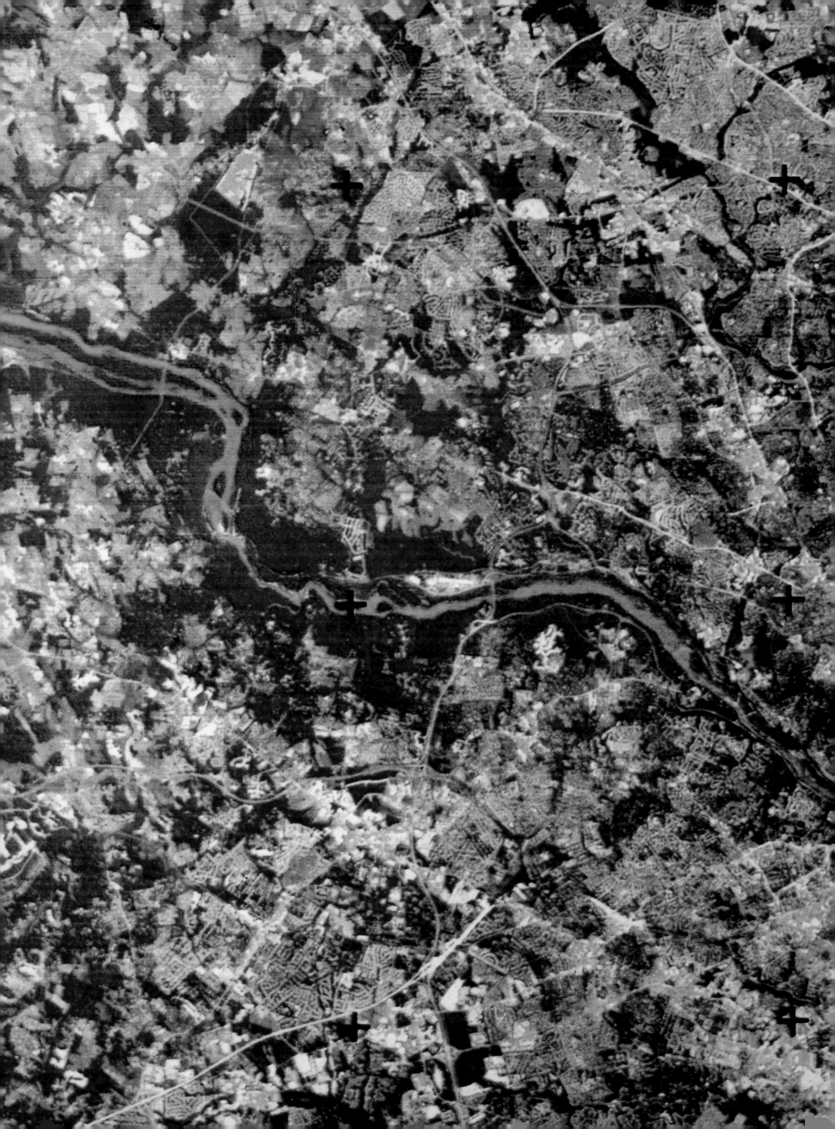

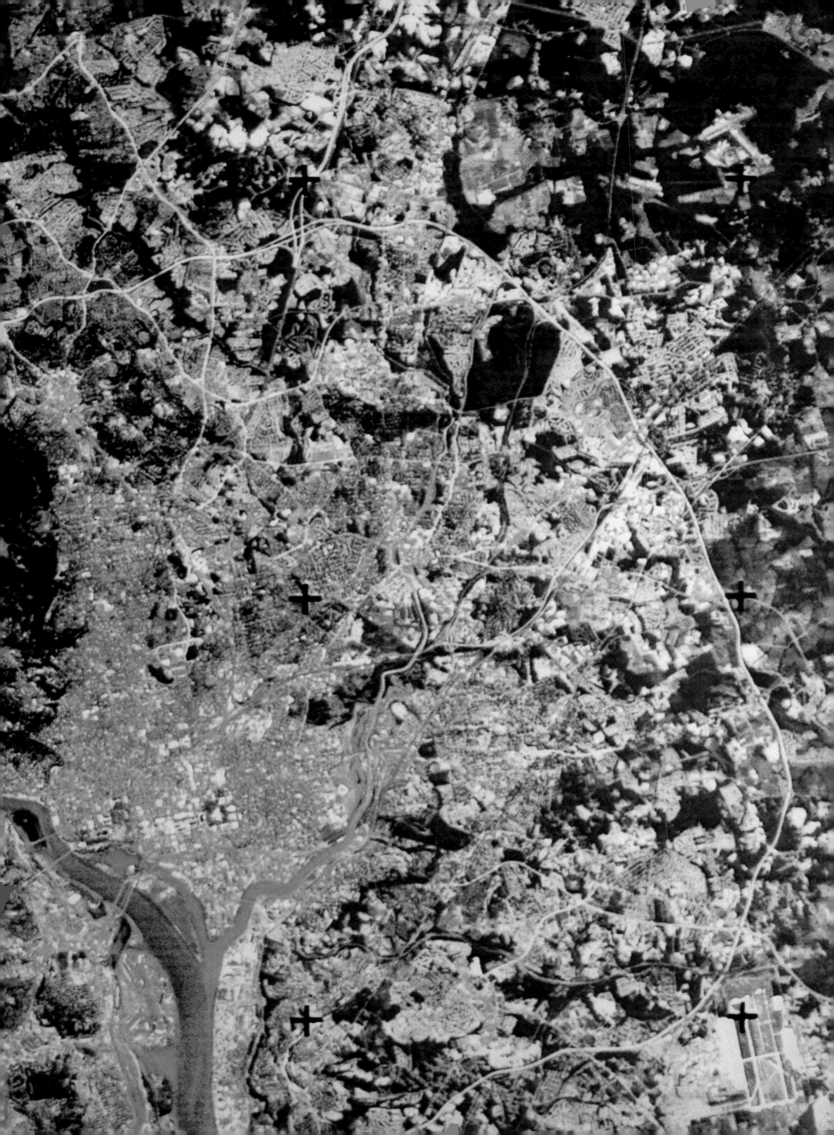

Index